D1310896

# Struggle Over
# the Modern

# Struggle Over the Modern

## Purity and Experience in American Art Criticism 1900–1960

Dennis Raverty

Madison • Teaneck
Fairleigh Dickinson University Press

Associated University Presses
2010 Eastpark Boulevard
Cranbury, NJ 08512

The paper used in this publication meets the requirements of the American National Standard for Permanence of Paper for Printed Library Materials Z39.48-1984.

Library of Congress Cataloging-in-Publication Data

Raverty, Dennis.
    Struggle over the modern : purity and experience in American art criticism, 1900–1960 / Dennis Raverty.
        p.   cm.
    Includes bibliographical references and index.
    ISBN 0-8386-4021-4 (alk. paper)
    1. Art criticism—United States—History—20th century.   I. Title.
N7485.U6R38   2005
701'.18'09730904—dc22                                                2004019815

PRINTED IN THE UNITED STATES OF AMERICA

# Contents

# Struggle Over
# the Modern

# Introduction

THE VARIOUS TENDENCIES THAT WERE DOMINANT IN AMERICAN ART in the decade preceding World War II and the Abstract Expressionism that rose to international status in the years following the war represent a particularly puzzling and momentous shift in critical consensus within the art world in the United States. The sheer magnitude of this shift from politically engaged realism to apolitical abstraction calls for a thoroughgoing exploration. So far we have had, at best, only partial descriptions of this shift from various vantage points. Long attributed, simplistically, to the exposure of American artists to European Modernists arriving in New York City during the war, such a radical shift in the art world now seems the result of circumstances much more complex than stylistic explanations alone can elucidate.

What is in question here is not so much the change in the artwork itself as the changes in the institutions, patronage, and the entire critical discourse that surrounded the emergence of postwar art that would make this paradigm shift possible. Even a cursory examination of the context of this shift indicates the causes are complicated and multidimensional. The change is probably best understood as a complex, overdetermined shift that will inevitably be explained not by any single study, but rather by unraveling a number of different narrative threads: political, economic, and broader "cultural" treatments that, when woven together, will provide fuller descriptions and explanations of this radical paradigm shift.

Interesting investigations of the political context and the institutional framework surrounding this shift have yielded important information and interpretations in recent scholarship. In Frances Stoner Saunders's intriguing book, *Who Paid the Piper: The Cultural Cold War and the World of Arts and Letters*,[1] the author helps explain the ascendance of Abstract Expressionism in terms of the hidden political and economic agendas of those individuals and institutions promoting and funding modern art.[2] On another front, Stephen Polcari's *Abstract Expressionism and the Modern Experience* uncovers previously unexplored correspondences amid contemporaneous thought from a number of different fields as wide-

9

ranging as philosophy, the rise of consumer society, and themes of Modern Dance contemporaneous with the origins of Abstract Expressionism.[3]

The critical and aesthetic discourse surrounding this shift from prewar to postwar American art is the subject of the present study. It will trace this shift in critical, aesthetic, and related writings of the period. These will be the principal texts explored in this historiographic examination of critical paradigms from the first half of the twentieth century.

Critical writings, examined historiographically, can yield important information because beyond their immediate functions of explanation and evaluation of contemporaneous art these writings imply an unspoken strategy for capturing and dominating the field of critical discourse, thereby influencing the way people think and talk about art. The history of critical thought in twentieth-century American art is also the history of this struggle for dominance.

Examination of the primary sources reveals an all but forgotten critical battle between opposing camps in American art criticism that appeared and reappeared throughout the first half of the twentieth century. The participants in this debate, comprised chiefly of critics and theorists as well as some artists, have changed throughout the years, but the same two competing premises are discernible.

The battle I speak of is not the familiar one between the conservative academics and the "progressive" moderns, but a struggle *within* the avant-garde, a struggle over which ideas would define the modern for future generations. In a sense, it was a battle for the very soul of modern art.

On one side, there were various manifestations of essentialist formalism, most familiar to us through the writings of the influential late modern critic Clement Greenberg; on the other, there was a cluster of generally overlooked critical ideas I am terming the "experiential," which emphasize experience over essence. Greenberg's rival, Harold Rosenberg, is an example of a proponent of the experiential paradigm still familiar to most of us today. It will be shown how the positions of these celebrated critics, whose ideas were so powerful in the postwar decade, were merely more recent installments in a battle that had been staged repeatedly in American criticism throughout the earlier part of the century.[4]

More than an obscure debate among aesthetes, this was a battle over the very terms and limits appropriate to art, a competition—stretching all the way back to the Armory show of 1913—to define art either narrowly as an exclusive self-referential endeavor, or broadly delineating

the boundaries between art and experience in a more inclusive manner. My purpose here is to lay bare and deconstruct both the formalist and the experiential strategies *as strategies*, tracing their development over time and thereby restoring to the era some dimensions of its polemics on their own terms.

It is not posited here that these are the only two strains of critical thought operative in America during the period, nor is it to be assumed that they always appear in an unadulterated form. However, by selecting and following these lines of thought in their development over time, it is hoped that a more complete picture of the situation will begin to emerge, and another dimension will be added to our understanding of this complex period.

Formalism is relatively easy to define as an exclusive and self-referential mode of thinking about art that emphasizes formal concerns, buttressed by historical explanations but largely removed from a social context. It is so familiar to us because of its pervasiveness in late modernist thought. Part of the success of formalism as a critical strategy during the period of late modernism was the suppression and defeat of its rival.

The other half of the discourse, the experiential, is less familiar, largely because of its relative eclipse in recent thought. During the 1930s, however, it held a position rivaling the predominance of formalism during the 1960s. The experiential position had its origins in the philosophy of pragmatism first articulated by the American thinker William James, and later elaborated on and applied to art by John Dewey in *Experience and Nature* and *Art as Experience*.[5]

Individual and actual experience is the primary datum in their thought. The "self" is seen by these thinkers as merely a construct that doesn't correspond to the fluid reality of experience as lived. In its place, they postulated a sequential, serial course of events that James called the "stream" of consciousness. Logical consequences of this dynamic view include the impossibility of true objectivity and the engaged nature of all experience within a context.

For James and Dewey, experience involved both a person and his environment in a unitary event, an *environment as experienced* by an individual. They called for a concentration on experience instead of essence in a conception of the universe as open-ended, pluralistic, and in process.

Because it is always relentlessly centered in the present, and because it is malleable and responsive to a changing environment, the cluster of ideas I'm calling the experiential is, by its very nature, somewhat fleet-

ing and elusive. Morton White calls this type of anti-formalist thought "cultural organicism" to indicate the intellectual tendency to explain phenomena by reaching out to the cultural surroundings to provide a context for meaning.[6] But cultural organicism is not a term used by the writers of the period themselves, whereas the term "experience"— defined in different ways by different authors at different times throughout the period under consideration—is a key word, which appears over and over again like a leitmotif. Therefore, despite the limitations of the word, "experiential" will be used to describe this series of modernist yet anti-formalist critical tendencies throughout this book.

The experiential paradigm has manifested itself clearly in a number of different forms within critical thought, tracing an erratic path from its inception in New York Dada and the Arensberg circle; as a minority position during the 1920s; through populist, nationalistic, and social-change art to dominate the critical arena during the 1930s; and into its almost existential form in the postwar writing of Harold Rosenberg.

The modern formalist position arose around the same time, being first systematically articulated in the writings of Willard Huntington Wright, who published his influential *Modern Painting* in 1915.[7] Formalist criticism dominated the field during the 1920s, but began to wane with the increased isolationism and nationalism in America at mid-decade—tendencies that increased after the stock market crash of 1929. During the following decade, the formalist position was all but eclipsed, yet survived as a minority position.

Clement Greenberg emerged to articulate the most complete and convincing form of the formalist paradigm in the postwar era, a fully historical argument that would assume the weight of authority in late modern criticism. Around the same time, Harold Rosenberg developed a rival theory to explain the new art, which developed aspects of the earlier experiential paradigm now centered on the specific experience of the artist's studio as an arena of action. Paradoxically, each critic championed the work of the same artists, the Abstract Expressionists, but they did so on opposing grounds: Rosenberg relying on direct experience and immediate environment, and Greenberg grounding his theory on essence and history. These critics brought to a culmination critical ideas that had been debated in one form or another throughout the century in American aesthetic thought. The history of this debate is the subject of the present study.

Before proceeding further, I want to point out that this book is informed by a particular kind of understanding of the writing of history.

My approach to historical discourse is derived largely from the philosophy of history put forward by contemporary Neo-Pragmatists Richard Rorty and Cornel West. Briefly described, their supposition is that there is no history "out there" independent from our descriptions of it. Description and re-description of events from different perspectives creates a number of differing stories, or narrative emplotments that we call history.[8] Rorty proposes that the dialogue or what he calls "conversation" between these differing narratives to be the basis of how this consensus is brought about in the art establishment (or as Adorno sardonically dubs it, the "art industry"). In art history, cannons are brought together only years or even decades later on the basis of this consensus. Paradigm shifts are achieved through the widespread consensus of opinion changing within a field, usually gradually but sometimes rapidly, from one dominant way of thinking to another—and then sometimes only after a protracted struggle. The language, narratives, and way of thinking that defines, constitutes, and limits the emerging paradigm, Rorty calls the "vocabulary," utilized. Looked at in this way, the formalist vocabulary that "triumphed" along with the art of the postwar period is the result of one of these reaching a new level of consensus and authority within the discourse. The new narratives were compelling and believable.

Historical narratives, like all skillful story-telling, use such literary devices as metaphor and irony, they create heroes and villains, plot-line development, tragedy, comic relief, and so forth, in the telling of the story. According to Rorty, the point is in the persuasive telling itself, and not in its correspondence to any "truth" out there. The stories are told to achieve pragmatic ends. They not only tell us "how things were," they help us to "get what we want." History is only "useful" in this pragmatic sense if it teaches us about the present or presents a vision of the future that might inspire action.

Cornel West, a theologian as well as a philosopher, goes beyond Rorty's call for "conversations" to more radical arguments based on a "prophetic" imagination of a possible future as the guiding principle for what he calls, "cultural workers"—those artists, critics, collectors, dealers, curators, teachers and others involved in the culture industry who are trying to achieve a new consensus or guide history in a certain direction.[9] In West's visionary hopefulness we can see the instrumental use of the telling-of-the-story to achieve radical ends.

This is exactly what many different parties in the first half of the century did to advance their own agendas for art world consensus—they had a pragmatic, operational attitude towards history, "emplotting" it

according to strategic aims—in West's terms, the "prophetic" envisioning of a possible future.

Furthermore, Pragmatism was the dominant philosophical discourse in the United States during this first half of the twentieth century, and so a Neo-Pragmatist understanding of the subjects might be particularly appropriate and may throw light on the instrumental approach so many of the writers I discuss use in their own historical descriptions.

———

The formalist and experiential strategies will be reconstituted from critical and related writings published in the United States between the turn of the century and the early 1960s. Since this is a history of the development of certain strains of ideas in American thought rather than a history of criticism per se, *written* sources other than critical reviews will also be utilized. Particularly important in relationship to the establishment of these ideas were the catalogues, pamphlets, and other explanatory material surrounding important exhibitions throughout the period; they often reveal the organizer's promotional strategy and the underlying critical paradigm.

Important also were the various "histories" of modern art—written about contemporary and recent art as it was happening—appearing throughout the period. Published by way of explaining the new art, these chronicles often constructed an historical line of development, one that invariably culminated in the art to which the writer was most sympathetic, while leaving out art which disagreed with his model.

A central figure to the ongoing critical debate was John Dewey. Far from an esoteric philosopher, Dewey was a pragmatic thinker, and a popular writer and lecturer (as was William James before him) whose work appears in a number of popular journals as well as books. His ideas on the nature of the art experience as well as his concepts of localism and community and the relationship between art and the larger culture would continue to exert an influence on aesthetic thought of the period, and so will play an seminal role in my discussion of the experiential paradigm.

The debate that developed in criticism and which is traced in this book had its genesis in the larger arena of turn-of-the-century American thought, a debate between formalist and anti-formalist tendencies from a number of different fields. These will be briefly put forth in a summary fashion to position this critical debate within the larger discourse of American thought in chapter one. The early development of the split in the avant-garde and its development from earlier paradigms will be

described in chapters two and three. The writings of Willard Hunting-ton Wright and Robert J. Coady, because they exemplify the debate so clearly and in such an unadulterated form during the second decade, will be discussed in detail.

In chapter four, I trace the development of the paradigms as they appear and are elaborated during the 1920s. Here is also introduced the aesthetic thought of Dewey as propagated in his book *Art and Nature*, published at mid-decade.

I devote a lengthy discussion to the paradigms as they appeared during the 1930s. The experiential side of the debate here splits along political lines, dividing into left- and right-wing strains. The experiential positions become so complex and important during this decade, that two chapters are devoted to it, chapters five and six. I felt this lengthy exposition was necessary because of the complexity of the issues during the period and their relationship to partisan politics. It was the heyday of the experiential paradigm and yet is quite unfamiliar to contemporary readers because that paradigm was so overshadowed during the postwar years. As part of the agenda of this book is the revival of this neglected position, I have devoted a generous amount of space to explaining it fully at this, its moment of dominance.

Formalism as a minority position is traced in chapter seven, through exhibitions, galleries, and influential teachers as well as through critical writings. Although overshadowed during the 1930s and early 1940s, it laid the foundations for the triumph of the paradigm in the postwar period.

Finally, in chapter eight, the postwar manifestations of the paradigm are exemplified in the writings of the influential critics Harold Rosenberg and Clement Greenberg, tracing the origins of their ideas to earlier manifestations of the debate and bringing them to their culmination. This was the period of the greatest influence of criticism in the American art world, a level that had not been attained before or since. The formalist paradigm established hegemony over critical opinion in the early 1960s comparable to the ascendance of the opposing paradigm during the 1930s.

I end my account at this point because, even though the paradigms continue, the subsequent developments in the critical arguments fall under the rubric of postmodernism, and introduce questions remote from those I am considering for the period between ca. 1915 and ca. 1965.

An article appearing during 1921 in the little magazine *Broom* sums up the approach to critical thought taken up in this study:

> Criticism is the artist's *weapon*, both of offense and defense, the weapon whereby he destroys or lames artistic tendencies inimical to his own . . ."[10]

Dominance of the critical arena was so important during the era of the emergence of modernism in the United States because the parameters of the critical discourse, once established, would also mark the limits of the art market and thereby influence profoundly the direction of subsequent art and even the very definition of the modern era for posterity. This, then, is a history of criticism as a weapon in America.

# 1

## Formalism and Anti-Formalism in Turn-of-the-Century American Thought

THE NINETEENTH CENTURY WAS DRIVEN BY A BELIEF THAT THERE exists a great, overarching set of scientific and historical principles providing a framework within which the natural and social orders operate. Today, we no longer assume the possibility of such a grand synthesis, but thinkers from that time were convinced that this order could be logically induced from empirically gathered data and would yield fixed "laws." The quest to determine the exact nature of these principles involved researchers and savants from various fields.

The search was considered to be of such pivotal importance because, with the discovery of these "laws," historical processes could be explained, the past could be interpreted "correctly," and the future could be predicted accurately. What was hoped for was a "scientific" historicism that would provide a key to unlock the future. And so the idea of modernism, paradoxically, was inextricably linked from birth to concepts of the past and of history.

By the end of the century, several such scientific and pseudo-scientific systems of historical development existed side by side. Each used a different system of historical "law" usually derived from either philosophy or from a legitimately scientific context such as physics or biology and then applied to history by what appears to us today as little more than a process of analogy. Naturally these systems yielded very different assessments of the present and predictions for the future.[1] These schemata, especially as they appear at the end of the century in the United States, have been labeled "formalist" by several authors.[2] They are said to be formalist because they are abstract, logical, apriori, and deterministic.

Against these "scientific" modernists arose a revolt of thinkers from a variety of fields who can best be described as anti-formalist.[3] Modernist in a different way, they postulated an open-ended and indeterminate

universe and an engaged, instrumental view of history. The debate be-
tween critical paradigms in the art world to which this study is dedi-
cated, had its genesis as part of this larger context of ideas.

This chapter will briefly examine the issues at the heart of the formal-
ist/anti-formalist debate as they appear at the close of the nineteenth
century and the beginning of the twentieth century in America. The in-
tention here is not to be exhaustive or to postulate a direct causal rela-
tionship between specific thinkers and specific critics but only to
provide a larger setting for my own, more circumscribed investigation.[4]
After a summary of some of the main formalist positions of the time, the
anti formalist position will be exemplified in the thought of William
James and echoed in other fields as well. Finally, the "New History"
(as the anti-formalist view of history was called at the time), will be
described and summarized in terms of its implications for art and art
criticism.

---

Karl Marx was one of the most eloquent mid-nineteenth century pre-
Darwinian thinkers to devise a grand overarching scheme to unite his-
torical processes. It was on the basis of a materialist analysis of history
proceeding according to fixed laws that Marx's socialism claimed to be
"scientific socialism," to distinguish it from earlier, utopian versions of
socialism. Marx demonstrated through his dialectical analysis of history
that socialism was inevitable. His prediction of the future was based on
his conviction that he had discovered the Hegelian principles of thesis,
antithesis, and synthesis operating in economics, and consequently in
history. Hegelian principles of historical development were regarded by
Marx almost as natural law.

But tough-minded American thinkers wanted to base their systems
on something more substantial than German philosophy. They sought
principles in the natural sciences, such as biology or physics, which
could provide sound, scientific bases for principles of historical or social
development. Underlying most of these systems was an advancing view
of history ultimately derived from Hegel. Earlier, cyclical models of his-
tory were now replaced by linear, progressive models.

Probably no single idea was as important to this quest for a scientific
system than Charles Darwin's theory of evolution, published in 1859.
Although it was not a theory of social development, it provided inspira-
tion to those who would like to have found similar laws underlying
human history. Darwin postulated a world in which biological life was
subject to constant change through mutation and adaptation to a chang-

ing environment. Darwin's theory was based on random mutations operating by chance. It should be noted here that he postulated no "advance" in species, no omega point, and no *telos* in any Hegelian sense.

While it is true that evolutionary ideas had been put forth previously, Darwin's version had the advantage of being a scientific theory based on empirical observation. In a century that placed great authority in science and scientific method, Darwin's principles of natural selection were very compelling. Although Darwin limited his theory to biology and did not place it in an ethical or teleological context, others were quick to seize on the implications of the new theory and extend the principles of evolution into other areas of thought.

Perhaps Darwin was best known to British and American readers and audiences through synthesists and popularizers like Herbert Spencer. By 1865, just six years after the publication of Darwin's *Origin of Species*, Spencer had integrated the new ideas into his grand synthetic philosophical work, *Social Statics*.[5] Spencer's version of evolution was based on an elaboration and extension of certain aspects of Darwin's theory.

According to Spencer, certain universal evolutionary laws of growth and development demonstrated by Darwin to be operative in biology, are also operative in many other aspects of life—including psychological, political, economic, social and historical realms. Through a series of cosmic generalizations, "laws" drawn from biology were assumed to govern social life and historical development.

But, unlike Darwin's random universe, Spencer's evolution was advancing and progressive. Man was the most advanced of the evolved life forms and his destiny is nothing less than moral, psychological and social perfection through increasingly harmonious adaptation to his environment.

> all excesses and all deficiency must disappear; that is, all unfitness and deficiency must disappear; that is, all imperfection must disappear. Thus the ultimate development of the ideal man is logically certain . . . [6]

This optimistic philosophy of guaranteed perfectibility through natural selection appealed strongly to laissez-faire capitalists in America. Through the agency of competition and struggle—as suggested by Darwin's "survival of the fittest"—we were assured of a better tomorrow, or so it was thought.[7]

In the final decades of the century, less optimistic formalisms were

put forth. American historian and writer Henry Adams shared the quest for operative "laws" derived from empirical science but felt laws should be derived not from biology but from physics.[8] Utilizing the second law of thermodynamics, the law of entropy, Adams postulated that thought (like electricity) was a form of energy and as such, was slowly dissipating with every expenditure of energy. According to the law of entropy, this degradation (his term) was inevitable and would lead to a general breakdown in the year 1921.[9] Like Marx's scientific socialism and Spencer's evolutionism, Adams's "degradation" was an inevitable result of historically determined patterns over which individuals had little or no control.

One of the indicators of Adams's degradation was the growing incidence of cases of nervous prostration—or neurasthenia as it was called—in the last decades of the nineteenth century. So common as to be labeled by many the "disease of the age," symptoms of neurasthenia afflicted Spencer, Adams, and William James. The physical signs of the new disease were first described by George Miller Beard, a neurologist, and included lack of energy, insomnia, nocturnal emissions, and tooth decay. Among its psychological symptoms Beard mentioned fear of responsibility, indecisiveness, even over small matters, "morbid self-consciousness," and a general paralysis of the will.[10]

Many doctors at the time attributed the disease to an overexpenditure of energy and proscribed a regimen of bed rest and conservation of energy. Slowly, it was thought, the mind and body could heal itself and regenerate its energy so the patient could eventually return to the world of action. It is to be noted that energy here, as in Adams, is treated as a finite, quantifiable potential, drawing its scientific analogy from physics.

T. J. Jackson Lears, in his excellent study, *No Place of Grace: Antimodernism and the Transformation of Culture 1880–1920*, associates neurasthenia with a sense of unreality, what Lears calls the "weightlessness" of late Victorian culture in America.

> For the late-Victorian bourgeoisie, intense experience—whether physical or emotional—seemed a lost possibility. There was no longer the opportunity for bodily testing provided by rural life, no longer the swift alteration of despair and exhilaration which characterized to old-style Protestant conversion. There was only the diffuse fatigue produced by a day of office work or social calls.[11]

While this resulted in protracted bed rest for some, others decided to pursue vigorous experience for its own sake, what Lears calls the "Cult of Experience."

Amid spiritual confusion, intense experience became an end in itself. Discontented Victorians embarked on a frustrating quest for authentic selfhood. Unable to preserve larger meanings outside the self, they remained enmeshed in the "morbid self-consciousness" of the therapeutic worldview—the cultural malady that had provoked their discontent in the first place.[12]

What I'm suggesting here is that, amid the complex causes cited by Lears—which he collectively refers to as the "therapeutic worldview"—neurasthenia is at least partly a loss of will resulting from the perceived individual powerlessness and lack of meaning in a deterministic universe as described by the formalists.

This certainly seems to be true in the well-known case of William James. As is recounted in several biographies, the severe depression, anxiety and lack of motivation James suffered in the 1860s and 1870s was diagnosed as neurasthenia. After the paralyzing "rest cure" that was standard treatment at that time, James was to come to the opposite conclusion: what was needed was not relaxation but an assertion of the will. A turning point in his mental health came from an experience he had upon reading of a passage from Renouvier:

> I think that yesterday was a crisis in my life. I finished the first part of Renouvier's second "Essais" and see no reason why free will—"the sustaining of a thought when I might have had other thoughts"—need not be the definition of an illusion. . . . I will assume for the present that it is no illusion. My first act of free will shall be to believe in free will.[13]

This is the point from which William James himself traces his recovery. James realized from his own personal experience that much of mental and physical health is based on beliefs and ideas that hold sway in the mind. Much of his mature work is devoted to refuting formalism and putting forth an indeterminate, open-ended concept of the universe in which the actions of free individuals accounts for history and where the future is undecided.[14] Underlying James's pragmatism was the idea that the individual human mind could create its own history.

Writing in *Atlantic Monthly*, James refutes deterministic systems of history in "Great Men, Great Thoughts, and the Environment." In this article, he compares Spencer's invocation of biological principles in human affairs to the invocation of the zodiac and heaps abuse on "scientific" history.

It is folly, then, to speak of the "laws of history" as of something inevitable, which science has only to discover, and which anyone can foretell and observe, but do nothing to alter or avert.[15]

He concludes, "The evolutionary view of history, when it denies the vital importance of individual initiative, is, then, an utterly vague and unscientific conception."[16]

James was not alone in his anti-formalist views. In the last decade of the nineteenth century, the revolt against formalism was signaled by the new approach to law propagated by Oliver Wendell Holmes Jr., the progressive constitutionalism of Herbert Croly, the economics of Thorstein Veblen and the pragmatism of James and his colleagues Charles Sanders Peirce and John Dewey—all challenges to formalism in their respective fields. David Marcell sums up well the nature of the revolt:

> Traditional approaches to law, philosophy, and the social sciences were, they found, too abstract and unyielding to sanction reforms they thought necessary; formalistic renderings of historical and social change, often given in the name of progress, were more often rationalizations of the status quo. . . . In essence, the antiformalists were indicting different spheres of nineteenth-century thought and scholarship with the same crime: overintellectualization.[17]

The most common method the anti-formalists used in their attack on ingrained nineteenth-century determinists in all these fields was what Morton White describes as cultural organicism.[18] Cultural organicism, according to White, is an attempt to find explanations in the environment, the "social space" surrounding the phenomenon in question. He characterizes the intellectual revolt against formalism in terms of this kind of organic engagement with environment "All of them [the anti-formalists] insist on coming to grips with life, experience, process, growth, context, function."[19] In the more circumscribed realm of art this approach was to be used extensively by the experiential critics throughout the twentieth century in promoting and defending their ideas.

The most relevant development in the anti-formalist camp at the turn of the century for subsequent aesthetics, art theory, and criticism is undoubtedly what was called at the time, the "New History." Synthesizing the historical aspects of the anti-formalists in other fields from the previous two decades, the New History made its first appearance in lectures presented at Columbia University in 1908 by its main proponents, James Harvey Robinson and Charles A. Beard.[20] Four years later,

Robinson published a collection of essays which sets forth the principles of his anti-formalist methodology, serving more or less as a manifesto of the new approach.

In his essay, "The History of Histories," (revised from his 1908 Columbia lecture) Robinson assails "scientific" historicism as an impossibility.

> Moreover, the historian now realizes clearly that all his sources of information are inferior, in their very nature, to data available in the various fields of natural science. . . . history must always remain, from the standpoint of the astronomer, physicist, or chemist, a highly inexact and fragmentary body of knowledge.[21]

From the weltering array of facts at his disposal, Robinson asserts, the historian's task is to choose what he thinks are the most significant and present them in the form of a narrative. His role, then, lies somewhere between a scientist gathering data and a man of letters telling a story.[22] The conflicting histories of the formalists are not due to a miscalculation of scientific historical "laws" but are simply the result of the differing emphases in their narrative and their choice of different events as significant. No single historical narrative is therefore necessarily truer than any other, according to Robinson.

This radical relativism is the reason every generation revises the received history according to its own lights, Robinson suggests. Far from being a cause for despair, this continuous reinterpretation is what makes history a vital and living subject. What history loses in terms of its formalist certainty is more than made up for by its ability to shed light on and influence the present. History, functionally conceived, can be an instrument used by groups to justify themselves and to influence the future course of events, Robinson suggests. This is precisely what critics throughout the twentieth century do with history: they justify and promote the contemporary art they endorse by creating a believable and authoritative history leading up to them.

An early example of the new functionalist use of history is contained in a book by Robinson's colleague, Charles A. Beard, *Contemporary American History, 1877–1913*.[23] This book, published in 1914, reviews recent history in light of understanding the present. In the preface, Beard acknowledges his instrumental intentions:

> I have omitted with a light heart many of the staples of history in order to treat more fully the matters which seem important from a modern point of view.[24]

He goes on to assert that there is no reason to suppose that historical distance is necessary to understand events, "that we can know more about Andrew Jackson whom we have not seen than about Theodore Roosevelt whom we have seen is a pernicious psychological error."[25]

The new history is not merely a chronicle of past events but a selective choosing and interpretation of past events that helped explain, operationally, the present. It strove not simply to explain *what* happened, but *how* it happened. In its selective scanning of the past, it did not feel constrained to limit itself to political events, but was free to utilize data from all aspects of experience. It freely borrowed data and methodology from the social sciences, without, however, deriving "laws" from these fields by analogy and grafting them onto history in the manner of the formalists. Like the anti-formalism in other areas of thought—psychology, law, economics—it was interdisciplinary, fluid and open-ended. It led to what Van Wyck Brooks described as "the search for a usable past."[26]

The struggle between formalism and anti-formalism in various fields outlined briefly in this chapter would be mirrored in the aesthetic struggles of the twentieth century. Would the new art be seen as an extension of the past, progressing lawfully toward a fixed goal or as an organic process reaching out to the environment and adapting itself to changing cultural currents? Would modernism in art be understood in terms of the cult of determinism or the cult of experience?

# 2

# Formalism and Anti-Formalism in the Critical Debate Surrounding the Armory Show

DURING THE DECADE BEFORE THE ARMORY SHOW BROUGHT MODERN-ism to the attention of a wide audience in 1913, formalist and anti-formalist types of premodern thought already dominated the critical arena in the United States. Classical formalism, as exemplified by Kenyon Cox, was conservative in taste and determinist in its approach to history. Less familiar to us today is the anti-formalist position of more liberal critics like Royal Cortissoz, who utilized a form of cultural organicism in a criticism prefiguring the experiential paradigm. However, Cortissoz differed from many later experiential critics in being a determinist, and this is why both premodern positions are usually lumped together today as "conservative," in contrast to the "progressive" stance of the moderns. Careful observation, however, reveals a more complex relationship between modern and premodern thought.

The Armory Show was so threatening to the critical establishment because it posited a progressive, open-ended alternative to both the conservative and liberal determinists of the time: an avant-garde, forward-looking history which progressed through a series of revolutions stretching back to at least the beginning of the nineteenth century and perhaps as far back as the Renaissance. The modern movements from Europe were here presented as the latest installment in this series of revolts.

The exhibition and the flurry of critical debate surrounding it caused a realignment in the critical arena and helped usher in the modern formalist and experiential paradigms which are the main subject of this study and which made their first appearance within a few years of the groundbreaking show. The modernist paradigms first emerged (in a still undifferentiated, avant-garde form) in reaction to premodern paradigms. The description of this genesis is the main content of this chapter.

But before proceeding to a description of the premodern critical paradigms of the first decade, it is necessary to understand just how marginal the avant-garde position was at that time. A substantial avant-garde, aware of the new European trends, already existed in New York by 1913. Its weakness, in terms of the influence it had, lay in its marginalization by the currently accepted critical discourse. Without entering the mainstream of critical activity, the avant-garde was doomed to be considered an eccentric form of creativity with few exhibitions and fewer sales opportunities.

The Armory Show's real significance for the future of American art lay not in its creation of an avant-garde, but in its use of the historicist methods of the New History to position the avant-garde as the logical outcome of a new and compelling model of historical development. Within the new model the moderns were no longer marginal eccentrics but pivotal players, and the trajectory traced by their position not only implied a new direction for the development of American art in the twentieth century, it essentially negated the premises of both the classical formalist conservatives and the organicist liberals that dominated the pre-Armory Show critical debate.

Virginia Mecklenburg, in her study of criticism from the period, states that the dominant dialectic in the pre-Armory Show critical debate was between conservative, academic classicists like Kenyon Cox and the more liberal critics, like Royal Cortissoz, whom Mecklenburg calls "expressionist-individualists."[1] Within the larger context established in the previous chapter, they represent the formalist and anti-formalist positions in their premodern incarnations.

According to Mecklenburg, Cortissoz and like-minded critics were influenced by evolutionary theory, especially as articulated by Hippolyte Taine. Their view of artistic production held that the influences of "race, milieu and moment" of a given period, would automatically become manifest in cultural expressions, and could therefore be described by White's term, "organicist." Advocates of this position based their understanding of culture, including the emphasis on racial characteristics, on contemporaneous anthropology. It followed logically that from an analysis of its artifacts, a trained viewer could inductively determine the characteristics of a given race and culture.

Liberal critics who adopted this organicist approach, like those advocates of the modern experiential paradigm that developed later, sought an American art that reflected a national character. Through sincere

self-expression, it was held, a uniquely American art would emerge. Into this moderately liberal conceptualization of the role of art in society, the boundaries could be expanded to include, for example, the naturalism of Robert Henri. Even avant-garde work could occasionally be admitted into this scheme, as long as it remained on the margins of the discourse.

The criticism of Royal Cortissoz and other antiformalists of his ilk failed to develop an operationally based historicism to counter the historical determinism of the conservatives. Perhaps this is the reason it remained a minority position at its time and is all but forgotten today, or when remembered, is lumped together with the academic formalists indiscriminately.

The formalist classical position, as exemplified by Kenyon Cox, rejected the cultural relativism of Cortissoz and the liberals and in its place postulated a universal ideal of beauty and order which artists represented in perfect forms, derived from nature but altered and rearranged to express the ideal.

In his book *The Classic Point of View*, published in 1911, Cox summarized his ideas in what is virtually a manifesto of the approach:

> The Classic Spirit is the disinterested search for perfection; it is the love of clearness and reasonableness and self-control; it is above all, the love of permanence and of continuity. It asks of a work of art, not that it should be novel or effective, but that it shall be fine and noble. It seeks not merely to express individuality or emotion but to express disciplined emotion and individuality restrained by law. It strives for the essential rather than the accidental, the eternal rather than the momentary . . . And it loves to steep itself in tradition. It would have each new work connect itself in the mind of him who sees it with all the noble and lovely works of the past . . . It wishes to add link by link to the chain of tradition, but it does not wish to break the chain.[2]

Most interesting for our purposes is his deterministic model of historical development. Cox's formalism relies on historical "laws," but at the same time is strangely "eternal" and ahistorical. It differs so significantly from the formalism of late modernist thought—so familiar to us today—that it bears summarizing.

Cox represents the history of Western painting as a straight line of development from Giotto, through Raphael and Rubens, to the art of the eighteenth century. The French Revolution, however, broke this line of continuity and, according to Cox, painting has been languishing

ever since in a "long confusion of opposing forces which is the history of modern art."[3]

According to Cox, several noble attempts had been made to return art to its classical fountainhead in the nineteenth century. His representation of nineteenth-century art history yields some surprising characterizations. For example, David is portrayed as the radical destroyer of tradition and referred to as the "dictator of art." Delacroix, by contrast, is construed as a classicist because he returned to the dynamic forms of Rubens, described by Cox as "the nearest source of authentic tradition."[4]

Millet is represented as the most heroic of the "classicists" because of his severe design and his use of Michelangelesque forms in the figures of the peasants he portrays.[5] Cox did not categorize Millet as a realist, as we do today. In fact, for most of his career, Cox saw realism as the most immediate threat to the art of painting. In his introduction to a recent compilation of Cox's essays, Gene Thorton writes that when Cox uses the term "modern art" it almost always refers to the naturalism of the nineteenth century and its successors in the early part of our own century.[6]

Cox represents Impressionism as an extreme of naturalism as well as a confusion of art with the science of optics. In a later essay, Cox writes:

> So it happened that Monet could devote some twenty canvasses to the study of the effects of light, at different hours of the day, upon two straw stacks. It was admirable practice, no doubt, and neither scientific analysis nor the study of technical methods is to be despised; but the interest of the public is in what the artist does, not in how he learns to do it.[7]

The narrow possibilities of naturalism having been exhausted by the Impressionists, the Post-Impressionists had nothing else to exploit than "eccentricity of method," which drives them, like the possessed swine in the Bible story, into self-destruction.[8]

The antidote to this directionless floundering of art since David, is, according to Cox, a return to "the permanent and ideal" as embodied in the "Classic Spirit."[9] The best hope for the ultimate triumph of the classical point of view over both liberal relativism and revolutionary avant-gardism, Cox concluded, is to inscribe these ideals in the mind and work of succeeding generations. Significantly, his treatise is dedicated to young artists, the "serious student of today [and] the serious student of tomorrow."[10]

When the Armory Show opened in 1913, Kenyon Cox was in his six-

ties but still maintained a powerful presence in the American art world. He immediately recognized the threat the new positioning of the avant-garde entailed and the trajectory its "progressive" representation of art history implied. In the face of this new threat, new alignments took place within the critical arena and a rapprochement was effected between the formalist conservatives and the organicist liberals to confront the new enemy. Cox and Cortissoz alike realized that if the avant-garde view prevailed, it would sweep both their views aside.

---

The position of the avant-garde had already been articulated for several years by Alfred Stieglitz in his little magazine *Camera Work* and in the exhibitions he held at his small gallery. With the Armory Show, however, the avant-garde tried to enter the mainstream of contemporary art on an equal footing with the academics. The organizers of the exhibition realized that to accomplish this, they would have to present the artwork in a broader context than that of the "expressionist-individualist" liberalism of Cortissoz. To gain parity with formalist theories of the classicists, they would have to validate the modern movement through an alternate historical schema, an avant-garde history of their own making.

This was accomplished partly by the selection and arrangement of the artwork itself. Organizers Arthur B. Davies and Walt Kuhn provided, as a prelude to the contemporary works in the exhibition, a retrospective section that would introduce and legitimize the more modern work. Included were nineteenth-century objects that were generally accepted in 1913, but had been controversial in their own time. Works by Goya, Ingres, Delacroix, Courbet, Manet, and the Impressionists presented an avant-garde view of art history that suggested the work of the Post-Impressionists, Fauves, and Cubists was merely the latest installment in an advancing series of movements. Just as the nineteenth-century masters appeared radical and unartistic to their contemporaries but were later recognized, so these modern masters would eventually be appreciated—or so the argument went.[11]

The organizers attempted a similar retrospective review of American art, but the relative weakness of this section of the exhibition revealed the history of American art did not lend itself as readily to an avant-garde model of historical development. Indeed, the lack of an avant-garde tradition in the United States was exactly the reason that the American modernists needed to be presented in such a self-consciously historical manner. To compensate for such a lack, the organizers of the

Armory exhibit attempted to *create* a tradition by presenting their pro-
gressive avant-garde schema as if it were an already established histori-
cal fact. The presentation of a historical construct as a historical reality
was designed to make their art and its avant-garde premise seem irre-
futable and inevitable.

This historical self-consciousness as a strategy was also evident in the
organizer's attempts to explain the new stylistic developments in ways
the intelligent lay reader could easily comprehend. For example, in the
special issue of *Arts and Decoration*, Davies published a chart of modern
art that attempted to divide modernism into Classical, Romantic, and
Realist tendencies, thereby forging links to nineteenth century catego-
ries of art.[12] This scheme placed Expressionism and Fauvism into the
camp of the Romantics, the Eight into the category of Realism, and the
Cubists into the realm of the Classicists. A preference was shown in
Davies's description for the classicism of Cubism as being the wave of
the future. The broad outline Davies sketched, despite its limitations,
has remained amazingly resilient and continues to be reflected in dis-
cussions well past the middle of the century.

The pamphlets published by the organizers, which accompanied and
explained the exhibit and were available for purchase on the premises,
also reiterated the avant-garde view of historical development. Walter
Pach, art critic and consultant to the exhibition, wrote a number of
these, including an essay, "Hindsight and Foresight," in the pamphlet
*For and Against*. In place of the dismal view that Cox held of the nine-
teenth century, Pach saw it as "one of the greatest centuries in paint-
ing."[13] He went on to characterize the succession of great artists of the
century as "misunderstood and attacked, until appreciated and canon-
ized." As an example, he cited a critic of Delacroix's time, quoted in
Signac's book, *De Delacroix au Impressionnisme*, who disparaged Dela-
croix's painting as "ignorant brutality . . . that he asks us to place beside
the beautiful art of the past."[14] The message was that critics are often
wrong and condemn art without really understanding it. It was this
very concept of a vanguard in art, ahead of the rest of us, even, and
perhaps especially, the critics, that Pach and the organizers sought to
emphasize.

Pach tried to establish a continuity through the ages by comparing
this succession of "glorious creators" to natural evolutionary develop-
ment, utilizing contemporary language from natural science. He used
these allusions not in a formalist, deterministic sense but as a form of
cultural organicism resembling evolutionist borrowings in the writings
of Cortissoz. Pach mixed methods in a concept of the modern that is

undifferentiated and had not yet split into separate formalist and experiential strains. Although Pach was later to come down on the side of the modern formalists, here he utilized methods later to be used by both sides of the debate.

Related to the references to evolution was the idea of the validity of change in art for its own sake. Playing on nascent ideas of "progress," ideas stemming from science and technology and associated with the industrial revolution, new styles of art were put forward as "progressive." Progress in this sense was not conceived of as a slow evolutionary development, but a radical departure from the past: a revolution or series of revolutions signaling the new era. This change was not related, however, to any predetermined goal.

In "The Cubist Room," another essay by Pach in *For and Against*, the author likened the radicalness of the moderns to the abolitionists of the previous generation, and dismissed their supposed subversiveness by stating that even Columbus was considered subversive to those who did not agree with his concepts of a round earth.[15] Such historical allusions emphasized the relevance of artistic debate to the general visitor by removing it from the realm of rarefied aesthetic discourse.

Furthermore, the very word "modern" conjured up a whole series of emotions and associations in those years after the turn of the century. The concept of "modernity" which surrounded the cluster of attitudes associated with science and invention also had social and moral dimensions. The polite customs and genteel morality of the late nineteenth-century Victorian era were increasingly viewed as stodgy and repressive. A new, looser morality which favored candor and a freer expression of unconventional roles and sexuality was emerging, especially in New York, and the new century was widely seen as a new age that would be markedly different than the previous one.[16]

Probably more irritating to the academic formalists than the avantgardes' ability to capitalize on being "modern," was the appropriation of language from the prevailing academic treatment of art history. Pach went to some lengths to demonstrate that the contemporary stylistic revolution had precedents in the past, both politically and artistically. In one particularly interesting comparison, he called on the difference in Quattrocento painting between the generation of Piero della Francesca and that of Signorelli. The supposed shock of that new style he presented as a parallel to the new styles of his own time.[17] Regardless of the merits of such a comparison, it is certainly significant that Pach chose illustrations from the Italian Renaissance, an era above reproach in regards to the seriousness and high quality of its art. As a rhetorical de-

vice, he used the ammunition of the conservatives against themselves. Classicists like Kenyon Cox were steeped in the art of the Renaissance as the pinnacle of Western culture. By insinuating that it was the radical moderns, not the conservative academicians, who were the true heirs to the pioneers of the Renaissance, Pach brilliantly turned the tables on his adversaries.

———

The historicist strategy of the moderns worked more effectively than the organicist strategy of the liberals in the struggle to overturn nineteenth-century formalism. Academic criticism in America never really recovered from the onslaught. This open-ended modernism was within a few years to yield its own kind of deterministic but this time modern formalism. This was epitomized in the writings of Willard Huntington Wright, art critic for *Forum* magazine, author of the influential book *Modern Painting*, and organizer of the Forum Exhibition of American Art at the Anderson Galleries in 1916.

# 3

## A Split Among the Moderns

ON MARCH 12, 1916, THE *NEW YORK SUN* PRINTED A SIZABLE ARTICLE IN anticipation of the Forum Exhibition of Modern American Painters, which was to open on the following day. The anxiousness with which the exhibit was awaited is obvious from the first sentence, "Wherever two or three were gathered together the topic was sure to be the 'Forum' exhibition of modern art that opens tomorrow in the Anderson Galleries. Expectations are keen . . ."[1] The issue was not that the artists were unknown. Each had shown work in one of the several New York galleries devoted partly or exclusively to modern art—galleries that had sprung up in the wake of the Armory Show of 1913. The eagerness was, rather, to see which particular paintings by these artists would be chosen by the distinguished experts on the new art. The selection panel included Alfred Stieglitz and Robert Henri and was led by the controversial critic for *Forum* magazine, Willard Huntington Wright.

The author of the *New York Sun* article points out the controversy the exhibition was already stirring up even before it opened, not only with the conservative critics (which by this time had come to be expected), but within the avant-garde community itself:

> One thing that will surely impress the public more than any other is the struggle that the various committees and individuals are making to swing the movement into different channels. If it is to be struggled for, there must be value in it, so will think the public.[2]

The *New York Sun* goes on to print a letter from Robert J. Coady challenging the criteria used by the Forum panel in their selection of art work and questioning the stated aims of the exhibition itself. This time the familiar denunciation was not from a conservative. Coady was the owner of the Washington Square Gallery, which had mounted exhibitions of Picasso and Rousseau as well as African art. The challenges Coady leveled at the Forum exhibition committee centered on issues of

quality, nationality, and the place of avant-garde art within the larger
scope of American culture. A few quotes will give the flavor of the
letter:

> Why are these 200 paintings "the very best examples of modern American
> art?" . . . What elements, quality or qualities do they possess which make
> them American? . . . I challenge each of you and all of you to back up your
> "critical selection" with proof.[3]

This was followed by a point-by-point response from Wright in which
he defends the choices and the underlying assumptions of the commit-
tee. A week later, the *New York Sun* printed Coady's response to
Wright.[4]

These contrary bids for the soul of modern art in America, touched
on in this exchange from *New York Sun*, recapitulate the formalist/anti-
formalist debate which was taking place in other fields at that time. The
difference here was that the revolt was no longer against an entrenched,
academic formalism from the nineteenth century, but a modern formal-
ism championing and defending the new art with an historical deter-
minism that placed avant-garde art as the inevitable result of historical
forces. The debate now took place entirely *within* the ranks of the avant-
garde.

The terms of this controversy will be reconstructed in detail from ar-
ticles written by W. H. Wright in *Forum* magazine, and R. J. Coady in
the short lived magazine entitled *Soil*, published during 1916 and 1917.
It will be shown that fundamentally different assumptions about the
function of art in American society guided the aesthetic positions of
these two writers. Moreover, Wright and Coady present alternate and
mutually exclusive strategies for promoting the new art. Wright's sys-
tem is exclusive and based on "laws" of historical development, Coady's
approach is inclusive and experiential. More than an isolated aesthetic
controversy of the time, the debate is paradigmatic of the struggles that
would continue to occupy critics throughout the following half-century.

---

When Wright was hired as its more-or-less regular critic in 1915,
*Forum* magazine had already established itself as well disposed toward
the new art. The Armory Show of 1913 was reviewed favorably in
*Forum* by W. D. MacColl.[5] MacColl was in general approving of the
European modernists and lauded their individuality, especially when

compared with what he saw as the provinciality and derivativeness of American work in the exhibition.

Individuality of expression was likewise postulated to be the operating principle of modern art by critic Frederick James Gregg in an article appearing in *Forum* several months later.[6] According to Gregg, freedom of imagination, guided by a strong individuality and personal vision, was the only worthwhile criteria by which to judge the new art. Apart from the Cubists, Gregg maintains, the moderns have evolved no "general convention." Raw, creative individualism was the only standard by which to determine quality in avant-garde art.[7]

Wright felt that this kind of generous, liberal critical stance was ultimately not helpful to the cause of the new art, and may actually prove harmful to its furtherance.[8] He calls this state of affairs "artistic anarchy" and maintains that it actually stands in the way of more intelligent appreciation.[9] It also played into the hands of the conservatives who had been decrying modern art as "anarchy" for the past several years. Wright warned that every advance in art was latched onto by "charlatans" and that modernism, because of the lack of critical standards by which to judge it, is particularly prey to their exploitation for purely commercial ends.[10]

To help remedy the situation, to clarify the issues, and to establish criteria for evaluating the new art, Wright in 1915 penned *Modern Painting*.[11]

The desire to establish criteria of quality for the new art in the absence of commercial considerations led Wright to organize the Forum exhibition. The press release from the Anderson Galleries, venue of the show, stated the objectives succinctly:

> To put before the American public in a large and complete manner the very best examples of the more modern American art; . . . to present for the first time a comprehensive, critical selection of the serious painting now being shown in isolated groups. The enterprise is not a commercial one. Its object is to help out modern art and to make it possible for the truly deserving American painters to have a fair and free showing.[12]

That the selection was made by a group of experts who received no financial remuneration presumably put the exhibit above the commercial concerns that drove the art market. It also added to the exhibit's credibility in terms of the charges of charlatanism and entrepreneurship that the conservative critics continued to level at every modernist enterprise.

Despite the diversity of the selection committee, the artists who were chosen to participate in the Forum exhibition were more reflective of Wright's taste than of any other committee member, with the possible exception of Steiglitz. The Forum exhibition conformed to the overall aesthetic sensibilities of Wright as revealed in *Modern Painting* and his recent criticism for *Forum* magazine. It should also be noted that it was Wright's intention to limit the exhibition to American art. This emphasis was a response in some ways to the Armory Show, at which the dazzling and highly controversial work of the Europeans overshadowed the Americans. European modernist work continued to be more popular with collectors and fetched higher prices in the New York galleries than comparable American work in the years since the Armory Show, when the market first expanded.[13]

Wright was a formalist both in the sense of positing laws governing historical development and in the more familiar meaning of placing priority on those aspects of art which emphasize form above other concerns. In this latter respect, he owes a great deal to the new British formalists, Clive Bell and Roger Fry, who had also put forth formalistic theories between 1908 and 1913.[14] In "The Truth About Painting," which appeared in *Forum* magazine more than a year before the Forum exhibition, Wright described the controlling basis of all art is "organization":

> Serious modern art, despite its often formidable and bizarre appearance, is only a striving to rehabilitate the natural and unalterable principles of rhythmic form to be found in the old masters, and to translate them into relative and more comprehensive terms.[15]

For Wright, abstract principles underlay all great art and in the correct combination and organization, forms were capable of arousing emotions in the spectator that were quite apart from any the subject matter itself might induce. Artists who painted primarily to depict emotions through narrative or subject matter were considered to be illustrators rather than artists.[16] Wright considered that as the moderns developed new methods and techniques, the illustrative side of painting was more and more relegated to secondary consideration and the most advanced art tended toward what he called "minimization." He described the "elimination of all superfluities from art" as part of its evolutionary development, or what he called, rather gracelessly, "the striving towards defecation."[17] Art, as it progressed through time historically, tended toward the exclusion and elimination of all nonessentials—that is, in Wright's words—"nearer and nearer [to] abstract purity."[18]

This theme of purity in art was to be reiterated in various forms by formalist critics right down to the late modernist writing of Clement Greenberg, in whose writing it remained a major theme.

To support his essentially teleological argument, Wright introduces his own interpretation of nineteenth-century painting. He traced modernism back to Delacroix. Its history, in his own words, "is broadly the history of the development of form by the means of color."[19] According to Wright's scheme, can be divided into two cycles. Delacroix, through his experiments with color and form, began the first cycle in rebellion against "that sterile and vitiating period of Raphaelic influence which had for leaders such men as Ingres and David."[20] Delacroix's explorations culminated in the Impressionism of Renoir. Cezanne, through his reestablishment of form and structure in painting, linked the nineteenth century with the Renaissance.[21] He initiated the second and more advanced cycle, which is seen as reaching its climax during the present (c. 1916) in the pure color abstractions of the Sychromists, Morgan Russell and Stanton MacDonald-Wright. MacDonald-Wright was, incidentally, Willard Huntington Wright's brother.

By conjuring up a deterministic historical model, Wright was able to establish definitive criteria by which to evaluate contemporary art. Here were the critical standards he found so lacking in the well-meaning but "soft" criticism of his predecessors at *Forum*. He was also able to compete on an equal basis with the deterministic formalism of the academic classicists. Unlike the open-ended, indeterminate historicism that underlay the sympathetic criticism of the Armory Show, Wright's model judged both the art of the past and of the present by its position in relation to a predetermined, evolutionary trend toward purity of form. This purity was based on the isolation of the aesthetic object for formal contemplation—a theoretical model based on exclusion. In Wright's model, purity was unique to each particular medium:

> The medium of painting is color. The medium of music is sound. . . . Aesthetic form is produced by the arrangement and coordination of the differentiations of these media.[22]

Each medium, then, seemed destined to seek out and define its unique essence in an irreversible push toward purity. Any conflation of the media—for example, literary painting or programmatic music—contaminated the purity of the art and impeded progress toward its inevitable end.[23] Since after the elimination of all superfluities the

irreducible essence of painting was color, Sychromism was, for Wright, the most advanced painting of the time.

This aesthetic of purism with its attendant, deterministic reading of history—the privileging of abstract form and the corresponding disparagement of subject matter—was a leitmotif throughout the Forum exhibition catalogue. Of course, it was to be expected in the introduction and forward by Wright, but it is surprising to what extent it is also present in the artist's statements, even in those by artists one would not expect to share Wright's deterministic and reductivist views.[24] The evidence suggests that Wright engineered the content of the Forum exhibition with a heavy hand to conform to his purist aesthetic and model of historical determinism: he selected the committee to do the choosing; he arranged for the exhibition to be sponsored by *Forum* magazine, for which he was the regular art critic; he wrote extensively for the catalogue; he chose the specific work to be reproduced in the catalogue; and he took great liberties in rewriting the artists' statements. In addition, he wrote a lengthy review of the exhibit in *Forum* magazine, in which he reiterated his views and summed up each of the artists in terms of his own aesthetics.

The challenges Robert J. Coady leveled at the Forum committee, which appeared in the *New York Sun* on March 12, 1916, on one level addressed the question of nationality and the relationship between high art and the culture in general, and on another, tactical level, reflected Coady's modernist yet anti-formalist strategy. This was now presented in a radically avant-garde form inspired by aspects of Dadaism.

Wright's reply to Coady failed to answer Coady's questions about nationality and culture sufficiently. Even the *New York Sun* referred to his response as "soft."[25] Wright asserted that there was no basic difference between American and European art. The formal problems with which they were grappling and the tendency toward purism were essentially the same, despite the cultural differences between America and Europe and the experience of war that had ravaged the continent.

On March 19, 1916 the *New York Sun* published Coady's response to Wright's reply. It is pointed and succinct:

My question in reference to American art seems to have gone completely over [their] heads. . . . They are blind to the great things that are going on around them. They are blind to the big spirit here that has grown out of the

soil . . . and has already expressed itself in terms of art that rank[s] with the great European epochs.[26]

True to his image, Coady published in 1916 the first issue of *Soil: A Magazine of Art* to propagate his opposing, experiential interpretation of American art. In some ways, *Soil* continued Coady's polemic against the Forum exhibition and everything it stood for. For example, in the first issue, a two-page spread juxtaposed the painting by Stanton Mac-Donald-Wright reproduced in the Forum catalogue, together with part of his statement for the show, with a window display of hats by a New York window dresser, likewise accompanied by a statement. At first glance, this may seem to be a simple put-down of the abstract painter, as if to say that his painting is as vulgar and crass as a window display, and equally artless. On closer inspection, however, the arrangement of hats actually seems to have considerable visual interest, the rhyming, rounded forms of the hats in many ways resembling the rounded forms in MacDonald-Wright's Synchromist painting. When one reads the accompanying texts, the pompous, inscrutable wording of the *Forum* statement compares unfavorably with the clear, down-to-earth wording of the window dresser. Although parody and irony are notoriously difficult to interpret, especially when some of the contemporaneous references are unfamiliar or forgotten, Coady seems here to be making a case that window dressing be taken seriously as art.

This latter interpretation is given greater weight by several of the articles in the same issue of *Soil*. Charlie Chaplin told of his craft in an article entitled "Making Fun."[27] A tailor submitted an article on dressmaking,[28] and Burt Williams, a black minstrel singer and comic, was sensitively interviewed and told, among other things, of the difficulties of being a black entertainer in a white society.[29] In an article entitled "The Stampede," Coady "reviewed" a rodeo that took place at Sheepshead Bay Speedway as if it were an art exhibition:

> The great field was filled with movement, —frenzied horses, maddened bulls, steers leaping and a general outburst of natural forces more or less controlled by human skill, —media, some of these, which certainly contain art possibilities.[30]

It is clear that the artistic possibilities mentioned are not in the realm of subject matter for painting or sculpture, but rather, that the cowboys themselves were the artists and the entire event of the rodeo is the art. The article contained photographs from the event. One of these re-

corded a bronco buster and was accompanied by the biting caption, "Jesse Stahl, he needs no 'ism' to guide him." In the last paragraph, Coady satirizes the isolationism and exclusivity of the critics:

> Infinity was boxed up within the Five Walls of Somewhere, struggling with the Cosmos, and could not get out to see, absorb and interpret. It could not get out and for that reason it could not get out.[31]

This last remark was a none-too-veiled reference to formalist exclusivity.

Coady also offered a scathing parody of the Forum exhibition entries by painting a hilarious pastiche of European modern styles entitled "Cosmopsychographical Organization." It was accompanied by an inscrutable text that contained references to Stieglitz's gallery at 291 Fifth Avenue, and Marcel Duchamp, in addition to quoting directly from Wright's reply to Coady from the article in the *New York Sun*.

Coady's anti-elitist and decidedly "impure" approach to American art is best summarized in a series of articles appearing in *Soil* collectively entitled "American Art." In these prose poems, Coady made a case for a broad and inclusive definition of American art:

> There is an American Art. Young, robust, energetic, naive, immature, daring and big spirited. Active in every conceivable field: The Panama canal, the Sky-scraper . . . the Tugboat and the Steam-Shovel . . . grain elevators, Trench Excavators, Blast Furnaces — This is American Art. It is not a refined granulation nor a delicate disease. It is not an illustration to a theory, it is the expression of life — a complicated life — American life. The isms have crowded it out of "the art world" and it has grown naturally, healthfully, beautifully. It has grown out of the soil.[32]

Coady defined modernism more as a sensibility, an aesthetic approach to a variety of situations. His assessment was localized to the particular experience of living in the United States at that time, not generalized to predetermined, universal, historical principles. The media of sound, sight, the word and other categories, which Wright believed destined to be separated and reduced to their essential quality, blended for Coady into an all-encompassing aesthetic experience, an exuberant cacophony.

In many ways Coady's approach more closely paralleled the contemporaneous "readymades" Marcel Duchamp was creating in New York than the formalist criticism of Wright. Duchamp chose objects from his environment, and in the act of choosing them, made them art. This creative choice based, as the artist called it, on aesthetic indifference. It

was the artist's prerogative to isolate objects as art and remove them from their environment. Duchamp robbed them of their utilitarian function by combining them, as in *Bicycle Wheel*, or by displacing them in such a way as to render them useless, as, for example, the snow shovel hung from the ceiling, or the coatrack nailed to the floor. Coady, in a similar but in some ways opposite creative act, designated utilitarian objects and events as art precisely by *not* isolating them, but by expanding the circle of art to include them. What's more, the railroad cars and steamrollers that Coady designated art, far from being rendered useless, vehemently retained their utilitarian function. They remained in context. In Coady's case, the creative act is not indifferent, but passionately involved. Duchamp stated, with some degree of irony, that America's bridges and plumbing are its greatest art.[33] In whatever degree of irony he originally meant it, R. J. Coady takes him at his word.[34]

In a similar spirit of inclusiveness, Coady wanted to expand the definition of who was to be considered an artist. The window dresser, tailor, minstrel singer, and broncobuster were all viewed by Coady as artists. Celebrated figures from popular culture such as Charlie Chaplin and prizefighter Jack Johnson are lionized in the pages of *Soil*. An article by Arthur Craven on the famous boxer was so laudatory, the prizefighter so romanticized, that one wonders to what degree the author is being ironic. Craven ended on an absurd, overblown note by rating Johnson (after Poe, Whitman, and Emerson) as the greatest American: "If there is a revolution here I shall fight to have him crowned King of the United States."[35]

Issues that highlighted blacks and other marginalized peoples were regularly addressed in the pages of *Soil*, as Coady traced his broad and inclusive circle. Coady's views on race were very advanced for his time. Unlike both his progressive and his reactionary contemporaries, Coady believed that artistic style resulted from cultural rather than racial differences among people.[36] The slogan of "Blood and Soil" may have been a patriotic sentiment in contemporaneous German society, but "soil"— the American environment itself—was for Coady the only parallel determinant of cultural identity in his country. Race, for Coady, could never be the basis for a genuine American culture. Moreover, the diversity of racial background that characterized life in the United States was a strong point rather than a weakness in the cultural expression of the country:

> All civilized races are mixed. It was through admixture that man turned from savagery to civilization and it is . . . culture . . . and not "race purity" which is all important.[37]

Coady's disdain for "purism" thus went beyond mere aesthetics and extended outward, embracing American culture in all its diversity. The January 1917 issue of *Soil*, contained a short piece on a native American, "Old John Smith," who claimed to be 131 years old. The article identifies him as the "oldest living American."[38] Even though there is a somewhat paternalistic tone to the piece, in an era of Frederick Remington and cigar store Indians, Coady's treatment reflected a relatively enlightened position. Even to speak of an Indian as an American in 1917 could be seen as radically inclusive.

*Soil* also reflected Coady's interest in what at that time was called "primitive" art, that is, the art of non-Western tribal peoples. Coady's Washington Square Gallery was one of the first places in the United States where African art was exhibited in an artistic, as opposed to ethnographic, setting. Yet there is evidence that the works he displayed were not decontextualized, reduced to stylistic terms and appreciated as mere aesthetic objects, as was so often the case at that time, both here and in Europe. Just as Coady appreciated the tugboat or the steam shovel in its utilitarian context in American culture, he appreciated the art of tribal peoples within the context of the belief systems of those peoples. *Soil* regularly featured articles on the cultures of Africa and Oceania and the March, 1917 issue boasted an African sculpture on the cover.

A feature of every issue of *Soil* was an article on boxing. Popular entertainments and sports, considered "lowbrow" at that time, were praised and encouraged in the pages of Coady's magazine and raised to the level of high art. Articles on the emerging medium of film and impassioned pleas against censorship in the movies appeared with regularity, as did other forms of popular culture, including a Nick Carter detective story in serial form.

The year before the Forum exhibition, Van Wyck Brooks published a piece in *Forum* entitled "Highbrow and Lowbrow."[39] The definition of these terms, for Brooks, corresponded to, but differs from, our own late twentieth-century ideas about high culture and popular culture. The view of *Forum* is definitely highbrow, in that it defines both terms from the vantage point of a dominant class. "Highbrow" was the high-and-dry realm of theory, while "lowbrow" is the business attitude that caters to the vulgar tastes and demands of the market. Coady saw real artistic worth in these lowbrow entertainments, despised by the elites but loved by the masses.

A large part of Coady's broad and inclusive aesthetic sensibility comes from a definition of culture rooted in anthropology rather than

aesthetics. Like an anthropologist, he looks carefully at items of material culture for clues about the society in which they were embedded. He does not isolate them for contemplation because they cannot be extricated from their environment without losing their essential character. This environmental and social matrix is the "soil" which gives rise to the fruits of a unique American culture.

Coady's experiential strategy differs from the earlier organicism of Royal Cortissoz in that the Tainian concepts of race, milieu and moment do not completely determine the form artistic activity will take in any given culture, but only provide the parameters within which a range of authentic expression may take place. Within this broadly delimited environment, a variety of equally authentic forms may be possible, or to extend Coady's metaphor, a number of different plants can arise from this soil. Cultural setting did not absolutely determine artistic form; Coady's experience-based organicism is open-ended and left an important place for human agency.

Wright posited a complex and closed system for critical evaluation of the new art. Culture, for Wright, was for the "cultured." Art operated within its own separate realm—implying, paradoxically, that the historical forces which drove modern art toward purity and abstraction operated outside any particular historical circumstances. These historical forces were taken to be particular to art, differentiated and progressively rarefied not only from their social, national situation, but even from other artistic media. Perhaps ultimately Wright's ideas reflect, on an aesthetic level, the isolationism that was coming more and more to replace the cosmopolitan attitudes that dominated American national life before World War I. Against the background of the Great War in Europe, Coady seemed to have found it difficult to believe that art merely continued on this straight trajectory, regardless of environmental pressures, apart from the culture as a whole.

The decontextualized stylistic development of art proposed by Wright is in many ways a modern version of the strategy of Cox. As different as they are and as antagonistic as their conclusions seem, both models are formalist in the sense that they are based on abstract principles which are logical, a priori, and deterministic. Perhaps ultimately, Wright's ideas reflect, on an aesthetic level, the isolationism that was coming more and more to replace the cosmopolitan attitudes that dominated American cultural life before the war.

---

Robert J. Coady's contribution to life in America ended with his death at an early age in 1922. That Coady died with thousands of other

Americans in the wake of the flu epidemic that became part of American national folklore seems, in a sense, uncannily appropriate—almost a work of art by Coady's own standards. As for Willard Huntington Wright, not long after the Forum exhibition he abandoned art criticism and moved to California. After a period of illness he set about writing popular detective novels under the pseudonym of S. S. Van Dine. He died in 1939.

# 4

# The Paradigms Take Shape

FORMALISM CAME TO DOMINATE CRITICAL THINKING IN AMERICA
during the 1920s. Even so, it gradually became clear that formalist pre-
dictions of the inevitable triumph of purist abstraction were not materi-
alizing as anticipated. In fact, many formalists began to incorporate
aspects of the more inclusive, experiential approach pioneered by R. J.
Coady. This became increasingly true as the decade progressed.

At the same time, a self-consciousness about the operational methods
of criticism entered the field. Art criticism began to understand and ar-
ticulate its role as a strategy for the promotion of particular agendas.
Critics utilized the instrumental approach pioneered in the New His-
tory and Pragmatism in defense of what they claimed to be significant
contemporary art. If their claims would be ratified by the market, they
could significantly influence the future direction of art.

In the second half of the decade, the growing tendency toward isola-
tionism in American political life made the search for a unique national
style more pronounced. Formalism, widely seen as essentially Euro-
pean, gave way more and more to a developing cultural organicism cen-
tering around the concept of experience—American experience. With
the publication of John Dewey's *Experience and Nature* in 1925, the posi-
tion was given a philosophical basis. By the end of the decade, the cul-
tural organicist paradigm was clearly in the ascendant, especially in the
writing of its principal spokesman, Thomas Jewell Craven.

---

The formalist approach, pioneered by critics Roger Fry and Clive
Bell in England and put forth in the United States in different forms by
Walter Pach and Willard Huntington Wright during the teens, came to
dominate mainstream critical thinking in America during the twenties.[1]
Although dominantly formalist, the modernism advocated was also a
compromise between the extreme positions of W. H. Wright and R. J.
Coady discussed in the previous chapter. As Chester Easterfield, editor
of *The Arts* magazine, put it in one of their earliest issues:

There is a danger from too much contact with things intellectual whenever there's too little contact with life. *The Arts* tries to preserve a balance between "High Brow" stuff and "Low Brow."[2]

Despite the disclaimer, *The Arts* tended to be fashionably highbrow during most of the eleven years of its publication. It made its appeal to collectors and included long descriptions of wealthy people's collections. Later in its run, it also featured regular articles on interior design.

After the death of Easterfield in 1922, the editorship was taken over by Forbes Watson, regular columnist for the *New York World*. Watson was a formalist in the sense that he emphasized formal aspects of works of art in his description and analysis. This was especially true in his newspaper articles. Yet as the decade went along, Watson became more and more critical of formalism and more attracted to the other camp within modernism: that which emphasized the local and experiential, now tied to a nascent nationalism.

In his article "The Latest Thing," from 1929, he sharply criticizes formalist determinism in favor of a nativist art with deeper roots in the soil:

Paintings made to be the last word to one degree or another, although sufficiently impressive in the eyes of brightly fashionable seekers, lack the deep roots that give permanence to growing ideas just as they do to growing life.[3]

Yet in the same article, he implies his belief in an evolutionary concept of history by wishing he could be transported to the year 1978 to look back on his own time so as, in his own words, "to arrive at a more dispassionate view of the struggle," and also no doubt, to find out who wins.

Whether artists accepted the strict deterministic formalism of Wright or the softer, more organic version of Watson and other moderate formalist critics, they seemed to take for granted the evolution of one style into the next, each new stylistic innovation supplanting an older, more outmoded manner. Ralph Block bemoans the critic's dilemma in this constantly changing matrix:

Somehow the idea of inevitable change, of an evolutionary development in form has become so established in the minds of artists that they look upon new modes, new aspects of expression, as something originating necessarily and entirely within the art itself . . . they have made a convention out of an extension of technical frontiers.[4]

This creates a very difficult situation for the critic who tries to maintain some kind of standards to judge the new art, and so is constantly forced to revise his criteria to keep pace with the rapidly advancing art.

Henry McBride, who has been described as the best-known critic of the 1920s, had been the regular art critic for the *New York Sun* since 1912. In 1920, he joined the staff of *The Dial*, a progressive magazine.[5] In his monthly column for *The Dial*, "Modern Art," he advocated a fashionable formalism. He could write eloquently about art in formalist terms when he wanted, but too often settled for articles on one or another aspects of gallery life and the art world. He had a progressive sense of historical development and saw contemporaneous art as a long sequence of periods, one following and built upon another.[6] However, he does not acknowledge a particular direction to this succession of styles and so does not recognize aesthetic purity, or anything else for that matter, as an endpoint.

However, McBride shared the exclusivity of a formalist approach with Wright in terms of keeping the realm of art separate from everyday experience and popular forms of art. McBride addresses the types of questions raised by Coady and others by dismissing it as hopelessly lowbrow:

> We hear a lot about democratic art and the tendencies of the age, of the infallibility of the common people whose idols, such as Charlie Chaplain and Babe Ruth, afterward became the idols of the supposedly astute. . . .[7]

McBride was disdainful of anything that compromised his progressive modernism, and would not be led astray by either the rabble or the sophisticated teleology of Wright.

In fact, despite his early trailblazing role in establishing the legitimacy of a modern formalist approach to criticism, it became common for many critics to distance themselves from W. H. Wright and his determinist theories after the author published *The Future of Painting* in 1923.[8] Wright had not published regularly since his stint on the staff of *The Forum* in the teens and was in semi-retirement in California when he published two articles in *The Freeman* that he later revised and turned into the short aforementioned book. It was his last foray into criticism.[9]

In *The Future of Painting*, Wright carried out his earlier thesis to the point of absurdity. The Synchromists, having brought painting to its purest form, were the last painters. Now the new art of pure colored light will take up where painting left off, he asserts. Color organs and other new light technology, not yet invented, will come to supplant art

as we know it. Although painting is seen as destined to continue in the form of illustration, for all practical purposes painting, as a fine art, was obsolete.

The publication of *The Future of Painting* was greeted by an onslaught of negative criticism. It must have been quite an embarrassment for the entire formalist camp to have the author of *Modern Painting*, at the time the leading text on the new art, to advocate such an eccentric, extreme view.

Thomas Craven (not to be confused with Arthur Craven), writing for *The Dial*, assailed Wright for holding tenaciously to outmoded theory. Wright, in Craven's view, "clings to the empathetic hypothesis of a decade past."[10] His hard critique of Wright's book gets to the heart of the matter in regards to formalism and history, "to believe that a mechanical evolution in the technique of art is of any importance is an illusion . . . arising from a misunderstanding of history."[11] It is interesting to note that Craven made his first contributions to *The Dial* and *The Freeman*, both of which had regular art critics, through the back door so to speak, by doing book reviews on art books and only later graduating to full-blown articles. The author was to rise to the position of one of the most influential critics in America during the 1930s and, although he started out as a formalist in the early 1920s, he eventually became the primary spokesman for a nativist, experiential approach to art.

Craven was given his own forum for an alternate reading of the history of modern art earlier that year in *The Dial*. In the two-part article, "The Progress of Painting," Craven describes the function of art and its relationship to society in essentially formalist terms:

> But art is not merely a reflection: inevitably linked to its environment by the expression of experience, it is, in its genuine manifestations, creative; it molds assimilated material into forms, and in this respect, like all theoretic endeavors is above temporary circumstances.[12]

This would seem to support a removal of art from its immediate environment in favor of a creative realm where only forms matter. Modern art, because it is so concerned with formal issues, lays bare as never before the artist's competence or incompetence in the all-important matters of composition and design:

> Modern plastic expression, by denying the value of literal reproduction, strips the artist naked—it exposes him ruthlessly for what he is, and forces him to the consideration of form. The rendition of form—form undisguised

by the allurements of naturalism, as in primitive art—lays bare the whole creative skeleton, and exemplifies the artist's ability to co-ordinate his reactions and ideas.[13]

This concern with forms he traces all the way back to the Renaissance where the "genius" of the artist was concentrated on the study of form, and on the sequences of line and mass necessary to hold together groups of objects . . ."

But when artists began to be overly concerned with the depiction of textures and surface realism, Craven tells us, "The *purity* of form was lost" [emphasis his]. With the introduction of what Craven calls the "evil practice of copying natural surfaces" the formal basis of painting was destabilized.[14]

This tendency to the dissolution of form in favor of naturalistic surface continued for the next four centuries, according to Craven, and culminated in the work of the Impressionists, where the essentials of composition and design were entirely sacrificed to the depiction of temporary light effects on the surfaces of objects. It was at this point that Cézanne, whom Craven at that time held in highest esteem, restored to painting the clarity and structural solidity of the Renaissance.

Cubism tried to extend Cézanne's structural experiments by breaking completely with naturalism, he claims. But even though Craven acknowledges its importance in "clearing the air" of a lingering naturalism and academicism, he sees Cubism as a transitional period between "the unfinished painting of Cézanne to the art of to-morrow . . ." and points out the recent classical work of Picasso as evidence of the swing.

He disparages the interest of his contemporaries in what was called at the time "primitive" art, but acknowledges Matisse's masterful use of those sources. Futurism and Dadaism are dismissed as fads created by the art world. But his worst criticism is saved for the "abstractionists":

> While we can single out no authentic school of abstractionists, the majority of the younger painters have clung to the belief that if you destroy representation, you have purified form, and accordingly have produced a higher art.[15]

But abstraction left to its own devices becomes merely decorative rather than pure in the sense that Renaissance art or the painting of Cézanne is pure in Craven's scheme.

Craven, utilizing history in a different way, but still operating from a formalist paradigm, has come up with an historically based explanation

of contemporary art entirely at odds with Wright's view. Craven, like Wright, brought history to bear in creating a "usable past." Despite all his criticisms of modernism, Craven acknowledges the new directions since Cézanne as "the most significant movement in art since the Renaissance."[16]

Yet Craven, even in this early, essentially formalist, piece already has pronounced leanings toward the experiential pole of the debate. His ambivalence is clear from the closing paragraph of the article:

> In concluding the review I wish to make clear that the term progress has been used for convenience only. There has been no evolution in the sense of superior aesthetic achievement—only cycles of growth, cumulation, and decadence. Art struggles toward a complete reality which, at certain favorable moments, is approached. But since perfection is unobtainable, the quest in all its forms is eternal. In addition, the context of art is peculiar to its time, and this, in itself, makes any duplication of import an impossibility. The warfare between abstraction and experience is perpetually waging, and within this field there are periods of progress and decline. Occasionally a mean is reached, and however simple it may be, if it strikes a man with a force equivalent to his experience, it is art.[17]

Thomas Craven was to become very important for the experiential camp in the later twenties and will be treated further in a subsequent section of this chapter. But it is here among the formalist criticism, despite his ambivalence, that Craven's early work must be placed.

The regular art critic for the *Freeman* was Walter Pach, who had maintained his open-ended, yet relentlessly progressive, modernism from the time of the Armory Show, when he first began to publish his views. Pach was in many ways the leading and most erudite of the critics associated with formalism. He had traveled widely in Europe before the war and was instrumental in the selection of work from the Armory Show by being Arthur B. Davies's and Walt Kuhn's host and main contact in Paris during the trip made by Davies and Kuhn in the Autumn of 1912. He was more cosmopolitan than McBride, whose main contacts were still British.

Pach feels so convinced of the plastic brilliance of the modernists that he is ready to canonize them. During 1921, in his regular article for *The Freeman*, Pach lauds the Metropolitan Museum of Art for exhibiting Post-Impressionists, as well as Picasso and Derain, lending its authority to these modernist works:

> We may well rejoice, however, that one of our great national institutions has taken this long step towards defining for the public the classic art of our

time . . . in this exhibition the Museum fulfills its function as the educator of those who are to carry on the divine fire of art.[18]

Pach knew well that ratification by museums was an important step in insuring the entry of modernism into history, and in providing a firm basis for future developments along the same lines.

He favors European painting and encourages America's appreciation for the "modern masters," as he calls them. He admits, however, "America has very few great artists who could be placed beside their French contemporaries without suffering in the comparison."[19] He flirts, in the same article, with popular entertainments like jazz and baseball, finding certain formal characteristics to be inspiring and possibly providing material for the creative artist.

However, in the end he refuses to see popular art in the same category as fine art, despite its predominance in the culture as a whole:

Neither is the unspeakable trash that the crowd likes—moderately—in our magazines and exhibitions to be thought of as American art simply because there is so much of it. One sees it as the only approach to beauty that the thousands of our dismal home-towns know anything about. . . . [20]

He feels that influence from European culture will eventually trickle down and improve the general state of things.

Improvement is slow, but as the increasing volume of good art in this country makes us aware of its virtues, we shall find the way to shape our conditions into harmony with it.[21]

In a strange inversion of the experiential approach, art for Pach is primary and we adapt the environment in order to bring *it* into harmony with art.

Pach, like his, at that time, less well-known colleague Craven, also published a response of sorts to Wright's *The Future of Painting* in his 1924 book *The Masters of Modern Art*. Adapted from columns first appearing in *The Freeman*, Pach attempted to create a definitive text on the new art to replace and update Wright's *Modern Painting* of 1915.

Curiously enough, Pach defines the modern period as having its genesis during the French Revolution but ending at the time of the First World War, presumably placing Dadaism and other recent or contemporaneous art in a post modern period as yet undefined. Modernism seems to be, for Pach in 1924, a phenomenon of the past, which ended in the previous decade. "To-day as we stand before a new period," he

writes, "we see how immense was the accomplishment of the one which is ending."[22] In at least this sense he agrees with Wright in announcing an end to modernism and placing artistic developments from Cézanne through the prewar movements of the first decade of the century as extensions of the same modernist ideas. Cubism, Fauvism and Expressionism do not form a "bridge" from the art of Cezanne to art of the future as in Craven's scheme, but are the final flowering of the movement that started with Delacroix.

He admits, however, the continuing development of art and the stylistic continuity from one period to another:

> Thus the work of the artist goes on "according to the days, according to the season," as Redon said. "Nothing comes from nothing," another of his sayings ran: each painting or sculpture is both effect and cause.[23]

That each style gives rise to its own successor is both cause and effect in the sense that each new solution creates new artistic problems, which in turn forms the new basis—the "cause" in Pach's terminology—for reaction and development. Art begets art in an insular world where formalist values reign.

Pach also admits the provisionary nature of his claim that modernism is over in the last sentence of the book:

> We divide off a certain period and call it modern so that we may, for the moment, study it for itself but these men whom we have been observing can not really be detached from the past, and they—with it—have in their hands the making of the future.[24]

Despite the mitigating influence of this disclaimer, it is clear that by 1924, when it was written, there was a crisis within the formalist camp and many formalist critics had felt compelled to address this crisis in one way or another.

Guy Eglington, writing for *International Studio*, dubs Pach the "Dean of Modern Criticism in America," in a favorable review of *Masters of Modern Art*. Although the book is described as a "masterly exposé," Eglington expresses fear that Pach's emphasis on form is a theory that has "seen its day."[25] He, like Pach, senses the exhaustion of modernism and attributes it to formalist theory having run its course, "A theory is valuable only so long as it is not fully realized and so is capable of development."[26]

Eglington was British by birth and had a regular column in *Interna-*

*tional Studio* during the middle years of the decade. He also wrote for other publications. Eglington's own brand of formalism was a curious mixture. He advocated modern art, on formalist grounds, for European art and had an avant-garde conception of its development. In an article appearing in the *American Mercury*, he outlines his progressive model, where artists once decried as insane are now set up as the arbiters of taste, themselves condemning the new outlaws.[27]

American art, however, did not follow the same pattern naturally, according to Eglington. He felt most American modernism to be imitative and formulaic, modernism being a foreign graft. The "vital impulse" in American art is, rather, "primitive in its manifestations."[28]

> I believe that the American man, artists included, is not only by nature and if left to himself, simple, but of a very childlike, primitive simplicity. The trouble is that he never is left to himself.[29]

Americans are more at home at a baseball game than an art gallery, he goes on to say, where their "frank boyishness" would be crushed. This observation, while somewhat patronizing, recalls Coady's description of the Rodeo as containing "art possibilities," in the sense that popular entertainments are raised to the level of art, or rather art experience. And this, as was shown in the previous chapter, is ultimately based upon Dadaist attitudes concerning a more fluid demarcation between art and life.

Eglington also published, in serial form, the irreverent "Complete Dictionary of Modern Art Terms for the Use of Aspiring Amateurs," in *International Studio*.[30] It is a parody of the art jargon of the times including many of the terms so often used by formalist critics: "Authentic," "Dynamic Symmetry," "Relation," "Significant Form," to name but a few, all given satirical definitions. Apropos to the formalist crisis of the mid-decade is the following definition, "Abstract—Formerly the big stick of the modern critic . . . going out of style in up-to-date criticism."[31]

That year, in what can only be understood as a reaction to the crisis, *Forum* published a series of letters by invited writers entitled "Pure Art? or 'Pure Nonsense'?" The answers ran the gamut from the devotion of Katherine Drier to the cynicism of Frank Jewett Mather:

> The problem is that Pach and his associates are caught by the big word purity and are unnecessarily out of sorts with natural appearances. They real-

ize that it is fatally easy to make a stupid representation of nature, but apparently do not realize that it is even easier to make a stupid abstraction.[32]

Perhaps Alexander Archipenko's reply to *The Forum* is, in its way, the toughest and cuts closest to the heart of the matter:

> You ask me whether Cubism is pure Art.
>   Yes. Why not?
>   But tell me please what is Art?
>   . . . After all why bother the tired heads of brave citizens with high brow questions? I suppose they would be much happier to know how much a man is worth who manufactures Chewing Gum.[33]

———

Despite the crisis for formalism by mid-decade and the rise of a new sort of cultural organicism based on experience, formalist positions continued to be expounded throughout the second half of the decade and could still prompt Henry Billings to state confidently as late as 1928:

> Order and its components of unity, rhythm and harmony and the like has no existence in nature and can only take on a human significance when set apart.[34]

The crisis which developed for American criticism in the early twenties centered around the issue of standards (or lack of standards) applicable to the new art. In the wake of academic formalism, where the standards by which to judge art were clear, the modern formalists were unable to agree on criteria. As was demonstrated in the previous section, several rival versions of the formalist paradigm developed but none of them had the authority of the old formalism. In the first years of the decade, it began to dawn on some critics that perhaps all standards were arbitrary, that the establishing of criteria was perhaps nothing more than a tool, a "weapon" with which to promote an unstated agenda.

In 1918, Irving Babbitt published an article in *The Nation* that dealt with the role of the critic in modern society, emphasizing the importance of establishing firm criteria:

> Criticism is . . . more than a squabble between Bohemians, each eager to capture the attention of the public for his brand of self expression . . . the serious critic is more concerned with achieving a correct scale of values and so seeing things proportionately.[35]

He goes on to state that the "best type" of critic creates or at least refers to standards that go beyond his immediate impression.[36] His role is therefore selective as well as interpretive.

Although Babbitt acknowledges a relativity of taste, he warns against the critic sinking into a dangerous relativism:

> With the elimination of the restrictive and selective principle—and the presence of standards is always felt as such a principle—what is left is the most dangerous of all forms of anarchy—anarchy of the imagination.[37]

But Babbitt here fails to see that achieving a "correct" scale of values, a "proportional" set of standards, is largely arbitrary and depends on what values and standards the critic happens to be promoting. Although Babbit here writes about criticism in general, it applies well to criticism about art.

A growing sense of self-consciousness about criticism and its promotional motives can be seen in articles appearing over the next few years in *The Freeman*. In "The Critic and the Artist," from 1920, the author (his name is not listed) implies that the critic helps the artist by giving the artist direction "His view is always toward the future."[38] The question is, how does one know the future?

Another writer (again no byline) bemoans the artist being led astray by critics and outside experts guided by wrong standards in the "The Illusion of the Critics."

> In this country perhaps, more than in any other, the arts are subjected to the interference of people who are disqualified from pronouncing judgment by ignorance of the principles at issue in any particular instance.[39]

The author refrains from stating exactly what these principles are, however.

W. G. Blaikie-Murdoch addresses the problem by asserting the speciousness of *all* set standards in "For Freedom in Criticism," published the following year, "art is a creation whose merit is not to be determined by reference to laws, as in science."[40] Blaikie-Murdoch states that when formalist critics refer to these standards, they are making a shibboleth of their own personal preferences.

> Is it not a mere contending that one's personal rating is necessarily the right one, and does this, in turn, betray a confounding of the sciences with the arts? . . . [In this case] there is here no criticism whatsoever, but rather a demand that all people's temperament should be like unto one's own.[41]

The standards of the critic, including the alleged "laws" of stylistic development are, for Blaikie-Murdoch, a matter of human vanity and an attempt at domination. "It maddens his tyrannical instinct to find others refusing to bow before his idols. . . ."[42]

The kinds of issues suggested but not resolved in these articles in *The Freeman* are brought into clear focus in an article by Conrad Aikin entitled "The Function of Criticism?" published in the little magazine, *Broom*.

Aikin agrees with Blaikie-Murdoch that in criticism there is no "law" we can call on.[43] He goes on, "If all the evidence, so to speak, were "in," then criticism might become an exact science."[44] He acknowledges an evolutionary progress in art and literature but states that it seems to adhere to no preordained order.

> Literature changes constantly, it may develop in a manner totally unforeseen, and who knows if the new book by Z. or Y. is the turning point or not? Z. or Y. do not know, certainly, though, of course, they hope so; and it is exactly in this situation that we should begin to see that criticism, under the conditions we now live in, has a function which we have overlooked, a function perhaps noble, though perhaps, equally, not ignoble, but a function quite natural and necessary. This function is not easy to describe , for it is complex. Perhaps, in its light, we may justly say that criticism is the artist's *weapon* [his emphasis], both of offense and defense, the weapon whereby he destroys or lames artistic tendencies inimical to his own; whereby on occasion he himself is destroyed. In a world in which there were no absolute aesthetic values such a weapon would be of paramount value. Where there is no law, strength will prevail.[45]

Thus, the critical field of discourse in the arts is the scene of an aesthetic struggle likened to the struggle for survival in the natural world as represented by Darwin. Like Darwinian evolution and unlike its more deterministic variant in Spencer and other popularizers, the future is open to whatever tendency is able to capture and dominate the field. As Aikin states it:

> We see here what we see so often other planes, the essentially competitive order of things, the cruel struggle for survival. Criticism is the battlegrounds for the arts. One theory goes out against the other, and the better method wins.[46]

By this means, criticism's function is not limited to explanation as it would seem on the surface, but becomes as he puts it, an "integral part

of art," in some senses insuring its very survival, or at least the survival of certain strains, which posterity will dub "significant."[47]

This instrumental conception of the role of criticism, where it becomes a tool for the advancement of certain tendencies, reveals a new level of self-consciousness in critical thought that parallels the self-consciousness evident in the New History. The New History, it will be remembered, acknowledges the selective choosing and interpretation of past events that help explain, operationally, the present. By a similar process of selection and interpretation, critics on both sides of the debate used aspects of the present scene to predict the future course of events. Criticism, like history, was utilized as a tool to advance a particular aesthetic agenda.

----

The survival of the ideas of Robert J. Coady past his early death in 1922 would seem unlikely in a decade increasingly dominated by formalist criticism. In "Champion in the Wilderness," published in *Broom* shortly after Coady's death, the author conjures up images of Coady as a sort of biblical David in boxing gloves, going out to meet the Goliath of the art world:

Who dares put on the shoes and gloves of this dead champion and take his fighting place in the wilderness of age?[48]

Despite their losing of a hero, it was in fact in the little magazines, like *Broom* itself, where the paradigm was most effectively carried on and developed during the opening years of the decade.

*Broom* was published between 1920 and 1924 and belongs in the category of what has been called the *tendenz* magazine. According to Frederick Hoffman, the aim of the *tendenz* magazine was to recognize and articulate "the forward direction of our thought and culture."[49] Like the larger circulation contemporaneous periodicals, *The Freeman* and *The Dial*, it dealt with art, literature, and larger cultural questions. Hoffman states that the *tendenz* magazine's quintessential contribution to the arts scene of the time was the critical philosophical essay.[50]

Although *Broom* was an American magazine, it was published by expatriates in Europe during most of its run. Despite its cosmopolitanism, *Broom* was devoted to understanding and addressing American art in terms already familiar from Coady and in fact, was openly dedicated to the furtherance of that vision. In *Broom*'s opening number, the editors

state their intention to "bridge the separation between 'highbrow' and 'lowbrow' that isolates the artist from the community."[51]

In an early issue, the editor introduces the concept of contemporary American art as in an "archaic" phase of artistic development, as opposed to the "classical" or even "decadent" phase of the contemporary European arts.[52] This idea is reminiscent of Guy Eglington's "primitivism" discussed in a previous section of this chapter. Accordingly,

> Europe can and does borrow safely from America; jazz, advertising, etc. are the foundations of aesthetic schools abroad, but the reverse process is deadly.[53]

Foreigners, he asserts, "understand with difficulty the American's blindness towards the creations of his own people."[54] Among these uniquely American creations are Hollywood movies (which he tells us the French flock to), baseball, and the Nick Carver detective novels already lauded by Coady.[55]

Charlie Chaplin, by this time practically an icon of popular culture, is quoted at length from his piece in *Soil* from 1916.[56] Chaplin's very popularity makes him suspicious to the elite, the author contends, while on the other hand, "to be nearly incomprehensible secures respect and careful treatment," among the mainstream, highbrow critics.[57]

In what can only be seen as a lampoon of formalist critical methods, the author describes an American bathroom in a museum:

> The bathroom is an American product. The architect had nothing to imitate. Beautiful, restful forms in porcelain, a mosaic floor of glistening white tiles. Soft, geometrical towels on nickel racks, faucets and stoppers in burnished metal. Perfect taste, perfect efficiency. One lingers long before returning to the museum outside.[58]

By placing the formalistically described bathroom in an art museum, he heightens the absurdity of the juxtaposition between high culture and vernacular culture by implying the superiority of the honest bathroom to the pretentious museum. The Dadaist attitude of this parody is clearly evident.

In "The Great American Billposter," by Matthew Josephson, another of *Broom's* editors and sometime contributors, it is asserted that America will never find an indigenous art if it depends on its intellectuals.[59] Rather, it should:

plunge heartily into that effervescent revolving cacophonous milieu (which not so remotely resembles the Purgatory of Dante), where the Billposters enunciate their wisdom, the Cinema transports us, the newspapers intone their gaudy jargon; where athletes play upon the frenetic passions of baseball crowds, and sky-scrapers rise lyrically to the exotic rhythms of jazz bands which upon waking up we find to be nothing but the drilling of pneumatic hammers on steel girders.[60]

According to Josephson, America is a "milieu," a "situation" whose raw beauty is "unaffected."[61] He lauds the Billposter as a creator and actually introduces different type styles into the piece, quoting in true Dada fashion from various currently recognizable advertisements and analyzing them critically as if they were literature. The spirit of irony here must not lead the reader to assume, however, that the aesthetic questions underlying the piece were frivolous. By considering the artist's experience of his local environment, his "milieu" as Josephson calls it, of such central importance for judging artistic worth and authenticity, Josephson reveals his own aesthetic experiential criteria. Again, the connection to Dadaism, via Coady, is a strain of the paradigm peculiar to the early 1920s which will become all but lost in the following decades, only to reemerge much later in the work of Harold Rosenberg.

Another of the little magazines to emphasize the importance of the artist's situation and surroundings over formalist standards was *Contact*, edited by William Carlos Williams and published in New York during the early 1920s. In the title page of its first issue, *Contact* states its purpose:

Issued in the conviction that art which attains is indigenous of experience and relations, and that the artist works to express perceptions rather than to attain standards of achievement.[62]

The standards set up by critics are seen by Williams not only as arbitrary, but also as a pernicious influence that thwarts the natural direction of the artist. The artist is urged, rather, toward experience and relations. He explains more fully these situational aspects of his concept of "contact" in a later issue.

In exploiting his position in America the artist, aware of the universal laws of his craft, will however take off only from the sensual accidents of his immediate contacts. The achievement of a *locus* [his emphasis], *Contact* has maintained, is the one thing that will put him on a comparable basis with Europe.[63]

The key to finding an authentic American art for Williams, then, is through the artist's direct and inventive contacts with his surroundings and by operating with fluidly conceived boundaries between art and life.

These same sentiments were echoed to some degree by the larger magazines as well. In an article entitled, "Art and Life," appearing in *The Freeman*, the author expresses the connectedness of art and everyday experience.

> art is life, life heightened to the point of imaginative realization, the essential quality of an experience sublimated by being consciously re-created.[64]

It was this vital contact with life that some apparently feared was being lost in the exclusivity of the then-dominant formalist modernism.

But these calls for the blurring of boundaries between art and life contain a further ambiguity. They also imply that the artist's experience of, say, a baseball game, is qualitatively different from the experience of an average fan in the stands, certainly different from a player on the field, or from a person listening to the game on the radio, or reading about it the next day in the newspaper. In the emerging experiential paradigm there was, in addition to the destabilization of the line between art and life, also a breakdown of the boundaries between the artist and the non-artist, or more precisely, between a person whose experience was more aesthetic and a person whose experience was more ordinary. The emphasis seemed to shift from the creator of art objects to the "artistic" experience of reception. As Laurence Buermeyer puts it in an article published in 1924 in *The Dial*:

> What essentially distinguishes the artist is not ability to make himself intelligible to others—this is the definition of craftsmanship—but the ability to see more clearly and profoundly than the average man the aesthetic possibilities of the world around him.[65]

This again brings to mind Coady's "art possibilities" in his description of the rodeo from *The Soil*, where what mattered was the experience of the event itself, and not the event as subject matter for art.

This differentiation of the roles of the producer and the receiver is referred to as the "artistic" and the "esthetic" respectively, by John Dewey in *Experience and Nature*, published in 1925, the pivotal text of the decade for the experiential paradigm.

On the one hand, there is action that deals with materials and energies out-
side the body, assembling, refining, combining, manipulating them until
their new state yields a satisfaction not afforded by their crude condition—a
formula that applies to the fine and useful arts alike [artistic]. On the other
hand, there is the delight that attends vision and hearing, an enhancement
of the receptive appreciation and assimilation of objects irrespective of par-
ticipation in the operations of production [esthetic].[66]

Both artistic production and aesthetic appreciation were seen as leading
to the same goal, which Dewey calls a "culminatory" experience.

A culminatory experience for Dewey, is an experience so heightened
with significance for the individual that it gives him new insight and
understanding; an experience whose meaning to the person is not
merely referred to, or symbolized, but is, rather, concretely embodied
in the experience itself: an experience, in short, which changes the per-
son.[67] Art—as the mode of human activity most highly charged with
meaning—is, as Dewey puts it, "the complete culmination of nature,"
in the sense that it is the instrument of attaining culminatory experi-
ence, rather than some other more mundane end.[68]

The activity of the artist and the appreciator are essentially alike in
Dewey's scheme—both utilize art, or more precisely, the experience of
art, to bring the person to culminatory experience. In the artist, the cul-
mination is at first merely suggested in the realm of unrealized possibil-
ity inherent in the material, but as the work progresses, it moves toward
the horizon of this sensed culmination and quickens as the artist ap-
proaches completion of the successful work of art. In the appreciator,
the work of art itself is but the site, or the occasion, of the culminatory
experience. In either case, the actual piece of art is merely an instru-
ment for achieving this heightened and meaningful experience.

Moreover, this instrumental notion of art as a type or mode of experi-
ence can be extended to situations and occasions not normally thought
of as art. Thus a sunset, but also a baseball game or a rodeo, have the
potential to produce these kinds of experiences as well. Artistic or aes-
thetic experience is therefore only a specialized, particularly meaningful
kind of experience. It can take place in the presence, but also in the
absence, of a specifically designated art object per se.

This engaged and instrumental approach to art takes for granted that
art is an activity necessarily embedded in a context, a specific situation,
or milieu which gave rise to it and charges it with meaning. An object
that is not also instrumental does not have the means for bringing about
culminatory experience and therefore cannot be classified as art. Anath-

ema to Dewey's concept is the formalist notion of an artwork separate from its context in experience, operating by its own intrinsic laws: "Order and proportion when they are the whole story are soon exhausted."[69] Such art, according to Dewey, becomes just a symbol of status, an emblem of power or privilege, in his words, "a form of commercialized industry in production of a class of commodities that find their sale among well-to-do persons desirous of maintaining a conventionally approved status."[70]

In Dewey's aesthetic theory, as expounded in *Experience and Nature*, the experiential paradigm was transformed from a vague Dadaist intuition based on the breakdown of conventional barriers (between art and life and the artist and non-artist), to full-blown theoretical respectability. Because of its emphasis on context or milieu, it also provided a useful basis for those advocating a unique American art.

This search for a national identity had been an animating force in American art at least since the first decade of the century, but at the time of the Armory Show of 1913, it took on a new kind of urgency, because even though the exhibit had been a boon for modernism, it had cast American art as comparatively weak and provincial. As art historian Matthew Baigell points out, World War I added a sense of urgency to the search for a national culture, "The diversity of national feelings about the war indicated that assimilation was not as successful as had been assumed. People had not melted enough in the melting pot."[71]

Yet Dewey cautions against thinking in terms of some sort of unified culture in America. In "Americanism and Localism," published in *The Dial* in 1920, Dewey asserts the importance of immediate, local environment as the basic integer of American society.

> It [American society] is a loose collection of houses, of neighborhoods, villages, farms, towns. Each of these has an intense consciousness of what is going on within itself in the way of fires, burglaries, murders, family jars [?], weddings, and banquets to esteemed fellow citizens, and a languid, drooping interest in the rest of the spacious land.[72]

This localism is in keeping with his emphasis on individual and collective experience. Even the immigrants who resist assimilation do so on the basis of this localism rather than on the basis of a rejection of national culture *per se*. Dewey asserts, "They decline to get Americanized for the same reason they put up with considerable annoyance rather than go back. They are chiefly concerned with what goes on in their tenement house, their alley, their factory, their street."[73] If the language

peculiar to that milieu is Italian or Yiddish or Chinese, if ethnic ways dominate on a local level, then this *is* American culture for them, to whatever extent there actually exists an American culture.

Dewey differentiates between the nation and what he calls, the country: "The country is a spread of localities, while the nation is something that exists in Washington and other seats of government."[74] Despite the quest by many for an American identity, the pragmatic reality for most people is a localized culture according to Dewey, "We are discovering that the locality is the only universal."[75]

Dewey's ideas about experience and localism would inform the developing critical position of Thomas Craven, who during the later 1920s was the main spokesman for the evolving experiential paradigm in American art criticism. Craven's mixture of a particular (and somewhat narrow) interpretation of Dewey's experientially based localism and pragmatic instrumentalism with Tainian cultural organicism would form the theoretical basis for his promotion of the Regionalist movement during the 1930s.

---

Thomas Craven has already been discussed in terms of his formalist criticism during the first half of the decade, and he will be discussed at greater length in the following chapter because of his importance in the critical struggles of the subsequent decade. He will be treated here in terms of his development out of formalism in the mid-1920s toward a vehement, experience-based, cultural organicism by the end of the decade. At the same time, he developed an outspoken style of writing which some have called chauvinistic.[76]

As has been mentioned, Thomas Craven began the decade as a formalist, but by 1925, he had distanced himself from formalism. For example, in what purports to be a review of a book on Daumier, Craven discusses at length his own views on contemporary art. He charges that the formalists, by abstracting reality and setting painting apart from experience, dehumanize art.

> "The purification of art" was the fine name given to this process of dehumanization; and the great majority of those interested in painting made an effort, irrespective of the true nature of their beliefs, to advance the idea. It was a captivating fantasy, and to be looked upon as "in the know," one was forced to subscribe to the pompous chatter about abstraction, empathy, dynamic color, significant form, and what not.[77]

Moreover, he insinuated that this was all done by art world elitists — highbrow critics, art dealers, and collectors — in order to hold onto or

enhance their privileged status.[78] This use of personal invective as a weapon in his critical arsenal would continue and increase as the years went by.

In "Photography and Painting," published later that same year, he stated his new concept of the primacy of experience over form, the latter flowing naturally out of the former:

> Given a genuine insight into the world of every-day experience, it is possible for the artist to dispense with all old forms and to create directly, trusting simply to the pull of such impulses as follow his sensations. By working in this manner new forms are inevitable.[79]

Forms and formal relationships remain necessary and important to Craven, but he sees the necessity of them being grounded in experience.

Photography, for Craven, can never be art, because it is a merely a mechanical simulacrum of visual experience without the necessary intervention of the artist's sense of form. Purist abstraction on the other hand, by limiting itself exclusively to form, ignores its grounding in experience and so in its own way is equally incomplete and barren.

> The profound meaning of art lies in the fact that it is a reorganization of the elements of experience into a new whole with a different meaning from that of nature. It is not a reproduction of natural facts, but a re-presentation of such facts, after human insight and will have discovered and established a sequence of new relationships.[80]

It is the fertile combination of inventive form based on real experience that characterizes great art, in Craven's estimation, whether in the work of Raphael, Daumier, or Cézanne.

Craven's promotion of his position increasingly included attacks upon rival theories and artists, calling to mind *The Broom*'s article about the use of art as a weapon discussed previously. His attacks took the form of increasing vituperation as the years went on. In "Men of Art: American Style," he slams Cézanne for being a master of form but being deficient in the realm of experience:

> But he [Cézanne] was neurasthenic and illiberal, thin-skinned, obtuse in matters calling for ordinary judgment, and pietistically shrinking in his contacts with life—qualities scarcely compatible with greatness in art, or anything else.[81]

Here personal biography and character begin to enter into the discussion under the guise of "experience," in order to savage the painter per-

sonally. In a similar vein he calls Gauguin "a malcontent and a barbarian," and accuses Matisse—because of his interest in African tribal art—of ushering in a generation of "Negromaniacs."[82]

The racist overtones of this last remark are echoed earlier in the article, when he insinuates that Jewish artists cannot truly represent American experience.

> What good American names greeted the spectator searching for native art! Wright, Benton and Hartley, and possibly Marin, might have originated in any one of the forty-eight commonwealths. (But what of Bluemer, Benn, Dasburg, Walkowitz, Of, and Zorach?).[83]

Apparently, women are also exempt in Craven's view.

> Painting is essentially a man's art, and all great painters have been coarse, earthy and intolerable. In the entire range of art there is not a single picture entitled to a moment's consideration that has been done by a woman.[84]

In Craven's definition of American experience, only certain types of people were really able to represent it authentically. He tells the reader what real American experience is. There is not much latitude for other types of experience beyond Craven's own xenophobic nationalism. Like Coady, he is involved in defining a national culture, but in contrast to Coady's open and engaged sense of experience in America, Craven defines relevant experience narrowly.

Perhaps his most radical essay in this regard was "Have Painters Minds?" from 1927. In this essay, Craven accuses the formalists of being deluded and of operating in bad faith.

> Writers on art are the toughest nuts in the literary basket. They seem to be incapable of lucidity and common sense; as a rule they know little of the actual problems of painting, and the best they can do is to deceive a public that knows even less.[85]

Not only do these writers not understand art, Craven tells us, they are purposely duping the public.

What interests these critics, Craven asserts, is the work of art as "'an organization of forms,' an assemblage of geometrical shapes independent of representative values and all basic human attributes which connect the painter, if he is alive, with the rest of mankind."[86] Such art works along with specious theories, Craven asserts, are out of touch

with the realities of human experience. He sums up his invective in the last section of the article.

> The modern painter is an inferior being. He is dumb and dull and conceited, an anti-social coward who dwells in miserable cocklofts, and runs frantically to his dealer bleating like a sheep about his soul, his poverty, and his unappreciated genius. If he is lucky enough to have a little money, he hurries off to Europe . . . to destroy himself in the dives of Paris. Of all the workers in the arts he is the least alive—no man of brains and education could possibly waste his life in performances which are, not only paltry and mechanical, but also totally divorced from current affairs.[87]

This divorce from experience on the part of some modernists is the root of their error and causes their art to be stillborn, according to Craven. He wields the weapon of art criticism with a heavy hand.

Yet, for all his invective and his disdain for formalism and the art world, he is not a conservative in the same category as Royal Cortissoz, his anti-formalist predecessor. Unlike Cortissoz, Craven is not interested in naturalism in itself. Rather, he presents himself as a progressive, modern and discerning critic who cannot be duped by the antics and publicity of the School of Paris.

Craven's nationalistic sensibilities crystallize in "The Curse of French Culture," published in *The Forum* in 1929. In this article, Craven accuses the French of turning modern art into a luxury commodity:

> Philosophy, poetry, and the fine arts are no more important to French culture as an agent of self-aggrandizement than are cookery, cosmetics, and prostitution.[88]

Paris is dismissed as "the paradise of second-raters." French culture and French experience are inferior to American culture and experience in Craven's judgmental view.

It is interesting to note that despite his almost blanket dismissal of the School of Paris he feels compelled to acknowledge Hippolyte Taine as a significant writer, despite the fact that he was French. As has been discussed in an earlier chapter, Taine's concept of "race, milieu and moment" as determining factors in art as an expression of a culture remained an important concept for cultural organicist positions well into the century.

The decade of the 1920s in American art criticism was a time of consolidation, and then destabilization, of the formalist paradigm, which nonetheless remained the dominant mode of discourse throughout the decade. Meanwhile, a new sense of cultural organicism developing out of Coady's experiential populism can be traced in the underground publications of the little magazines. At the same time, John Dewey's evolving aesthetic theory regarding the nature of experience, despite its localism, provided a base for a nationalistic approach to contemporary art. Moreover, its pragmatic sense of the instrumentality of art was interpreted as quintessentially American.

A related instrumentality was imputed to art criticism, seen as a "weapon" for advancing certain artistic directions and damaging others. This instrumental use of criticism was taken up with a vengeance by Thomas Craven, who mixed the ideas of a Tainian cultural organicism with Dewey's concepts of experience to advance his own rather narrow concept of a national culture based on an American background. His views would raise him to a position of considerable influence in the following decade.

# 5

# The Paradigm Comes of Age I:
# The Social Parameters of Experience

DURING THE DECADE OF THE 1930s, THE EXPERIENTIAL PARADIGM dominated critical thought in America and was operative in a number of different forms. The economic collapse and depression threw into high relief the problems of the isolation of the artist and the social function of art. From the grandstanding of Thomas Craven to the militancy of the American Artist's Congress, the critical thinkers of the time were united in their attitude about the importance of environmental and societal obligations on the artist on the one hand, and the impact the artist could have on changing the environment and the society on the other. Because of the breadth of the paradigm during the decade, the material will be divided between this and the following chapter. Formalism from the period, a minority position, will likewise be dealt with subsequently.

In the opening years of the decade, the American Wave, as it was called, hit home. Thomas Craven became the principal spokesman for the new movement and developed further his own controversial and yet popular version of the paradigm. He enjoyed an enormous influence and was held in high regard at the time, an esteem that dropped sharply after the 1930s. Today he is little known or studied except for historiographic purposes. Yet he occupied a position of authority during that decade which rivaled Clement Greenberg's in the 1960s. Craven's mature critical thought—which crystallized during the decade—because it is so unfamiliar to today's readers, will be reconstituted and examined at length in this chapter.

John Dewey continued to develop his thought during the period and remains an important thinker, influential on and yet outside the arena of art criticism itself. We will examine a series of articles by Dewey that appeared at the opening of the decade dealing with the individual and society in relation to culture. He articulates better than most the widespread call for a new type of social contract demanded by the economic

depression and its aftermath. Dewey's most important work of the decade is undoubtedly *Art as Experience*, which appeared in 1934. A brief examination of this book yields insight into contemporaneous critical thought.

---

The experiential paradigm was already gaining widespread critical acceptance during the last years of the 1920s, as has been shown in the previous chapter. The stock market crash of 1929 hastened along its ascendance. As art historian Matthew Baigell puts it:

> A precipative agent, the Crash energized the belief in the high quality of American art, forced Americans to face the issue of European dominance . . . and gave prominence to theories of environmental influences on him [the artist].[1]

Chief among these environmental issues was the role of the artist as an individual and his relationship with and responsibility to the society in which he lived. Anti-elitist sentiments hurled at the formalists for their exclusivity took on a new and more class-conscious dimension in light of the social displacement and massive unemployment of the depression. Again, we find John Dewey at the crux of the problem at an early date, setting the philosophical parameters of ensuing discussions in a number of fields, including art criticism.

A series of articles by Dewey, collectively entitled, "Individualism, Old and New," appeared in the *New Republic* during the first few months of 1930. In these essays, Dewey traces the decline in what he calls "the individualistic philosophy of life," a petite bourgeois remnant of the mid-nineteenth century and in its place, the formation of a new individualism, a corporate or collectivist "scheme of interdependence."[2] Dewey asserts that a new individualism can only come into existence in so far as it can be "brought into harmony with the realities of the corporate age"[3] —a corporate age not necessarily either capitalistic or socialistic in nature.[4]

Cut off from a direct and meaningful relationship with his community, the individual cannot survive except in a space apart.

> The individual cannot remain intellectually in a vacuum. If his ideas and beliefs are not the spontaneous function of a communal life in which he shares, a seeming consensus will be secured as a substitute by artificial and mechanical means.[5]

These "artificial means" could be interpreted in terms of the situation of the artist as the "seeming consensus" of dealers, curators, critics, collectors and other taste makers who people the art world and who Thomas Craven so savagely attacked in his writing of the period.

Dewey's point is simply that in the absence of genuine community, an artificial or pseudo-community is often formed, a rarefied consensus is established which has no organic connection to the society at large, no deep roots in the soil of shared experience. Although not explicitly connected by Dewey to the art world, it was an easy step for Craven and others to cast formalist modernism in light of Dewey as a kind of parasitic pseudo-culture.

For our purposes, the most important in this series of essays by Dewey is certainly "The Crisis in Culture." In this essay he repudiates the standard definition of "Culture" as the cultivated attitudes of an elite and instead defines culture broadly as "the type of emotion and thought that is characteristic of a people and an epoch as a whole, an organic, intellectual and moral quality."[6] It is a cultural organicist conception of society, informed by paradigms in anthropology.

Dewey finds the lack of organic connection between the arts and the society as a whole a sign of a profound cultural dysfunction. Unless we can achieve more than an "age of high personal cultivation," Dewey asserts, our culture will remain American only in a "typographical sense, but not a spiritual one."[7]

> The personal gap which, generally speaking isolates the intellectual worker from the wage earner is symbolic and typical of a deep division of functions. The division is the split between theory and practice in actual operation. The effects of the split are as fatal to culture on the one side as on the other. It signifies that what we call our culture will continue to be, and in increased measure, a survival of inherited European traditions, and that it will not be indigenous.[8]

Dewey clearly calls for an art more integrated into the fabric of society, an art with organic links to its environment, an indigenous art widely appreciated and accepted by the public.

Dewey does not, however, demand a surrender of individuality. On the contrary, an authentic and this time integrated individualism was now possible through "creating a frame for itself by accepting the scene in which it must perforce exist and develop." Thus the artist is not just a passive instrument, merely responding to the social and material environment, but an active, creative and important contributor, who creates

his own frame of reference within the existing scene. He even has the power to influence or change the social and material environment. It was toward this individualist yet social integration into the general cultural scene—a sort of functional populism—that both the right wing and the left wing variations on the environmental paradigm urged the artist throughout the decade.

Unlike Dewey, who spoke in terms of specific localities and interpersonal situations, the argument for an indigenous type or style in the art press was couched largely in terms of national culture: not merely a local scene but an American scene. It was in such terms that the so-called "American Wave" swept the art world during the 1931–32 season. In much of the writing from that important season, echoes of Dewey's themes of the social integration of the artist with a receptive and informed audience abound.

The season was ushered in by the top award, for the first time ever, going to an American artist in the Carnegie Institute's International Exhibit, at the time the county's most important annual of contemporary art. This was followed in November by the opening, amidst much fanfare, of the Whitney Museum of American Art, the first museum with a permanent collection to be devoted primarily to recent and contemporary American art. As *Time* magazine reported it:

> Until last week there was no museum in the land devoted exclusively to U.S. art. There were galleries, there were dealers, there were magazines increasingly eager to preach the American renaissance. But a museum, a repository of the Muses, was lacking.[9]

These achievements at home were matched by plans for important exhibitions of American Art in Paris and Venice the following spring. The autumn of 1931 must have been felt by many as a cultural coming of age for the United States.

The entire November issue of *Creative Arts*, in fact, was devoted to the nascent "American Renaissance." Henry McBride sets the tone for the issue in his introductory article:

> America is having a Renaissance and Americans know it. It is an even bet that the general public is more aware of the fact than the artists themselves; and this state of affairs is all to the good. It is the community that creates an atmosphere and it is the flowering of this general consciousness that constitutes a renaissance.[10]

This renaissance, to McBride, is not so much a matter of artistic flowering but, rather, of more enlightened public receptivity.

With the hoped-for breakdown in barriers between the artist and the public, McBride feels that the exclusivity of the artist may be near an end, "there may no longer be the necessity for the artist to 'protect' himself from the public. The public will have become so enlightened as not to constitute a danger."[11] Nourished by being given an important role in the community, the artist would finally become an integral part of society. This kind of sentiment is new for McBride, who it will be remembered was basically a formalist. (It was the failure of this marriage between artist and the public that prompted another formalist, Clement Greenberg, to sue for divorce in "Avant-Garde and Kitsch," published at the end of the decade.)[12] McBride admits in the article that this rapprochement is more of a hoped-for ideal than a reality at present.

The press continued to publish articles on the new movement throughout the spring of 1932. By April, even *Time* magazine had jumped on the bandwagon:

> This year U.S. painting has at last attained an international vogue. The opening of the Whitney Museum started it. Loan exhibitions of U.S. paintings are touring Europe. The Louvre has bought a Thomas Eakins. Famed French critic Waldemar Georges wrote in surprise six months ago: "Why have we not seen these pictures before . . . Why do their young men swarm to Montparnasse?" For the first time the Venice Biennial Exhibition of Modern Art will have a permanent building for U.S. painting when it opens in June. . . . Canny New York dealers are hastily pushing French modernists aside to make way for the native sons.[13]

Yet where were the American artists who would be the Leonardo, the Michelangelo of this new renaissance? The winner of the Carnegie International was Franklin C. Watkins, hardly a household name to us today. Needless to say, his moderately expressionistic "Suicide in Costume" has not become a classic in the annals of American art. Baigell perhaps sums it up best, "it [the American Wave] represented a fervent wish that America had artistically come of age"—a wish but not a reality.[14]

Perhaps the most articulate exposition of the hopes which embodied that American Wave were stated in "American Art Today" an essay by Holger Cahill in *America as Americans See It*, published in 1932.[15] Cahill frankly admits that whether or not we have an actual renaissance in art, we definitely have a "renaissance of public interest in American art."[16] He points out that this is an important achievement and lays the groundwork for the emergence of an authentic indigenous art, which he feels is sure to come:

Painting and sculpture, like the other arts, need a public. A discriminating and sympathetic public is a necessary element in the full development of a national art. It alone can create an environment in which the artist can function freely and fully.[17]

The artist, on the other hand, effects a reapproachment with the community that "needs him and is learning to understand him."[18]

From its inception, the idea of an American renaissance was as concerned with developing audiences through community education as about principles of a form or even subject matter for the artist. In *The American Renaissance*, published in 1928, Robert L. Duffus charts the course for what he calls an "aesthetic revival" in American culture chiefly in terms of audience development. This revival, though secular, has about it an evangelistic air. It will be accomplished, the author claims, not by artistic geniuses but by college art departments, community art centers, and educational programming at regional museums. Through interaction at a local level between artists, educators and the public, a new more democratic infrastructure will be created for art.

Most of the book is devoted to describing specific educational and exhibition programs currently in place throughout the country and calling for more. In his conclusion, the author (in a prophetic tone that recalls R. J. Coady) states that the renaissance, though not yet among us, is imminent:

> It is young, it is unformed, it is divided by the desire to imitate a gentlemanly civilization that is past and the urge to wrest a more democratic civilization out of the future. . . . Nevertheless, I think that there can be no doubt that America, having expressed herself politically, mechanically and administratively, is on the point of attempting to express herself aesthetically. . . . Our very crudities, our very vulgarities, are lusty. In manner, indeed, the foreign influence is still heavy upon us. But we are beginning to dream of walking alone.[19]

By the autumn of 1931, the dream began to seem like a reality, leading Henry McBride to go so far as to state, rather rhetorically, in the last line of his essay for the special issue of *Creative Arts*, "we have already reached this delectable stage of progress. And with closer contact to what height may not our art reach?"[20]

McBride also admits, almost as an aside, the attempts of critics, dealers and curators to steer the new movement:

". . . within recent months there has been such an emphasis to the feeling that something like a contest has developed among us as to who shall be the first to exploit it, to engineer it and even to profit from it.[21]

The frank self-consciousness of the remark recalls the instrumentality of art criticism as a weapon. And it was Thomas Craven—that most savage of weapon-wielding critics—who ended up winning the contest of which McBride wrote, to become the movement's principal spokesman.

---

From the very beginning, it was Thomas Craven who dominated the critical arena that favored the American Scene movement. Surely the publication of his first book, *Men of Art*, in the spring of 1931 helped set the stage for the ensuing American Wave later that fall.

*Men of Art*, though long (over five hundred pages), was not conceived of as a scholarly text, but rather as a kind of plain talk, no-nonsense book for the average person. Released as the April selection for the Book of the Month Club, it immediately had a wide and diverse readership. The author states in the first paragraph of the introduction his intention of reducing speculative and technical jargon and of writing for a general reader. This focus is at least partly due to the what Craven believes is the social function of art, the whole book being a "tribute to artists" through the ages whose work is "interwoven with the fabric of the social structure."[22]

He also states up front his distaste for much of contemporary art because of this very lack of a meaningful relationship with larger society, and assures us that his will be a fully contextualized history of art, a history that takes into account social relationships and environmental concerns; it will not be just another formalist reading of art history based on visual analysis where one style supplants another. "Plastic relations," the author tells us, "are determined by human relationships."[23] He goes on to what practically amounts to a declaration of war on modernist formalism:

> If art is to be stripped of all human and social values; if it is to be reduced to congestions of cubes and cones the sole meaning of which lies in mechanical ingenuity; if it has no higher function than is claimed for it by certain Modernist sects; then it is not worthy of consideration.[24]

This polemic against formalism and the insistence on an art engaged in its environment are major, recurring themes in the book. The descrip-

tion of historical periods throughout is often punctuated with comparisons to contemporary art.

It is frankly admitted in the last sentence of the introduction, that the whole enterprise is directed to throwing light on contemporary issues, in the manner of the New History (now no longer new), "For, after all, our chief concern is in the art of our own time—whether we like it or not."[25]

It is therefore not so surprising that the first chapter, "The World Before Giotto," opens with a description of contemporary Fascist Italy. By comparing and contrasting modern Italy with Giotto's Italy, Craven points out similarities and differences that illuminate his Tainian view of art. Hippolyte Taine, to reiterate, felt that influences of "race, milieu and moment" determined the art of a given culture. The Italian milieu was essentially the same as it had been in Giotto's time, according to Craven, and the racial characteristics of the Italian people remain the same, "a race of egoists."[26] *Il Duce* is understandable in terms of Machiavelli because of this racial continuity, he asserts, the Italians being a people given to the adulation of petty despots.[27]

Despite these important continuities, modern Italy is not ripe for a renaissance because, according to Craven, its "moment" has passed, and its environment is different due to modern developments. Great art, however, is not the automatic result of environment, the "race, milieu and moment" merely setting the necessary conditions for the possibility of great art. To have a truly great art, for Craven, means the emergence of great men, and this is the reason so much of the book is devoted to biography.[28]

Giotto was the right man in the right place at the right time. To Craven, Giotto's art is differentiated from his predecessors not so much on the basis of formal and stylistic issues, but rather by Giotto's ability to directly express and transmit human experience in a way that was understandable to everyone.[29] Before Giotto, Craven tells us in a none-too-oblique reference to contemporary issues, "art, for want of freshening contacts with nature, withered into a repetition of bloodless abstractions."[30]

He suggests that we are in a similar situation: the soil is ripe for a new renaissance. What is sorely needed, according to Craven, is a man of genius.

Just now what we need more than anything else is an artist of the stature of Giotto, one who is bigger than formulas and studio obsessions, whose vision extends beyond inconsequential details into the main currents of

modern life, who is capable of reorganizing the world on a vast and impressive scale, thus taking painting out of the hands of triflers and establishing it once more on an equality with the other arts.[31]

The air of anxious, almost messianic expectation was contagious and it was echoed throughout 1931 and 1932 throughout the art world, as has been noted. According to many, America was on the brink of a new renaissance, or at least, all the conditions for its arrival were in place. What it lacked was an artist of genius, like Giotto, who could effect a similarly authoritative and understandable transmission of shared experience.

Because he conceives of *Men of Art* as a social history of art, Craven tries to sum up the national character, not only of the Italians, but also the Dutch, the Spanish, the English, and the French (the Germans are excluded because their influence has been "slight"), sometimes devoting an entire chapter to establishing the cultural setting.

This setting is based, to some extent, on what Craven believes to be inherited racial characteristics. Most of these sound today as little more than stereotypes. Accordingly the Dutch are described as cheery and practical; the Spaniards fiery and temperamental; the Anglo-Saxons sober and undemonstrative; the French effeminate and snobbish, and so forth. These glib characterizations, disturbing today, were common in the 1930s and were loosely based on turn-of-the-century anthropological thought, which emphasized race. It is largely these racist elements in Craven's thought which make him so unacceptable during and after the war. Similar racial ideas were at the basis of the "science" of eugenics, and helped form the rationale behind Hitler's contemporaneous call for racial purity. It should be noted that the more recent anthropology of the time, coming out of the thought of Franz Boas and his students, regarded culture as learned rather than based on inherited racial characteristics.[32]

Craven devotes surprisingly little space to description or visual analysis of individual works in *Men of Art*. The illustrations—all black and white, rarely referred to directly, and cropped to fit the page—seem almost to be an afterthought. The bulk of the thick book is devoted to a long series of impressionistic descriptions of historical and national contexts on the one hand and artist's biographies and "experience" on the other.

Most interesting for present purposes is his description of Cézanne, the last artist to whom an entire chapter is devoted. Cézanne is treated sympathetically, as he had been from the beginning for Craven. He is

still acknowledged as an important innovator of form. The new point about Cézanne in *Men of Art* is his relationship to society. Because he was rejected by the art world of his time, Cézanne moved away from Paris and worked out his mature style in isolation. And it is this lack of meaningful dialogue between the artist and the public, rather than any lack of competence or even genius on the part of Cézanne, which makes his work inferior to that of Giotto or Rubens, according to Craven.

Cézanne's brilliant but isolated art was built on too narrow a social basis to support what came after it. Contemporary art is represented as teetering on the brink of collapse because of this weak base and, according to Craven, "The world has paid a heavy penalty for Cézanne's genius."[33] The author's opinions regarding experience and formalism were to be expanded considerably in his next book, *Modern Art: the Men, the Movements, the Meaning*, and so will be dealt with at greater length subsequently.

The last chapter of *Men of Art* is only six pages long, but it is a densely packed prescriptive for contemporary American art. In "Conclusion: Hopes and Fears for America," Craven sums up the principles reiterated throughout the book and applies them to the current situation:

> Home again, after our long journey through European traditions, we enter a new environment for art. We are confronted not only with new physical conditions, but with what is more significant, a new mental attitude toward the world. America possesses no revered or time-honored artculture [*sic*], and our country as a whole, in word and deed, does not seem to regret it. . . . This, translated into terms of aesthetics, means that art for its own sake, or beauty's sake, or for the sake of any abstraction whatever, will not thrive in America.[34]

Paintings "exploited" by the foreign dealers (presumably formalist abstractions) are dismissed as "hot-house products nurtured in pots of imported soil" which will never have any place in American life or thought, according to Craven, because they cannot root and thrive in our soil, our physical and spiritual milieu.[35]

He dares young artists to "throw off the European yoke" and predicts that the future of art, the "significant expression of the new age," will not come from Europe but is destined to emerge either from North America or, provocatively enough, Russia, a country which had not appeared in the text until this point, the penultimate sentence of the entire book.[36]

*Men of Art* received generally favorable reviews in a number of impor-

tant journals. *Art Digest*, as could be expected, was laudatory. So was *Art News*, whose review opens:

> The humanizing of knowledge still goes on, this time through the vibrant personality of Mr. Thomas Craven. Art to him is something more than the plaything of millionaires, . . . it is a commodity of, by, and for the people.[37]

The democratic, populist tone of the book is understood and appreciated well here and the Book of the Month Club is congratulated on its choice.[38] *Parnassus* magazine went so far as to assert that Craven's essays in the recent past "led many readers to suspect that here was one of the strongest critical intelligences working in America."[39] It was likewise reverential to *Men of Art*, whose unflinching representation of contemporary art, according to the reviewer, is written with "a manly moral indignation which serves to make even the most casual reader aware that art is not the product of studio teas."[40]

He continued to publish at key points during the following season. His call for a national culture was echoed during September in a short article by Craven, "Renaissance Near?" Strategic in its timing, it appeared in the September 1931 issue of *Art Digest*, kicking off that important season.[41]

Riding the crest of the American Wave, Craven published his most vicious attack yet on the art world in general and the formalists in particular in "The Snob Spirit," appearing in the February 1932 issue of *Scribners Magazine*.[42] In this article, the rhetorical tone is so heightened that it reads almost like a manifesto:

> Again and again, with all the temper at my command, I have exhorted our painters to remain at home in a familiar background, to enter emotionally into the strong native tendencies of their own land and kind.[43]

This is presumably so because Craven, like a prophet, discerns the new art on the horizon, as he puts it, "like the good politician in search of new issues, I have discovered in the undercurrent of American art the direction of emerging tendencies.[44]

Drawing heavily on James Jackson Turner's frontier thesis, Craven reiterates his sincere belief and hope that American artists are on the frontier of developing a truly American art, a manly art immersed in native experience and appreciated by a broad public. Yet he can not point to this new art because it does not yet exist; it is, rather, an anticipated art, an awaited art.

The elitist attitude, what Craven calls the "parvenu spirit," on the other hand, seeks to reduce the social base of art rather than broaden it. In their hands, Craven asserts, "it [art] has ceased to function as a social need and has become the property of vainglorious dilettantes," many of whom, Craven insinuates, are Jews or homosexuals.[45]

Although he is damning in his criticism of the moderns, he also makes pains not to be mistaken for a conservative by condemning all sterile academicism, "both classic and modern," in both cases, according to Craven, art based on other art instead of on life.[46] Craven does not present himself as a conservative, but as a forward-looking individualist—a virile, regular American guy who is not to be the dupe of fashion and fads in an art world inverted upon itself and dominated by misfits.

"The sole means of escape for the American painter," from this situation of impotence in both the elitist right and the equally elitist left Craven says, quite vaguely, "lies in the discovery of the local essence," but what exactly are local essences? Craven never tells us. He goes on to even vaguer predictions, "after which we hope for a viable native school and eventually for the sublimation of its forms."[47] Form, then, has *something* to do with this anticipated renaissance, the goal being to somehow "sublimate" form. Is he here talking about a psychological process happening on a mass scale? Is the sublimation on the part of the artist or the audience, or both? Or does he simply mean there shall arise a national style? It is all very unclear. Craven's clarity about the "snob spirit" and the precision with which he attacks the formalists contrasts sharply with his vague prescriptives for the future to which he points with such vehemence.

Craven's celebrity was such that he took the show on the road with a lecture tour across the nation in the spring and summer of 1932. According to an article in *Art Digest* entitled, "Craven's Crusade," the critic was described as already having presented to over forty audiences by the end of April. They quote from an article in the *Los Angeles Times*, which describes Craven as an "art evangelist whose self-stated aims are to awaken the American artist to his task of living and interpreting American life and to convince the people of the need of such art."[48]

Craven's magnum opus on contemporary art is certainly *Modern Art: The Men, the Movements, the Meaning* published in 1934.[49] In this sizable book, he incorporates much of his material from earlier publications, usually somewhat toned down (i.e., "the Snob Spirit" becomes a chapter).

In the introduction, Craven states, perhaps more cogently and con-

cisely than anywhere else, his environmental, experiential theory of art, and so I will quote from it at length:

> I have devoted almost half of the book to America. Which is as it should be—for art begins at home. Art is not a philosophical system embracing the whole world; it is the expression of the adventures and discoveries of the human organism reacting to environment, of the perpetual readjustment of habit to the procession of changing facts. Such apprehension of the stream of facts as leaves a mark deep enough to affect the personality occurs within a limited range. The distinguishing, indeed, the inevitable, sign of a great art, is the mark of this limited range—the mark of a specific environment, the impress of a specific civilization.[50]

Since so many of the most important ideas of Craven's writing up to this point are incorporated in this book, and have been examined already, I will deal here only with what is new material in *Modern Art*.

The most obvious difference from earlier work is the extensive use of autobiographical material to describe the environment. The entire first chapter of some sixty pages is an extended description of the author's firsthand impressions of artistic life in Paris when he traveled there as a young poet, living in garrets, drinking, philandering, and adventuring. This swaggering autobiographical material serves both to set the scene and to legitimize the judgments the author later makes in regard to this milieu, which he calls "bohemia."[51]

In such an environment, asserts Craven, art feeds upon itself and loses all its connection to life. This false paradise, only really possible in Paris, the author tells us, is so intellectually inbred that it is actually "an environment destructive to the sensibilities."[52] The chapter on Modigliani reads like a moralistic object lesson on the danger and self-destructive potential of unnatural, bohemian life. Modigliani's drug addiction, womanizing, and romantic posturing are emphasized to the exclusion of any serious or sustained discussion of his painting. Experiences emanating from this small, self-enclosed bohemian world cannot hope to have meaning for the public, Craven tells us, because the public's experiences and environment are so vastly different.

He debunks Picasso and Matisse in separate chapters by first misrepresenting the underlying intentions and theories of Cubism and Fauvism, and then refuting his own misrepresentations. For example, Cubism is referred to as "methodism" in art, an inordinate concern with technical matters of composition and pattern. "The Cubists," he asserts, "denied the value of direct experience, of representation, of all the

meanings of art as they relate to the behavior of man in any specific environment."[53] As a result, they ended up with "geometrical posters."[54]

In a clever turning of the tables, Craven refers to Matisse as essentially an illustrator, a term often used by formalists to denounce American Scene painting.[55] His work should not be framed as art, according to Craven, but "sold by the bolt," as the essentially decorative French yard goods it is.[56] The only contemporary European free from Craven's scathing criticism is George Grosz, to whom is devoted an entire chapter of *Modern Art*. Significantly, Grosz never lived for a great length of time in Paris and so is presumably free from the curse of French culture (those "beauty specialists") and from the inbred art of bohemia.[57] Grosz's participation in the antics of Berlin Dada is likewise downplayed.

When Craven turns to American art, the environment is again described in terms of autobiography and personal anecdote. The chapter, misleadingly entitled, "America: The Background," gives not a background of American art or culture or history but instead chronicles the author's personal background: born in the Midwest, living in various locales including San Francisco and New York City, trying his hand at poetry, working a number of odd jobs and so forth. As was the case in his description of bohemian Paris, it is Craven's experience that qualifies him as an authoritative spokesman on American art.

But here we again run into the hobgoblin of Craven's theory: experience. Experience is used as a concept in so many multifarious and sometimes contradictory ways in Craven's writing that it becomes a hopelessly vague term. Instead of being given a precise meaning—as it is given by John Dewey that same year in *Art as Experience*—experience for Craven is a catchall term used in different ways at different times. It thereby can serve any number of functions within an argument: it sometimes has a general meaning for Craven as it does for William James in his experiential stream of consciousness; the author sometimes gives it the more specific meaning of an actual happening; it is said to form habits and patterns through repetition, ideas stemming from contemporaneous behaviorist psychology; it can be used as grounds for authority—certain "experience" qualifying the author to speak with direct knowledge of the situation, etc. No wonder, then, when Craven exhorts artists to create forms equivalent to their experience, it seems so vague—the author has used the term so elastically, that it has little remaining cohesiveness of meaning.

Yet on the other hand, according to Craven, if the artist's experience is not universal enough, it may be lost in subjectivity.

Unless the artist finds in experience the stimulus to a new alignment of his materials and to new functions for his instruments, his discoveries remain purely personal. Thus it happens that the average painter is an amateur or an academic hack. He may attribute deep meanings to his aimless repetitions, but the true nature of his work cannot be disguised.[58]

Again, the artist's salvation is in an "experience" so vague and yet so exclusive—causing "new alignments" in some artists, but not in all, or even most.[59] Narrow is the road to salvation, wide the gate to perdition.

In a particularly disturbing reference, Alfred Stieglitz is dismissed as "a Hoboken Jew without knowledge of or interest in the historical American background."[60] None of the artists he represented are "noticeably American," despite the clever change of the name of Steiglitz's gallery to "An American Place."[61] The insinuation that Jews and foreigners run the cabal is furthered by the placing of various names, this time including Jewish artists and artists such as Kuniyoshi and Stella, on a list of what he ironically called the "fine old American families," that dominate Steiglitz's circle.

Finally, Thomas Hart Benton is put forth as the quintessential contemporary American artist—the only one to have a full chapter devoted to him. His link to "experience" is emphasized in the biographical nature of the chapter. He was born in Missouri and, like the author, became a bohemian dandy in Paris, where they met. He later shucked his bohemian dandyism to become a rugged American artist:

> Benton, mural painter, draughtsman, anthropologist, and interpreter of American civilization, falls into none of the neat categories of modern art. To the conservatives, he is a Red; to the radicals, he is a chauvinist. . . . For Benton is an American. He has the rawhide individualism, the cynical laugh, the rough humor, the talent for buffoonery, and something of the typical Westerner's sentimental slant on Life. And he has, to the full, the American's distrust of ideas divorced from facts.[62]

Ultimately, Benton is seen as an artist sensitive to national character who is working mainly in mural, a public medium, in an understandable style.

Like *Men of Art*, *Modern Art* opened to generally favorable reviews in many periodicals. *Art Digest* went so far as to call it an "epochal book."[63] But *Art News* was more guarded in its appraisal, noting that Mr. Craven had prejudices which marred the descriptions.[64] The *American Magazine of Art* was the only major journal to publish a bad review of the book. The reviewer stated that never had a "more superficial, more dogmatic

or more misleading book on modern art ever been published."[65] He
pointed out the inappropriateness of the title, *Modern Art: The Men, the
Movements, the Meaning*, and suggested the following as a more accurate
description of the contents: "Modern Art, a few curiously assorted per-
sonalities largely misrepresented; a few movements superficially
grasped with key movements misunderstood or omitted; and the mean-
ing completely garbled by one man's astigmatic vision."[66]

Although Craven continued to write and publish after *Modern Art*, the
book remains his main critical achievement and contains all his mature
ideas in their most developed form. It may have been partly a result of
his continued adherence to the model put forth therein, that he slowly
bowed out of the critical arena by the end of the decade.

It would have been interesting to see Craven's reactions to the crisis
in American art during the late 1940s and through the McCarthyist
hysteria of the early 1950s, when modern art was to come under such
vehement attack. Although opponents of modern art from that later
time—like Michigan Congressman John Dondero—were to use Cra-
ven's strategies in their attacks, Craven himself remained silent. He
continued to publish from time to time through the 1940s and 1950s
occasionally writing articles for *Good Housekeeping* on how to appreciate
art or how to make art creative for children. He wrote texts for quick-
reference paperback books on art in the Dell Pocket Book series and
provided rather bland copy for *The Rainbow Book of Art*, a "coffee table"
picture book.[67]

One of Craven's last serious writings is the introduction to a mono-
graph on the Italian sculptor Benvenuto Cellini, published in 1937.[68]
Craven's interest in this late Renaissance master is particularly under-
standable because of the lusty autobiography left to us by the sculptor.
It provides just exactly the background of experience and anecdote that
allows Craven to situate the artist within his environment. But Craven's
turn away from contemporary art may have been partly the dawning
realization that the anticipated renaissance had failed to materialize as
he had hoped. Cellini, on the other hand, afforded him an artist in the
context of a real renaissance.

And so, ironically, Thomas Jewell Craven's ultimate fate parallels
that of Willard Huntington Wright. Having made impassioned pre-
dictions for the future direction of art and then, witnessing those predic-
tions go unfulfilled, they left the critical arena.

Both had succumbed to a type of determinism: for Wright a formal-
ist, historical determinism; for Craven a determinism of experience,
race, and environment. For although he started out as a formalist enliv-

ened by a sense of the vitality of actual experience, informed by both Dewey's aesthetic concepts and his ideas about democracy and society, Craven hardened into a rigid dogmatist in his mature critical writings. His experiential model was not flexible enough to accommodate most of the important American art produced after 1940.

***

John Dewey's concept of experience and its relationship to both the creation and the reception of art is in vivid contrast to that of Thomas Craven, even though the latter was influenced by the former. In Dewey's *Art as Experience*, published in 1934, a definition of experience is put forth which is at once more precise than that found in Craven, and at the same time has greater latitude.[69]

In *Art as Experience*, Dewey expands on the ideas he put forth in germinal form in *Experience and Nature*, discussed in the previous chapter.[70] His concepts of the nature of experience are here more fully developed.

As in his earlier treatments of the subject, aesthetic experience is not conceived of as something set apart but rather as a particularly heightened type of normal experience. Experience is conceived of, by Dewey, as a continuous phenomenon for all living, "environing" organisms (those which interact with their environment). Yet, even though it is a continuous activity, the quality and intensity of experience varies greatly. In much of our ordinary experience, according to Dewey, we are not concerned with making connections to what went before and what comes after, things just happen—we drift. There is no closure and little apparent meaning.

The kind of experience that he alternately calls culminatory or consummatory or integrative experience is that experience which somehow stands out from the general stream. Although integrated into the total fabric of continuous experience this standout experience seems to have a beginning; it develops over time toward a climax and reaches an end which is marked by a sense of completion or fulfillment. This sequence of what are perceived as significant events moving toward closure is what Dewey somewhat clumsily calls "an experience"—circumscribing the active, verb, sense of "experiencing" with the noun sense of fixed, reciprocal actions over a definable period of time. On a phenomenal level, what differentiates *an* experience from the general stream of experience is the directly felt sense that it is fraught with intrinsic meaning for the observer (or more accurately, for the environing participant). This type of experience, according to Dewey, is by its very nature aesthetic. It encompasses, but is not limited to, actual works of art.

Experience of all types, for Dewey, falls into alternating patterns of action and receptivity—or, as he describes it, rhythms between doing and undergoing—in the reciprocal influence and counter influence of the organism engaged with its environment. This alternation between doing and undergoing in the production of art is the process of transformation of raw materials into works of art by the artist. If it is to be an art that is instrumental, which leads to *an* experience, then the mutual influences, the experiential give and take of artist, materials and environment, lead toward an experience of consummation and closure.

Likewise, a sense of both undergoing and doing are active in aesthetic reception of a work of art. Reception for Dewey is not merely passive, but involves a series of grapplings with the work of art, in which the alternation between doing and undergoing experienced by the artist is reconstituted and recapitulated in the observer. For the "expressive object" (as he calls it), to have significant meaning for the observer, for it to be the occasion of consummatory experience, the viewer must participate in the process, a process differing from, but mirroring that of, the creator. In Dewey's words, "To perceive, a beholder must *create* his own experience."[71]

What is more, every observer interacts with the expressive object in a different way and in this sense there is not a single meaning, but rather a multiplicity of possible meanings. Indeed, a plethora of meanings and aesthetic experiences characterize the great work of art, whose layers of meaning seems inexhaustible and to which a person can return time and again, each time bringing something new to the interaction, each time experiencing something different.

In fact, past exposure and previous experience can make the observer more seasoned, more practiced in perception. In this sense, past experience in other situations can sensitize a person for current experience, giving his experience more breadth or range—deepening it.

> For then its varied parts are linked to one another, and do not merely succeed one another. And the parts through their experienced linkage move toward a consummation and close, not merely to cessation in time. This consummation, moreover, does not wait in consciousness for the whole undertaking to be finished. It is anticipated throughout and is recurrently savored with special intensity.[72]

The anticipation involved in the process adds to the experienced tone of suspense, heightening the deliciousness of the promised release.

In at least this sense, then, what Craven defines somewhat more nar-

rowly as experience, does indeed contribute to the shaping of both our creation and reception of art in Dewey's scheme. As "environing organisms" we are shaped by our interactions with our material and social environment, Dewey says. It would stand to reason, then, that environing in Paris, or environing back home, would produce a different stream of experience, a different personal history that would ultimately have its effect on artistic expression as Craven suggests. But it is not so easy to characterize the effects of nationality on expression as Craven claims to do by indicating that the artist is a Jew or an Italian or a Parisian bohemian.

But while admitting the effects of environment and personal history, and acknowledging that every culture has its own "collective individuality," Dewey explicitly rejects Tainian determinism based on "race, milieu and moment" as too superficial.[73] Lost, in this view, is what Dewey regards as the important role of the individual as a free agent producing in the complex context of community. The Tainian hypothesis also attributes characteristics to race, which according to Dewey are specious — man being what he is, "not by native constitution, but by the culture in which he participates" — i.e., culture is learned, not inherited.

Yet Dewey shares with Craven his rejection of formalism, which he calls the "compartmental conception of art," because it is cut off from common experience. According to Dewey, this separation and exclusivity is a kind of "holier-than-thou attitude," which uses segregation of aesthetic objects from common experience as part of a strategy to establish superior culture for an elite.[74] As a result, the average person utilizes popular entertainments such as the movies, the comic strip, and jazz music to seek for satisfying experience with an aesthetic quality.

> When, by their remoteness, the objects acknowledged by the cultivated to be works of fine art seem anemic to the mass of people, esthetic hunger is likely to seek the cheap and vulgar.[75]

Apparently for Dewey, these popular entertainments fall short of what we should be able to expect as members of an integrated, interdependent, democratic community. The dilemma of the split between high and low culture, according to Dewey, is symptomatic of the deep schisms that rend our society. These problems are too complex to yield to the kinds of simple, wrongheaded solutions Craven advances: the weeding out from our native soil the foreign, homosexual, and Jewish influences in the art market; the virile depiction of common scenes and experience by native artists (i.e., Anglo-Saxon, male); the publishing of

popular and affordable editions of art books worded in easily graspable language, et cetera.

Dewey devotes an entire chapter in *Art as Experience* to the function and the problems of art criticism. Dewey goes directly to the functional problem in contemporaneous criticism: how it operates in society. He strips naked the hidden promotional agendas of criticism as a weapon at the beginning of the chapter:

> Diverse tendencies among the arts have given rise to opposed theories that are developed and asserted for the sake of justifying one movement and condemning another.[76]

It is precisely the history of these critical struggles that is being traced in the present study. He goes on:

> Criticism is thought of as if its business were not explication of the content of an object as to substance and form, but a process of acquittal or condemnation on the basis of merits and demerits.[77]

These forms of intrigue in the art world are entirely outside the realm of criticism's real function, Dewey asserts.

The role of the critic, according to Dewey, is not to establish an authority to judge works of art as good or bad according to some outside standard, much less to steer trends in the art world. The critic, rather, provides a guide, a road map so to speak, to the viewer's experience of the expressive object. As Dewey puts it, "It is a survey." And like a surveyor, the good critic describes the terrain and provides a way of seeing it, of getting into it; he shows the viewer how to use the object as the site or the occasion of *an* experience. If he can facilitate this kind of access to the work of art, then "his surveys may be of assistance in the direct experience of others, as a survey of a country is of help to the one who travels through it."[78]

Although the critic's main function is as a guide to appreciation, he or she also judges the success or failure of the expressive object. These however are not absolute judgments rendering the object good or bad, but are pointed out as rough spots in the terrain, if the surveyor metaphor may be extended. The critic judges the work based only on the criterion of his own experience of it as an expressive object, which either leads him to a consummatory aesthetic experience or a somehow unsatisfying one.

In no way, however, is the critic's judgment final or binding; it is sim-

ply the documentation of one person's experience. Other viewers may disagree, seeing alternate avenues through the terrain that can lead, for them, to a consummatory experience. The critical response to an expressive object, then, "issues as a social document and can be checked by others to whom the same objective material is available."[79] Dogmatic dicta about worth, on the other hand, "operate to limit personal experience."[80]

If we apply this to the most dogmatic critic of the decade, Thomas Craven (whom Dewey had most certainly heard of), it is seen that, ironically, Craven's call for an art of experience (based in large part on Dewey) actually undermines and inhibits the ability of expressive objects to actuate the only kind of experience that is meaningful in regard to art for Dewey.

Dewey's fluid view of the *process* of art, on the other hand, provided a means—within the paradigm—of explaining American Scene painting while avoiding a critical dead end when the style passed. It was, in fact, elastic enough to act as a vehicle for the interpretation of that later, process-oriented art, Abstract Expressionism.

# 6

## The Paradigm Comes of Age II:
## The Political Parameters of Experience

THOMAS CRAVEN WAS CERTAINLY THE MOST OUTSPOKEN OF THE AD-
vocates of the new art that was ushered in by the American Wave.
Other influential critics of the 1930s, while still within the paradigm,
were generally less dogmatic. Edwin Alden Jewell, principal art critic
for the *New York Times*, and Peyton Boswell Jr., editor of *Art Digest*,
were major taste makers of the time and each developed a more moder-
ate defense of indigenous art, both of whom will be briefly explored.
Each called for an art that would reflect the environment.

Many artists of the period, however, were not content to merely re-
flect their environment, but wanted to use art to take active measures
to change the environment. These activist artists formed the other
branch of the experiential paradigm during the decade. The various
federal relief projects created during the period gave artists further
hope that, if organized, they could have an important impact on the cul-
ture as a whole. They wanted to use the persuasive means of art to fur-
ther their social and political goals. These social agendas were
invariably on the left end of the political spectrum.

The most articulate spokesperson for this position was Dr. Meyer
Schapiro, an art historian and professor at Columbia University. The
shifts in his position from Communist at mid-decade, to Trotskyist in
the last years of the decade parallel the drift of many radicals during
those years who were disillusioned by events transpiring in the Soviet
Union.

---

Edwin Alden Jewell was art critic for the *New York Times* throughout
the 1930s. He occasionally wrote for the magazine *Parnassus* and during
these years published two books, one at the beginning and one at the
end of the decade. As is indicated by their titles—*Americans*, appearing

in 1930, and *Have We an American Art?*, 1939—both books wrestled with the problems of defining an authentic national art.

Even more than Craven, Jewell was convinced of the importance of the environment on artistic expression. He acknowledged Dewey as the source of these ideas, quoting from the articles that appeared earlier that year in *The New Republic*, discussed in the previous chapter:

> (quoting Dewey) "Individuality will again become integral and vital when it creates a frame for itself by accepting the scene in which it must perforce exist and develop." Of course we want our artists to be universal. Yet as I have tried to indicate, this does not involve renunciation of the kindly fetters of "place" and "soil."[1]

In fact, for Jewell, the environment is such an important influence on art that it transcends matters of race and even changes what appear to be inherited characteristics.

Jewell reports a case, by "first hand witnesses," as he states, that a child born to white missionaries in China and raised on various Chinese foods developed, over time, eyelids resembling those of the Chinese.[2] He attributes this, half in jest, to the food the child ate, but this was merely a metaphor, Jewell asserts, for the all-pervasive influence of culture and environment on an individual. On the basis of this curious kind of approach to nationalism, Kuniyoshi, Pascin, Stella and Weber are admitted to the ranks of authentic American art because of their long residence in the country and despite the fact that they are immigrants.[3] Like the missionary's child, they have "taken root," in the "soil" and become part of the "race," a term which has a strange ambiguity in Jewell.[4] He argues at length on behalf of their authenticity and compares these artists to the case of the sixteenth century painter, El Greco, an essentially Spanish artist born, however, in Crete of Greek parents.[5] This conception of culture as essentially learned rather than based on inherited characteristics is echoed in anthropology of the time as has been mentioned.[6]

Jewell writes enthusiastically and hopefully throughout the season of the American Wave of 1931–32. In the lead article for *Parnassus* magazine in April of that season, he sums up the "coming of age" of American art in triumphal terms. Jewell makes it clear that the art proceeding out of this renaissance is to be an engaged art. Using the language of Dewey, he asserts an experiential conception of art:

> Our art is not an isolated phenomenon, detached from the great stream of life. For it, we are all in one way or another responsible. Art is always—at

least if viewed collectively, as a community or race expression — product of some deeply felt, if often obscurely expressed, social need.[7]

The continued references to "race" in the writing of Jewell, must be understood in light of the comparatively enlightened position he held in regard to this term.

At the end of the decade, Jewell, like Craven, seems disillusioned with the movement, yet continues to defend it. In *Have We an American Art?*, Jewell responds defensively to the overwhelmingly negative reviews by French critics to several important American exhibitions taking place in Europe in the spring of 1939. In this somewhat rambling book of opinion on a number of subjects, Jewell asserted the existence of an authentic national art with a vehemence that betrays a certain level of doubt.

> The appearance of a truly American archetype as exemplified in all the arts — painting, sculpture, architecture, music, drama, the dance, literature — can no longer, I think, be missed except by those who refuse to see the writing on the wall or misread the message there conveyed. The dawn is at hand.[8]

The doubt is betrayed by the continuing use of the metaphor of a dawn being "at hand." Even in 1939, the renaissance is still held out as a promise for the future, despite, one infers, the continued failure of its appearance in the present.

Jewell goes on to extol honesty and authenticity in American art and urges artists to stay away from extremism, both right and left.

> Let it be always a genuine art that we laud and encourage: an art so real, so good, so original and unhampered by the devitalizing fumes of academicism (right wing or left wing, as the case may by), an art so fed by the sources of our own experience, and of our unique life as a people, that it requires no noisy fanfare and need fear no honorable tests that may challenge it along the highway or at the tribunal of an enlightened world.[9]

The right-wing academics he describes are no doubt the classicists, in 1939 no longer really an important force in American art. It is unclear whether what Jewell refers to as the "left wing" are the formalists, as it may at first appear, or what is more likely, the politically engaged artists who form the other wing of the experiential paradigm during the decade and which we shall discuss at some length subsequently. In language not dissimilar from contemporaneous political slogans, artists

(and collectors) are urged to steer a middle road avoiding extremes, "Neither Fascism nor Communism," seemingly becoming, for Jewell, neither academicism nor propaganda.

But before turning to these left-wing artists, I want to briefly describe the role of Peyton Boswell Jr. in regard to the entire enterprise of the American Scene movement. The magazine he published, *Art Digest*, was founded by his father, Peyton Boswell Sr., with the idea of providing readers with synopses of critical writings from a number of sources. Its position was ostensibly a neutral one in regard to contemporary trends and it claimed to offer criticism from a variety of different viewpoints. In reality, it was the principal vehicle for the promotion of the American Scene movement. It had the largest circulation of all the art periodicals of the 1930s.[10]

In 1940, Peyton Boswell Jr. published a folio-sized, impressive-looking survey of American art, *Modern American Painting*. It presented the American Scene movement as the forefront of contemporary art, while acknowledging "propaganda art" as a legitimate minority position on the current scene. It proved to have been an inaccurate guide to the future direction of American art in the 1940s (which it tried to do), but was an excellent summing up of the critical positions of this whole branch of American art criticism for the 1930s, and that is why a discussion of it is presented in this chapter. As would be expected, *Modern American Painting* presented the American Scene Movement as the most important development in twentieth century art, comparing it in significance with nothing less than the Italian Renaissance.[11]

Boswell ridicules contemporary artists who had been influenced by what he sees as the spiritually bankrupt and essentially decorative School of Paris and asserts that "today our exhibitions contain fewer little Picassos, fewer little Matisses."[12] In Boswell's schema of historical development, the effects of modernist formalism were seen as a passing fad:

> The vogue for ultramodern art has long since passed into the discard, with only the clever publicity machines of Paris standing between it and oblivion.[13]

The word, "ultramodern" came into wide use during the period as a pejorative term used to refer to abstract art of a formalist bent.

The American Scene movement, for Boswell, was not only the most significant art of the present but was also the undeniable wave of the

future. It was indomitable and amounted, in Boswell's words, to an "irresistible force—with no immovable object in sight."[14]

———————

Economic conditions during the early 1930s turned artists increasingly to a consideration of their place in the social order. To many, artists seemed to lack that most important and pragmatic of American qualities, usefulness. At the same time, as has been shown, there was an active, almost obsessive quest for an authentic American art that would be readily understandable to an average audience. The stage was set for a rapprochement between the artist and the people. Little wonder, then, that many artists would turn to the radical political agenda being put forth by the organized left as the means to that rapprochement. As art historian David Shapiro puts it, "American art was searching for a style at the same time Social Realism was urging its claims."[15]

John Reed Clubs had been organized throughout the country by the Communist Party U.S.A. (CPUSA) since 1929.[16] They published journals (i.e., *Partisan Review* was originally the literary magazine of the Club), organized local exhibitions, and held art classes and lectures. They also established the American Artist's School in New York City.

Part of the appeal of the John Reed Clubs lay in their empowerment of the artists precisely at a time when the artists felt particularly powerless. The platform of the club emphasized the important role artists were to play with reference to all society, with artists taking a central rather than a peripheral part in changing it.[17]

Anita Brenner, writing a review of their 1933 annual exhibition, "The Social Viewpoint in Art," finds it to be as important as the historic Armory Show, held some twenty years previously.[18] Included in the current exhibit was the work of, in Ms. Brenner's words, "the most well-known living American artists," some of them members, many of them guests, of the John Reed Club.

Brenner points out the continuities between the experimental modernism of the first quarter of the century and the current directions indicated by the exhibit. She implies that Social Realism may become the new American modern, a legitimate heir of the pioneering modernism of the prewar years. Both were rebellions against academicisms: the first against late nineteenth-century traditional academicism, the second against the new modern academicism advocated by Clive Bell and the formalists.[19] Both also share, she says, a taste for "contemporary actualities," a taste which in the case of earlier modernism, had hardened into exclusivity and dogmatism only later during the 1920s. She points out

a parallel rebellion in contemporaneous European Surrealism (also, she asserts, struggling with a doctrinaire, formalist modernism) which she notes is also resolutely communist.[20]

In autumn of 1935, the John Reed Clubs in the United States, though still popular among artists, were disbanded and the American Artist's School was closed. This was largely an accommodation to the new policy towards the arts put forward at the Seventh World Congress of the Communist International held earlier that year in Moscow. The new strategy for dealing with the rising threat of Fascism was called the Popular Front. Briefly stated, the Front called for collaboration of communists with bourgeois liberals and socialists in defense of peace and democracy and against war and fascism. The American Artists' Congress, rising in 1935 from the ashes of the John Reed Clubs, like the legendary Phoenix, was the quintessential Popular Front organization. Because one did not have to be a communist in order to be a member of the Artists' Congress, the broader-based organization attracted many more artists than its more doctrinaire predecessor and provides us with some of the most important documents of this branch of the paradigm.

But before discussing the Congress, it is important to understand the pivotal role played by the various government projects set up during the decade to provide work relief for artists. The projects provided the backdrop before which the drama of the Artists' Congress, the Artists' Unions, and the radicalization of the artists unfolded. It was here, more than anywhere else, that artists became "proletarianized."

It now seemed to many artists that the bohemian self-expression and individuality which was cultivated by the pre-Depression moderns only led to their own alienation and marginalization. What is more, the nature of the limited market for contemporary American art made survival among artists highly competitive even during the boom years of the late 1920s and led to their further isolation from one another.

In contrast, working for the Federal projects meant, besides a regular weekly check—sharing work space or being assigned space in close proximity with other artists; working together on projects as artists sometimes did; and having a common employer—conditions which laid the ground for a new sense of identity among artists and for their collective, organized action. With the formation of the Artists' Union, a direct result of the government projects, the marriage of the bohemian and the radical was consummated and it must have felt like a new, politicized avant-garde, which transcended 1920's modernism, had been forged.

In 1933, the Section of Painting and Sculpture in the Treasury De-

partment was inaugurated for the decoration of Public Buildings and in 1935 the Federal Arts Project (FAP) was instituted as a large-scale relief project for artists. Holger Cahill, already noted for his interest in the public awareness of the American renaissance, was named national Director of the FAP.[21]

At its height, the FAP employed over five thousand persons as artists, designers, teachers and administrators in its nationwide network. Driving the project from the start was the populist idea that art should be for everyone, not just the affluent. In urban school systems and settlement houses, professional artists were sent to teach. In addition, the FAP established over one hundred Community Art Centers throughout the country staffed by artists, which offered art classes and lectures and housed galleries which showed traveling exhibitions of Project art.

In 1936, after a year of successful nationwide programs, the FAP organized an exhibition at the Museum of Modern Art, summing up its first year of accomplishments. Cahill notes in the introduction to the catalogue, that among the gains brought about by the project, the most important has been the end of isolation for the artist and his reapproachment with a wide public.[22] This democratization of art was an important justification for what many in the United States Congress may have felt was a frivolous activity for the taxpayer to underwrite. The resemblance between the new community art centers and the old John Reed Clubs also made some suspicious that the whole enterprise was somehow a devious communist plot.

This impression was certainly heightened by the organization of the Artists' Union in 1934, a militant artists' advocacy group modeled on trade union organization and dominated by Marxists and other left-wing radicals.[23] Although it fought for artists' rights in general, it specifically represented those employed on the government projects. The formation in 1936 of the American Artists' Congress, organized by members of the Communist Party, added to the apprehension. Although it was not directly associated with the Government projects, the American Artists' Congress furthered fear and suspicion of artists and artists' groups within the United States Congress.

Partly in response to such challenges, Cahill arranged for an elaborate report to be published on the FAP during 1937. Included in the report was to be testimony of artists and the people whom their work touched. To be entitled *Art for the Millions*, the report was destined never to be published by the government and was only published much later in the 1970s.[24] It contains what is perhaps the most articulate defense for the continuation of the projects, and states its underlying theory.

The foreword by Cahill stresses the importance of the relationships between artists and the communities they serve. He advocates the expansion of the project on the basis of a democratic social contract between artist and the public, managed and financed by the federal government. His aspirations for the project, he states unambiguously, are derived from the writings of John Dewey.

> If art is defined, as John Dewey defines it, as a mode of interaction between man and the environment, then we may say that our art resources will fall into three categories: the resources in man himself, the resources in the environment, and the resources which come about through the methods and techniques developed in the particular type of interaction between man and his environment.[25]

The rest of the foreword is an explanation of how the FAP addresses and taps each of these resources, followed by reports from artists, teachers, and those affected by the projects. In fact, the entire manuscript of *Art for the Millions* has as its foundation a Deweyan understanding of experience and sense of community.

Against this background of economic depression, government support and left-wing organizing, the American Artists' Congress was founded.[26] With the disbanding of the John Reed Clubs the following autumn, The American Artists' Congress filled a lacuna and attracted many former members of the now defunct clubs.

In the John Reed Clubs, membership had been open to anyone sympathetic to their revolutionary goals, whereas in the Congress, candidacy for membership was decided by election from within and favored those artists who had established reputations.[27] Despite these restrictions, membership in the Congress grew rapidly. By November 1935, the organization had grown from twenty to 114 members. By the first meeting of the Congress the following February, the numbers had climbed to over four hundred. At its peak in 1939, membership approached one thousand.[28] However, after 1939 the Congress suffered from internal struggles leading to defections from which the organization never recovered.

Meyer Schapiro, one of the most articulate members of the American Artists' Congress and a professor of art history at Columbia University, formulated the clearest Marxist interpretation of the experiential position during the decade. In three key articles from the period, Schapiro put forth his social, class-based explanation of recent and contemporary art; he effectively refuted Craven's nationalist version of the paradigm; and he clarified his position in regard to formalist theory.

His developing thought in the last years of the decade and his eventual defection from the American Artists' Congress in 1939 reflects and embodies the transformation of many Marxist intellectuals from communist supporters of the Soviet Union to Trotskyists, to independent leftists and liberals by the time of the United States entry into World War II.

Among the papers read at the first convocation of the American Artists' Congress in 1936, was Schapiro's "The Social Bases of Art."[29] It articulates the class-conscious, Marxist variation on the experiential paradigm better than any other document from the period. It also embodies the mood of exuberance and the tone of confidence that characterized the papers of that heady first convocation.

Schapiro states in the first paragraph, the inextricable link between works of art and the social conditions that give rise to them. These environmental conditions of "time and place" are operative in the production of art even when the artists themselves are not conscious of it, Schapiro asserts.

The apparent isolation of the modern artist from the public (a concern voiced by so many during the decade) is not a function of irreconcilable differences, Shapiro claims, but rather of specific social and historical conditions peculiar to our time. By an analysis of these conditions and social relations, artists can understand their true place in modern society and are thereby empowered to take steps to change them in terms which are capable of impacting what Schapiro calls their "immediate common world."[30]

According to Schapiro, the social aspects of contemporary art have been obscured by the insistently independent and subjective nature of avant-garde art on the one hand, and the preoccupation of so many modern artists with formal problems on the other. Schapiro points out how both of these are temporary situations related to the economic conditions of late capitalism and specifically to the system of bourgeois patronage.

The typical consumer of art in our society is a member of what Schapiro calls the "leisure class."[31] Separated from the process of production and work by their wealth, these individuals are primarily consumers, a preoccupation that the most sensitive of them develop to the point of connoisseurship. Their cultivation of experience, however, is always on the plane of the passive spectator and as spectators they savor experiences as "aesthetically refined, individual pursuits."[32] Con-

temporary artists, whether they are aware of it or not, and regardless of their own class background, are predisposed to similar imaginatively related, individual concerns.

This is particularly true, Schapiro says, in formalist art where content and subject tend to relatively unimportant compared to the free manipulation of forms within a limited field. This field tends to be vertical in contemporary art as opposed to the older horizontal depiction of space in depth, Schapiro claims, because it corresponds to an intimate individual encounter with a surface of "random manipulations" rather than horizontal depth, which Schapiro refers to as "the plane of our active traversal of the world," thereby reflecting the individualist concerns of the bourgeois patron and his retreat from active engagement with production and with "the public." In fact, the artist and his patron share a distaste for the public on the basis of their shared alienation from the mainstream culture of production and work.[33]

> The conception of art as purely aesthetic and individual can exist only where culture has been detached from practical and collective interests and is supported by individuals alone.[34]

The concerns of formalists, far from constituting necessary and immutable conditions for art, merely reflect contemporary modes of consumption.

According to Schapiro, instead of recognizing the class basis of their formalist approach, these critics and artists imagine that they have discovered the eternal principals of art, and apply their biases not only to the interpretation of contemporary art, but also to art of the past. It is pointed out that Giotto, on this basis, is appreciated for his formal designs alone—his subject matter being seen as arbitrary and imposed. But this, Schapiro asserts, is a uniquely contemporary reading of Giotto that misses the important point that "the qualities of his forms were closely bound up with the kind of objects he painted, with his experience of life, and the means at his disposal."[35] Giotto's subject matter, although dictated by the church, nonetheless reflects and embodies commonly held beliefs of the society at that time. The subject matter is not arbitrary in Giotto, Schapiro asserts.

In the same manner, the subjects favored by contemporary artists are not arbitrary, but reflect the secular and private nature of our bourgeois society of leisure: playing cards, musical instruments, a pipe, "all objects of manipulation, referring to an exclusive, private world, in which the individual is immobile, but free to enjoy his own moods and self stimula-

tion."[36] Contemporary art merely reflects the interests and preoccupations of the class that supports it.

With the transfer of this economic base from the "leisure class" to another sector of society, the artist would presumably be predisposed to other subjects and forms. Schapiro also seems to assume that a change in the economic base will end the artist's isolation and bring him into a more direct and useful relationship with society.

Although it is imagined by some that the formalistic creations of many contemporary artists are "purer," or more completely, works of art than earlier kinds of art, this is an illusion, according to Schapiro. It means, merely, that "the personal and aesthetic contexts of secular life now condition the formal character of art, just as religious beliefs and practices conditioned the formal character of religious art" of Giotto's time.[37]

Schapiro and Craven would then seem to agree on at least this fundamental point: both the art of Giotto and the art of our own time are the result of specific environmental influences acting upon the artist, conditioning his experience, and thereby affecting his art. The major difference between the two is in their conception of precisely which aspects of the social environment form the context of relevant experience: for Schapiro, it is a matter of economic support and the preoccupations of class; for Craven it is a matter of individual experience and racial predisposition.

Schapiro addresses the racial problem directly in an article published in the Artist' Union journal, *Art Front*, entitled "Race, Nationality and Art."[38] In this article, he attacks the very concept of the national character, supposedly evident in art, to be an illusion, arguing for the social, class basis of the form that art takes in any given culture. As evidence for his view, Schapiro points out the similarities of French and German peasant art, much closer to each other than the aristocratic art of either country, which resemble each other on the basis of their aristocratic patronage more than either resembles the art of the peasant classes within their respective nations.

He also gives the Jewish people as an example, a "race" whose art is so inextricably bound up with the nation in which they live, that Venetian Jewish art can be more readily distinguished from Rhenish Jewish art by its stylistic similarity to the mainstream art of Venice and the Rhine, which they closely resemble, rather than to each other.[39] The art of these peoples varies greatly with locale, providing further support for the importance of environment over genetic predisposition.

Schapiro, therefore, finds disconcerting and offensive the idea of a

national American art based on Anglo-Saxon heredity as promulgated by Thomas Craven. He characterizes Craven's attack on Stieglitz as a "Hoboken Jew," incapable of understanding American culture, as "chauvinistic and cheap."[40] "By a similar logic," Schapiro retorts, "Mr. Craven, coming from a region which has contributed so little to the world's painting and criticism, should not be taken seriously as a writer on European art."[41]

In conclusion he states that "the American character is as varied as the American scene," utilizing and refocusing an appellation popular with the Regionalists whom he is rebutting.[42] He thereby turns the tables on Craven and other racially based theoreticians, claiming instead an explanation of national characteristics based solely on social and cultural environment, more in line with contemporaneous anthropology as well as with the more moderate critics like Edwin Alden Jewell.

Having put forth his theory of the social bases of art, and having refuted the chauvinism of the Regionalists, he turned to a discussion of abstract art in his essay, "Nature of Abstract Art."[43]

The article is an elaborate refutation of the formalist view put forward by Alfred Barr, director of the Museum of Modern Art, in that institution's important exhibition (and in the accompanying catalogue), *Cubism and Abstract Art* from 1936. Schapiro's attitude toward abstract art is complex. It is the formalist interpretation of modernism rather than abstract work per se that Schapiro finds inadequate.

Although this important exhibition catalogue will be discussed in more detail in the following chapter, it can be briefly summarized here as the most articulate formalist model yet put forth to explain the development of modern styles since Impressionism. The remarkable chart by Barr, from the catalogue, sums up his art-derived explanation for art, much more elaborate of course, but not essentially unlike the grouping of artists by Arthur B. Davies listed in the special edition of *Arts and Decoration* which accompanied the Armory Show.[44]

Barr's scheme seems, on the surface, to be merely descriptive and comparative in his exposition of stylistic development, but Schapiro reveals the underlying theoretical assumptions implicit, but unstated, in Barr's formalism. Barr's description of the development of form, Schapiro points out, is simplistically based on the idea of the avant-garde as a succession of styles which arise in an antithetical relationship to what went before.[45]

But Schapiro points out that a description of an antithetical style is dependent on those features of the original style selected as salient. While the generation of the Post-Impressionists and Cubists reacted

against Impressionism because of that movement's perceived superficial naturalism, as Barr rightly claims, critics from the time of the Impressionists disparaged it, on the contrary, for its "monstrous unreality" Schapiro asserts.[46]

A number of different stylistic reactions to Impressionism are traceable—whether by antithesis or extension—from previous art, but the real causes of change and development, writes Schapiro, "far from being inherent in the nature of art, issued from the responses that artists made to the broader situation." He goes on:

> The history of art is not, however, a history of single, willful reactions, every new artist taking a stand opposite the last, painting brightly if the other painted dully, flattening if the other modeled, and distorting if the other was literal. The reactions were deeply motivated in the experience of the artists, in a changing world with which they had come to terms and which shaped their practice and ideas in specific ways.[47]

The simplistic reaction of one style to another is likened by Schapiro to fashion, where, if one year skirts are long, the next year they're short. The similarity to fashion itself is understandable given the economic basis of the art-consuming leisure class. Like fashion, contemporary art is a luxury item marketed to an elite audience of consumers. Its resemblance to fashion is superficial and based not on eternal principles of art but on the current market and system of patronage.

Schapiro attacks Barr's formalism and his deterministic view of artistic development, denying Barr's assertion that Malevich foresaw "the inevitable conclusion," in his Suprematist paintings, and asserting Malevich's experience of the war and the Russian revolution as important determinants of his form, as well as his exposure to Cubism and Futurism in Paris.[48] He dismisses Barr's "progressive" history of style as ultimately unhistorical.

Formalism as a way of understanding art based on its visual aspects alone had been extended to past art and the art of other cultures by formalist art historians and critics, continues Schapiro, creating "a grand confraternity in the arts," where formal values were disengaged from the object, "making it possible to enjoy the remotest arts," on the basis of form and style alone.

> The art of the entire world was now available on a simple unhistorical and universal plane as a panorama of the formalizing energies of man.[49]

Such a view of art, although commendable in some respects, is so reduced and impoverished as to cause as much confusion as understand-

ing. It is also resembles, Schapiro observes, capitalist imperialism in its ambition to colonize and render a superficial understanding of subjugated peoples and cultures. It colonizes history the same way, reducing work from all periods and subjects to their underlying abstract qualities.[50]

The fundamental cause of these errors according to Schapiro, is the mistaken assumption that abstract art, and by extension all art, "is a purely esthetic activity, unconditioned by objects and based on its own eternal laws."[51] And so he concludes, "there is no "pure art," unconditioned by experience; all fantasy and formal construction, even the random scribblings of the hand, are shaped by experience and by non-esthetic concerns."[52]

---

Meyer Schapiro was among the leftist artists and writers who, shocked and dismayed by the Moscow Trials of 1936–38, began to distance themselves from the policies of the Soviet Union. *Partisan Review*, once the magazine of the John Reed Clubs, had split from Party affiliation in the mid-1930s and allied itself with Trotskyism. Its editors and writers helped form the League for Cultural Freedom and Socialism in open opposition to the Stalinist-controlled CPUSA (who carried the official Party line). Schapiro was among the league's original members.[53]

In August 1939, the League published a statement in *Partisan Review* attacking the "spurious anti-fascist unity" of front groups such as the Artists' Congress. With the signing of the Stalin/Hitler Non-Aggression Pact later that month, the accusations got stronger. But the invasion by the Soviet Union of Finland, in December of that same year, proved to be the breaking point for the Artists' Congress and led to the disintegration of the artistic left in America.

Schapiro and his group broke with the congress at that time. An article in the *New York Times* described the secession and reprinted a statement released by the group and probably penned by Schapiro.

> The American Artists' Congress, which was founded to oppose war and fascism and to advance the professional interests of artists, at its last membership meeting on April 4, endorsed the Russian invasion of Finland and implicitly defended Hitler's position by assigning the responsibility for the war to England and France. . . . The Congress no longer deserves the support of free artists. We therefore declare our secession from the congress and call on fellow-artists within and outside it to join us . . . .[54]

Although they broke with Stalinism, most of these artists remained radical leftists, many of them later becoming liberals.[55]

With the United States entry into war in 1941, the complete discontinuation of all the federal arts projects by 1943, and the gradual breakup of the artistic left, Social Realism never recovered. Regionalism, as well, seemed like a political anomaly, with its isolationist and provincial solutions no longer credible during the war and in the postwar era. In fact, the entire project of the rapprochement between the artist and the public on the basis of a Deweyan sense of community—which had been such an important vision for artists throughout the decade—was largely abandoned.

The experiential paradigm was, however, not exhausted and was to be continued with a non-political agenda in the work of the Abstract Expressionists and the writings of Harold Rosenberg, one of that generation's principal spokespersons.[56]

Art critic Milton Brown, returning from Europe after serving in the war, wrote an article for the *Magazine of Art*, describing changes in the art scene after his three-year absence.

> It seemed to me in 1943 that the major trend in America was social art, with abstraction a growing but temporary phenomenon. Social art covered a wide range of attitudes and styles roughly divisible into American scene and social realism. And, frankly, it appeared to me that the struggle for supremacy would be between these two factions. I have returned to find with some surprise that in the interim the dark horse of abstraction has swept into the land.[57]

# 7

## Formalism as a Minority Position in the 1930s and into the 1940s

FORMALISM WAS NEARLY ECLIPSED DURING THE FIRST YEARS OF THE decade in critical circles, its only prominent advocate being veteran critic Henry McBride. Sam Kootz was also an outspoken defender of a more or less formalist modernism during these years. His book, *Modern American Painting*, published in 1930, presents a "progressive" apologia for a European-based modernism. Its defensive and at times overblown rhetoric betrays the embattled position of formalism at the time. However, some of the ideas in this book, particularly Kootz's view of the genesis of modernism as a rejection of Romanticism, would become central to Clement Greenberg's late modern version of the paradigm.

While the experiential paradigm ruled the critical arena, the formalist position was kept alive through émigré artists/teachers and was disseminated to younger artists who were to become important after the war. Major pedagogues such as John Graham and Hans Hofmann, were especially influential on the emerging generation of artists and helped build an understanding of, and sympathy for, European abstraction, but in a decontexualized, synthetic form which blurred the differences between European movements and blended them into an eclectic and teachable modernism. In this depoliticized and homogeneous exposition of European movements, issues of form were paramount.

Modern art was also more available for examination by artists than it had been during the 1920s. Besides the commercial galleries, exhibitions organized by the Museum of Modern Art, the Whitney Museum of America Art, New York University's Gallery of Living Art, and other institutions, kept artists abreast of developments in international modernism.

The most important catalyst for the development and consolidation of formalism in America during the decade was the Museum of Modern Art's pivotal exhibition, "Cubism and Abstract Art" of 1936, organized

by the museum's director, Alfred Barr. Barr was without a doubt the most influential and articulate advocate of the formalist position during the decade. In the catalogue, he posited a sophisticated view of modernism in which each new movement arose in reaction to previous movements (an approach with which Schapiro took issue). He traced stylistic influences and counter influences among the avant-garde with the methodology and the language of art history. As a Harvard-trained art historian, Barr lent the formalist position a new kind of respectability. Cognizant of the diversity and complexity of European modernism, as few at the time were, Barr tried to present recent art, not as an homogeneous movement or style as so many had done before him, but attempted in his exhibitions and publications to explain the differing theories and disagreements among the various factions. The catalogue from this important exhibition, discussed in the previous chapter by Meyer Schapiro, is to be examined here at more length.

The following year saw the formation of the American Abstract Artists (AAA), organized in part in response to the lack of critical attention formalist art had received during the decade. George L. K. Morris, painter and collector as well as critic, emerged as the group's principal spokesperson. He was also editor of *Partisan Review* from 1937 to 1943 and became one of formalism's few advocates within the ranks of criticism itself (so many of the others being teachers, gallery owners, or museum curators). It was also at the end of the decade that both Clement Greenberg and Harold Rosenberg made their appearance in *Partisan Review*, and it was at that time that they developed their versions of the paradigms which would come to dominate the critical arena during the 1950s.

Henry McBride was over sixty when he spoke enthusiastically about the "American Wave" in 1931, described in the previous chapter. This veteran defender of modernism was the only prominent American critic representing a formalist line during the first part of the decade. As chief critic for the *New York Sun* and editor for the magazine, *Creative Arts*, he was well known and respected, but his views must have seemed a curious remnant of an outmoded aesthetic. McBride's criticism continued through the decade to be an eclectic impressionism with a lot of talk about the art world. He adopted a somewhat conciliatory position toward the dominant wave of representational art, acknowledging its validity but continuing, nonetheless, to champion European formalism.

More outspoken, Sam Kootz published his polemical *Modern American*

*Painters* at the opening of the decade. Despite its somewhat misleading title, it is a defense of formalism against nationalistic chauvinism in criticism, and a plea to artists for the development of new forms more in keeping with human experience. As such, it is an interesting compromise strategy for the promotion of the beleaguered minority position.

He states brazenly in the opening paragraph of the foreword, "The word American has nothing to do with painting," it is merely a descriptive word, he insists, representing the geographic locale in which the artist happens to work.[1] He thereby implicitly denies not only the possibility of a national art but also reveals his antagonism towards an environmental or experientially-based understanding of art altogether.

Furthermore, Kootz states up front (in a comment which would make Craven's blood boil) that he uses the standards of contemporary French painting as criterion by which to evaluate current American art, "Because," as he states, "France is the breeding ground for all that has been most significant in modern painting."[2]

Like so many others from both the experiential and formalist side of the debate, Kootz felt compelled to provide a unique and constructed history to confirm his reading of contemporary art.[3] He divides the text into two introductory parts: "Modern Movements;" and "The American Scene." (A third part, containing the main text about the contemporary American artists, follows). The first of these sections contain Kootz's historical apologia.

According to Kootz, modern art was born as a reaction against the excesses of late Romanticism — seen as melodramatic, overly literary and sentimental. The pioneering work of Cézanne and the later experiments of Picasso and Braque tried to bring formal order into this chaos of emotionalism in that they asserted "the right of the artist to paint in a purely impersonal manner."[4] The author concludes that:

> The inventions of Cubism, in brief, have given us a new esthetic based upon the pure interplay of line, form, and colors, divorced from realism and relying upon a deliberate, disinterested and supremely objective geometry.[5]

The linear progressivism and the anti-Romantic historical model, put forth in *Modern American Painters*, would be the main ingredients of Clement Greenbreg's much more sophisticated formalism ten years later.

In a bow to the dominant language of the experiential paradigm, Kootz calls for a reintegration of artists with the society and the reentry

of a warm humanism into a formalism which he admits has become too calculated in recent art.

> Cognizance of externalities is the possession of everyone, but experience has disappeared. No destiny is within them; they have become permanently exiled from life. . . . Contentment with the present fetishes of design and significant form serves only to enlarge the production of more spineless painting, completely divorced from any individual experience.[6]

Such a strategy addressed the accusations of the insularity and elitism of formalism by agreeing with the experiential critics up to a point. The answer to the present crisis is to be sought however, not by an abandonment of these "progressive" formalist principles or a wholesale repudiation of modernism, Kootz suggests, but by a readjustment from within modernism, a movement towards experience without a total capitulation to vulgar populism, and styles related to it via a narrow nationalism.

Just as earlier modernism's reaction to Romanticism made it cool and detached, according to Kootz, a reaching out into experience and life is evident in the recent vanguard work of the Mexican muralists whose contact with "human values," as well as formal design, combines to herald a "new classicism," a new "sublime order," which, presumably transcends both the old 19th century Romantic sublime and the detached, classical formalism holding sway earlier in our own century.[7]

In the "American Scene" section of *Modern American Art*, Kootz unleashes a savage tirade against American art which dismisses virtually all of previous American painting as second rate, and roundly condemns it as the unfortunate result of Puritanical influence. These puritanical influences, when mixed with the anti-Romantic rebellion of European modernism, have brought American formalist painting to an overly refined sterility and made American painters "soft." Again Kootz uses the technique of agreeing with some of the observations of men like Craven—i.e., modern artists are not rugged—but names different causes and offers solutions which grow out of, rather that in opposition to, contemporary formalist art.

The naming of this section "The American Scene" would lead the reader to assume that this section dealt at least somewhat sympathetically with the emerging American movement. Instead, it is a polemic against the American Scene painters, which he characterizes as just "another abortive addition to the long stretch of American mediocrity."[8] Perhaps by naming the sections in this misleading manner, he hoped to

attract inadvertent readers from the other camp and convince them of their errors.

In the same way, the very title of the book seems to be to a certain extent, aimed at an audience of those from the opposite camp. Appearing as it does at a time which was obsessed with understanding and defining an authentic American art, *Modern American Painters* jettisons the whole enterprise as beside the point and a waste of time.

Kootz's outspoken antagonism to the American Wave of the following season is manifest in his deliberately provocative "America Uber Alles," which appeared in the *New York Times* as an opinion piece in December of 1931.[9] He compares the obsession to find a national art to the slogans of the National Socialists in Germany, and rejects the whole "American Wave" phenomenon as a clever marketing invention of the galleries and the critics. He labels the antics of the art world over this supposedly national art as a "premature circus," thereby hinting at a P. T. Barnum-style grandstanding by "partisan whipcrackers" (and turning the tables on those who accuse abstract art of charlatanism).[10]

Despite the vociferous defenses of formalism by Kootz and the continuing support of McBride, there are few other voices within art criticism itself during the first half of the decade to defend a formalist understanding of art and, as has been shown, even McBride and Kootz felt obliged to mitigate the formalist position, at least to a certain extent, to accommodate the dominant experiential paradigm.

The reason Milton Brown (quoted at the close of the previous chapter) was so surprised when the "dark horse" of abstraction had swept in during the war to dominate postwar critical thought was this apparent dearth of critical writing. However, the paradigm was kept alive in the decade of the 1930s through activities largely outside the arena of published critical materials, especially in New York City.

Particularly influential in that city, were the émigré artists John Graham and Hans Hofmann. More than any of the other Europeans, they were accessible to young artists and propagated their own ideas about European modernism. Because they were both from Europe and figured, however marginally, among the historic avant-garde during the first decades of the century, their interpretations of modern art were taken by Americans to be authentic and authoritative.

Graham's influence was behind the scenes. He had a profound effect upon several important artists of the time, most notably Arshile Gorky, David Smith, and Jackson Pollock.[11] He organized exhibitions and introduced artists to one another (Lee Krasner met Pollock through Graham), but he is said to have been most influential as a brilliant

conversationalist.[12] The written fragments of his thought are usually phrased in question and answer form and are gathered together quite effectively in Allentuck's book (they were originally published in a very small private edition in 1937).

Although sometimes self-contradictory, the ideas in this little book anticipate some of the most important ideas in formalist criticism of the following decades. For example, question 14 of his manuscript poses the question, "What is the ultimate, logical destination of art?" and answers:

> The ultimate, logical destination of art is the reduction of the same to its minimum elements. Painting starts with a virgin, unified canvas and if painted upon ad infinitum it reverts again to a plain unified surface. . . .[13]

As Allentuck points out, these ideas prefigure the reductivism and teleology of Greenberg's thought by at least three years.[14] As can be seen in the present study, these determinist ideas have also been present in American criticism as far back as Willard Huntington Wright and form part of an unbroken chain of critical thought. Unfortunately, Graham never followed up these observations or expanded on them systematically.

Even more important in keeping formalist ideas alive during these years was the teaching of Hans Hofmann. He taught American students while still in Munich, and was already well known by the time he emigrated in 1933 and opened his own school in New York.[15] Hofmann presented modern European art in a unique, synthesized form for his American students. Drawing on cubist and constructivist theories of form filtered and purified through Bauhaus ideas about design, and mixed with color theory derived from Matisse and German Expressionism, Hofmann taught what can now be seen as a somewhat conservative and eclectic summary of the ideas of the European avant-garde of some twenty years previous.[16]

Hofmann's synthesis eliminated and smoothed over any points of disagreement among the various avant-garde groups and extracted all political elements from the original European movements. This decontextualized and generalized idea of modernism reinforced the already decontextualized understanding in American formalist circles. That a European artist taught likewise, could only underscore and confirm this oversimplification as a correct reading of European modernism.

Also very important to the transmission of formalism during these

years were the various, more or less public, institutions that had risen up in New York City. Undoubtedly, the most important of these were the Museum of Modern Art, which opened in 1929 and the Whitney Museum of American Art, which opened in 1931. However, other organizations also offered exposure to avant-garde art.

Peggy Guggenheim's Art of this Century gallery, which opened in 1943, was essentially a showplace for the Surrealists in exile, but also provided their first solo exhibits to some of the most important of the Abstract Expressionists, including Jackson Pollock and Robert Motherwell. The Museum of Non-Objective Art, which opened in 1939, housed a broad collection of Kandinsky's work and was also available for viewing without charge by appointment.

More important, (and earlier on the scene) than these to the maintenance of a strictly formalist understanding of modernism was the Museum of Living Art at New York University in Greenwich Village (long an artist's neighborhood). First opened in 1927 under the name Gallery of Living Art, the museum displayed the collection of A. E. Gallatin, a major collector of Cubist and post Cubist works by both Europeans and Americans.

The collection was large enough, and contained enough, important works by major artists from Cezanne forward, that one could form an understanding of the development of modernism entirely from the works on view alone, even if one did not have any other background. In fact, works in the gallery were laid out in a chronological manner in order to recapitulate the history from a particular, and it must be said, distinctly formalist, vantage point. As Gallatin admitted in the short essay that he wrote in 1933 for the catalogue of the museum, "The omissions have been calculated."[17] In other words, the narrative history so smoothly presented in the catalogue, and the arrangement of art works, is a narrative with a particular perspective—a formalist perspective.[18] It necessarily leaves out other contenders.

For example, Surrealism (a reoccurring problem for formalists) is only represented in its abstract forms, in the works of Miro, Masson and Arp. Gallatin follows the development of modern art through the School of Paris almost exclusively. He makes a nod, however, to the experiential paradigm by characterizing the work of Marin, Sheeler and Hartley as rooted in "the American Soil."[19]

Gallatin's activity was not limited to the Museum of Living Art. He organized a number of exhibits around New York City including a show of contemporary formalist abstractionists to coincide with the Museum of Modern Art's "Cubism and Abstract Art," during April

1936. Barr's concentration on historical, European art in the Museum of Modern Art exhibit was complemented by Gallatin's exhibition of contemporary Americans who seemed to continue the tradition documented in Barr's exhibit uptown.

The important exhibition at the Museum of Modern Art, and the articulate catalogue essays written by Alfred Barr which accompanied it, were in many ways the most authoritative statements on the formalist paradigm published in America up to that point.

Unlike the defensive rhetoric of Kootz or the compromising apologetics of McBride, the catalogue to this exhibit by Barr is supremely self-confident. The reader would have no way of knowing, from anything stated within the catalogue itself, that cubist or abstract art was not universally recognized and appreciated at the time of its publication. "Abstract art today needs no defense," Barr boldly asserts, at the beginning of a section of the catalogue, which ironically is dedicated to precisely such a defense.[20]

Barr gives the catalogue a moderate or even conservative tone by emphasizing the scholarly and historical nature of the exhibition. This conservative image is probably intended to counter impressions of the radicalness of modern art with assurances of its essentially moderate and unpolitical nature. As he states in the opening of the Preface:

> The exhibition is intended as an historical survey of an important movement in modern art. It is conceived in a retrospective—not in a controversial spirit.[21]

Later in the same paragraph, Barr underlines the conservative image by stating with a strategic modesty that the show is in no sense a "pioneer effort," and this in turn heightens the impression of the exhibit as a chronicle of things everyone already knows and accepts.

Art from the period the show covers, Barr implies, can now be analyzed in a scholarly fashion the same way any other period of art can be analyzed. He reinforces this impression by speaking, as a Harvard-trained art historian, with equal ease of modern art and Renaissance art, a ruse as old as the Armory Show. Supporters of the moderns are not gullible, wealthy eccentrics, as Craven implies, but instead are erudite, progressive and in the know.[22]

By chronicling the development of abstract art in these art historical terms, the museum was presenting itself as a sort of irrefutable arbiter of significant form, with the authority to set an historical canon. The self-confident and scholarly (but not too scholarly) tone of the cata-

logue essays reinforces this impression, and makes it seem to have an authority that no other institution of the time really possessed (with the possible exception of the Whitney, which in any case favored figurative art).

Barr reveals himself as a quintessential formalist on the elaborate chart that was on the dust jacket of the original catalogue.[23] Here we see an elaborate and authoritative definition of modern art based entirely on influences and cross influences in terms of style. The chart is arranged chronologically from top to bottom spanning the years 1890 to 1935. Movements are indicated by semicircles. Solid black lines indicate direct stylistic influences, as from Neo-impressionism to Cubism or from "(Abstract) Dadaism" to "(Abstract) Surrealism." Influences outside of modern art itself, but which had an important effect on its development never the less—such as Japanese prints or African sculpture—are surrounded by boxes and in the original appears in red, as do the lines of influence stemming from them. Indirect influences are indicated by dotted lines, as between Redon and Expressionism. Modern Architecture is the only deviation from this plan, it being neither part of modern art per se nor an art form entirely out of the realm of modernism, like African Sculpture. It is represented as a box with dotted lines of influence running towards it. Modern Architecture, it would seem, stems from influences in sculpture and painting.

As compelling and complex as it is, Barr's elaborate chart, like so many earlier versions of formalist history represents the development of art as a process driven entirely from within the parameters of the profession itself. Nothing on the chart represents events such as the First World War or the Russian Revolution, as important as these events were.

In a section entitled "Abstract Art and Politics," Barr addresses these issues. Abstract art's involvement with politics is described here as unessential to its content or basic program. There is nothing intrinsically communistic, for example, about Constructivism, but it was utilized by that regime for a time because of the power and simplicity of its forms. Noting the fall of the leftist artists in the Soviet Union, he concludes that the involvement with politics is usually bad for modern art:

> The essay and exhibition might well have been dedicated to those painters of circles and squares (and the architects influenced by them) who have suffered at the hands of philistines with political power.[24]

The two exceptions to the rule that art movements are essentially independent from politics are the cases of Futurism and Surrealism, linked

programmatically to Fascism and Communism respectively. These radicals from the far right and far left are presented in contradistinction to the rather moderate or conservative position of the catalogue and the museum, which tries to distance itself from the political aspects of the work to concentrate on the issues of form.

An important difference here from the earlier formalisms put forth in American critical thought, is Barr's acknowledgment of the complex theoretical differences between the European movements. No universal, overarching and ultimate goals across movements are postulated. Unlike so many formalists of the century, from Wright to Greenberg, Barr does not assume some absolute telos towards which modernism is directed, some endpoint such as purism. He leaves the future comparatively open-ended. In keeping with his conservative tone, Barr is not willing to venture a prediction.

The various movements which contributed to Cubism and Abstract art, however, do tend to flow towards two major types, according to Barr: geometric abstraction (i.e., Mondrian); and non-geometric abstraction (Arp or Miro). He states that the less geometric style seems at present to be in the ascendant and "will probably dominate for some time to come the tradition of Cézanne and Cubism," that is, the "tradition" to which the exhibition is devoted.[25]

To be a convincingly conservative and authoritative historical voice, the Museum of Modern Art (MoMA)—unlike, for example, the Museum of Living Art—had to be able to place the events it chronicled squarely in the past. By presenting the art in this way, it assumed the traditional role of a museum as a repository of great masterpieces of the ages whose taste and authority were beyond question. It did not lower itself to the level of the current debate, but struck a posture which remained above such controversy. Cool and aloof, it presented the work as an established historical fact that required no particular defense.

This strategy, however, was difficult to accomplish in the anti-modernist climate of the mid-1930s. To this end the museum produced an impressive looking catalogue with well written, scholarly essays by its Ivy League-trained art historian and curator. The layout and design of the catalogue, while being up-to-date and modern, is not avant garde in style but, in keeping with the entire exhibit, strikes a conservative chord and resembles the design of catalogues at the Metropolitan Museum of Art, that authoritative institution which MoMA undoubtedly emulated.

But while the strategy of placing the movements it describes in the past helped establish this work as canonical and its validity as beyond question, it raised problems for contemporary artists working in a for-

malist mode. In light of the way abstract art was presented in this ex-
hibit, contemporary abstract artists were not seen as avant-garde
ground breakers, but as somewhat conservative practitioners of an es-
tablished tradition, or worse yet, as imitators of a style of the past not
unlike those artists who continued to paint in an impressionist mode.
Contemporaneous abstract artists, who saw themselves as progressive,
disliked being portrayed in this conservative manner.

The conservative representation of this exhibition, then, while it gave
a measure of validity and even prestige to abstract art, outraged many
contemporary American abstract artists and served as a catalyst for
their collective voice. Amidst the overwhelmingly anti-formalist climate
of the decade, when critics were lined up against them and exhibition
opportunities were few, when even the Museum of Modern Art charac-
terized abstraction as an historical and essentially European phenome-
non, the American Abstract Artists group was formed early in 1937 to
promote the cause of abstraction in contemporary American art. Al-
though it had no specific stylistic program, it was dominated by artists
practicing some sort of geometric abstraction.

Its inaugural exhibition, held at the large and prestigious Squibb Gal-
lery in midtown Manhattan was well attended but its critical reception
was, not surprisingly, less than enthusiastic. Edwin Alden Jewell of the
*New York Times* summed up his appraisal of the show with his by now
familiar condemnation based on their exclusivity and self-referentiality.

> Much of the work is clever and accomplished, but it may be felt that at
> length our out-and-out proponents of abstract speech have settled into a
> thoroughgoing academicism. . . . The fact remains that he [the abstract art-
> ist] has entered into a sealed chamber whence there is no outlet. . . . At any
> rate the air is extremely rarefied, nor is there more than just enough of it to
> keep one from gasping.[26]

The stifling insularity of formalism is characterized here, as it had been
in the past, as a new academicism as rarefied as the old.

The 1939 exhibition of the AAA, at the Riverside Museum on the
West Side of Manhattan, was reviewed by Robert M. Coates in the *New
Yorker*. Although he was sympathetic and had good things to say about
particular pieces and artists, he criticized the overall "mood" of the
show.

> With few exceptions, the trend of the group is toward "pure" abstraction,
> in which all recognizable symbols are abandoned in favor of strict geometric

form. . . . Purity in art, as in life, if carried too far can become an exceedingly negative virtue.[27]

Again, it was the formalist purism and the lack of connection to living experience which was singled out for criticism.

It was in response to such negative criticism that the AAA published and distributed the provocative pamphlet, *The Art Critics—How Do They Serve the Public? What Do They Say? How Much Do They Know? Lets Look at the Record*! In this short but very pointed piece, the critics are brought to task for their lack of support and their general inability to recognize and deal with "the form problem and the vital significance of its continued development."[28]

The pamphlet takes on and dismisses what has been designated in this study as the experientially oriented critics one by one. Cortissoz (still, amazingly, writing) is sharply dismissed as a "fool," who prefers Sargeant to Cézanne. Craven is criticized for his vociferous, chauvinistic defense of American Scene painting under a heading sarcastically entitled "Grapes of Wrath." His recent retreat from mainstream criticism is noted, as is the toned down rhetoric in his recently published coffee-table picture book, *A Treasury of Art Masterpieces*, a change attributed in the pamphlet to his desire to still be taken seriously as a critic in an artistic climate that has moved away from his narrow program. Edwin Alden Jewell is also roundly pummeled for his insistence on a national, environmentally-determined art. Jewell's insistence that group traits are "products of a given area, a specific soil" is ridiculed and it is inferred that his position is similar to that of Fascism abroad.[29]

Peyton Boswell Jr.'s *American Art Today*, with its insistence that Regionalism is the greatest art since the Italian Renaissance, is singled out for particular abuse, as is the journal he edited, *Art Digest*. In reference to Boswell's near deification of Curry, Benton, and Wood, the pamphlet sarcastically notes that "Abstract art can obviously not compete with this reincarnation of the Trinity."[30]

Henry McBride, that old war horse, is complimented in this pamphlet as is Robert Coates, seen as at least somewhat sympathetic, despite his recent criticisms noted above.

A significant thing about this pamphlet, and the AAA in general, is the attempt on the part of artists themselves to enter the critical arena and criticize the critics. Not since the Armory Show had we witnessed such an attempt by artists themselves to steer the course of contemporary art.[31]

It was artist/critic George L. K. Morris who was to become the

AAA's (and formalism's) most prodigious spokesman in the last years of the 1930s and the early years of the 1940s. An accomplished abstract painter himself, Morris was independently wealthy, a fact which gave him entré to the studios of the most important artists during the late 1920s and early 1930s.[32] It was as a collector and purchaser of art rather than as a mere artist that he was welcomed into the studios of Picasso, Leger and the other masters of the previous generation. His view of modern art, although knowledgeable and erudite, was almost exclusively oriented towards the School of Paris of that earlier generation. Dutch De Stil and Russian Constructivism were seen through the Parisian synthesis of the *Abstraction-Création* group of the early 1930s. Surrealism was not recognized as significant by Morris and German art, with the exception of the circle of the Bauhaus, barely seemed to exist.

Unlike Alfred Barr's more heterogeneous formalism, Morris's strict determinism could not admit a multiplicity of authentic styles, but rather hardened around a nucleus of formalist concerns. In many ways Morris was a quintessential formalist. He displayed in his writings, qualities we have seen reoccurring in American formalist critics of the previous decades: elitism, independence of art from its environment, and historical determinism.

Morris began publishing his writing in *The Miscellany*, an eclectic arts magazine, not unlike the earlier *Dial*. He was closely associated with Gallatin's Museum of Living Art and wrote an important piece for the 1936 edition of the catalogue for that institution.[33] In 1937, he became one of the editors of *Partisan Review*, now no longer an organ of the Communist Party but an independent leftist journal with ties to Trotskyism. Ironically, as a wealthy individual, he was also a major supporter of the magazine financially. Many of his most important writings appeared in this journal, for which he continued to serve as an editor until 1943.

Morris held to an exclusionary view of art and taste—hobnobbing among the famous and affluent, he was openly an elitist. He presents the minority position of abstraction in contemporary art not as a sign of its marginal or esoteric status, but rather as a mark of its superiority and the enlightened understanding of its supporters. He asserts that likewise, the preference for a rare burgundy over Coca-Cola doesn't have to be explained but rather is entirely understandable—its superior quality a more or less self-evident matter. Despite the fact that many in America undoubtedly prefer Coca-Cola, he muses, burgundy "seems to retain its distinguished quality."[34]

He believed along with his formalist predecessors that art occupies a

realm apart from its surroundings. Artists, according to Morris, should not try to "depict life," and their art should be as "independent and self-contained as [in words that sound like Jean Arp] any tree or stone."[35]

Moreover, he was an historical determinist who believed that art proceeded according to set patterns which were generated not from the environment, but from within the technical parameters of art itself. Morris agreed with Barr in so far as he asserts that one stylistic mode led to another in modern art. But he differs by postulating a predictable course to these stylistic transformations.

Unique to Morris and setting him apart from his formalist predecessors (and successors) was his view of the history of art as a series of self-generated and predictable cycles, rather than as a linear, "progressive," advance.[36] In this, he hearkens back to the cyclical theories of Vasari and Winklemann from the period before the nineteenth century, when a more Hegelian model began to predominate modern historical thinking.

These cycles proceed, in Morris's scheme, from a brilliant early phase dominated by innovations in plastic qualities—an architectonic phase—to a later, decadent phase when literary qualities predominate.[37] He groups most nineteenth century art in this latter, decadent category as well as the more literary art movements of the present (ca. 1935) that is—Regionalism, which he calls the "new vulgarianism," and Surrealism, that "flimsy outhouse" of the unconscious.[38]

Art in the early phases of a cycle, according to Morris, is characterized by its resemblance to architecture, rather than to literature.[39] The architectonics of the early Renaissance in painting and sculpture is pointed out as an example. Art of the Italian Renaissance, with its "passionless control," its sense of order, clarity, harmony, and balance is primarily a plastic art, a sensibility in which the subject matter counts for little more than the excuse for formal arrangement, according to Morris.[40]

Even the greatest technical innovation of that era, linear perspective, was primarily a means of ordering forms, not merely of depicting space, according to Morris. The present era was likewise inaugurated by the new way of thinking about space in the work of Cézanne and the Cubists.[41]

Presumably, the phase recently inaugurated has still a long way to go before reaching maturity or even dominance in the field. Critics are therefore premature, Morris insists, in dismissing abstraction as a style of the past—fashionable for a time during the 1920s, but now basically derivative.[42] On the contrary, the new art is just not so shockingly novel anymore and this is why it doesn't get as much notoriety as during those

pioneer years when it seemed so new. Was Dürer criticized for being derived from Italian Renaissance forms? No he was not, Morris insists, because he was building upon a solid tradition.[43] Formalist abstraction has now become such a tradition. But just as late Gothic art vied for a while with the new style of the Renaissance, we are currently witnessing not only the beginning of a new cycle, but the final collapse of the old.

Like Kootz and later Greenberg, he blamed the excesses of the late nineteenth century for the present dilemma.[44] Romanticism was the end of one cycle, according to Morris. We now are experiencing a transitional time during the rise of the new cycle, heralded by the formal innovations of Cezanne and Cubism. Meanwhile the old cycle's lingering influences still mark the worst of contemporaneous art.

The formalist approach to art has a universalizing effect, bringing works of art from disparate times and cultures together under one all-encompassing system of formal values, Morris claims.[45] Morris suggests that the Museum of Modern Art should organize an exhibition of the history of art from the stone age to the present based on the universalizing principles of formalism.[46]

Yet, even though Morris conceives of art in such socially detached terms, he acknowledges the importance of the visual environment on the artist and the forms he chooses.[47] He also explains the "collapse" of art during the 19th century in terms of social forces, such as the industrial revolution and the rise of the bourgeois class to a dominant position.[48] These environmental influences, however, simply set in motion a cycle which then plays itself out in a rational predictable manner, irrespective of further environmental influences because the historical cycles always proceed from the architectonic and structural (here seen as good), to the literary and naturalistic (viewed here as bad).

Although Morris was an articulate spokesman for the formalist camp during these years, his somewhat narrow and dogmatic approach to contemporary art was not flexible enough to accommodate or encompass the Abstract Expressionism that developed during the second half of the decade of the 1940s. His insistence on cyclical instead of linear development, his anti-Romantic stance, and his preference for pure, geometric form made him unsympathetic to that later art. However, in an era dominated by the experiential paradigm, Morris kept alive a rigorous version of the formalist position that was less impressionistic than McBride's, less defensive than Kootz's, and less heterogeneous than Barr's, although equally authoritative in tone.

In the meantime, two young critics from the Marxist camp were be-

ginning to write for *Partisan Review* under Morris's editorship: Clement Greenberg and Harold Rosenberg. They were to become the most influential critics in postwar America through the mid-1960s, providing the continuation and the culmination of the paradigms being traced in this book. Because of their importance, their work from the late 1930s will be discussed in the following chapter in conjunction with the development of their thought from that time through the twenty-year period when their ideas held sway.

# 8

# The Culmination of the Paradigms in Postwar Critical Thought

During the postwar period, American art rose to a position of unprecedented international influence and prestige and by 1960 had come to dominate European art. Clement Greenberg and Harold Rosenberg emerged as the critics whose writings defined what the current consensus holds to be the most important work of the period, Abstract Expressionism. Their positions were the two dominant strains of interpretation of the new art by the late 1950s. They continued—albeit in an altered form—the formalist and experiential paradigms that have been shown to be operative since the beginning of the century in American critical thought.

During the same period, the new international importance of American art was reflected in the rising status of the writers who articulated and defended it. By the early years of the 1960s, the most powerful players in the contemporary American art world were the art critics, not the curators or dealers and certainly not the artists themselves.

Since their criticism dominates this period and since they embody the paradigms so fully, Greenberg and Rosenberg will be concentrated on in this chapter to the exclusion of other critics of the period, who for the most part, follow their lead (like Willard Huntington Wright and Robert J. Coady, who ushered in the paradigms).

Unlike earlier critical debates outlined in previous chapters, where competing artistic tendencies were vying for dominance, the paradigms were here used to defend the very same work, Abstract Expressionism, but on different and in some ways, mutually exclusive grounds. This situation was possible at least partly because of the reticence of the artists themselves to talk about their work. Other circumstances, as well, caused critics and criticism during this period to rise to an unprecedented authority in the art world, an authority which began to break down during the mid 1960s when artist-theorists came more to dominate the aesthetic discourse and brought with them new concerns.[1]

120

The full development of Rosenberg's and Greenberg's critical positions in regard to Abstract Expressionism took place during the 1950s, but were based on ideas they had developed earlier in defense of other art. These defenses were developed during periods of acute crisis for modern art: the immediate prewar years between 1939–42 when the leftist coalition in the American art world crumbled and America witnessed the rapid rise of Fascism in Europe; and the immediate postwar period from 1946–52, when anti-Communist frenzy gripped the country and at the same time mature Abstract Expressionism emerged as a phenomenon to be explained.[2]

Greenberg's strategy was essentialist and as in previous formalisms utilized an historical explanation for contemporary art, forging links to the past and implying directions for the future, but cutting it off more convincingly and effectively from the culture at large than in any earlier versions of the paradigm.[3] Rosenberg's solution was a new, more private form of the experiential paradigm, utilizing Dewey's aesthetics in a different, more process-oriented, material/pragmatic, interpretation while neglecting the social aspects of Dewey's populism—the painter disengaging from the larger arena of life and society and, while working in relative isolation, making his canvas into a world. His "environing" took place in the studio.

Rosenberg's interpretation tended to be more influential during the first years of the 1950s, while Greenberg's formalism gained ascendance by the end of that decade. By the early years of the 1960s, formalism had come to dominate American critical thought, paralleling the dominance of the experiential paradigm during the 1930s.

---

Greenberg began within a Marxist framework, and started contributing to the *Partisan Review* during the period just before the United States entry into the war. His seminal article, "Avant-Garde and Kitsch," from 1939, seeks like so many earlier formalisms to set modernism (here referred to as the avant-garde), apart from exterior social forces.[4] This, however, is not done on the basis of elitism or "good taste" but instead is explained in compelling social terms. The forces of consumer culture threaten to devour authentic art, Greenberg asserts, which therefore must be kept in a realm apart for its very survival. He places contemporary avant-garde art dialectically within a larger social and historical context, contrasting it with kitsch, its cultural nemesis. The exclusivity of formalist reductivism is not a question of good taste

verses bad taste for Greenberg, but is a matter of objective social and historical necessity.

Greenberg provides a more comprehensive social and economic context for the avant-garde than do any of the formalists before him and, at this point in his development, he does it in terms of Marxist dialectics. In Greenberg's model, a "false," mass culture was first engendered by the industrial revolution, when there was a mass migration from the countryside to the cities. No longer satisfied with traditional folk arts in their new urban environment, the people demanded products to suit their own cultural needs:

> To fill the demand the new market, a new commodity was devised: ersatz culture, kitsch, destined for those who, insensitive to values of genuine culture, are hungry nevertheless for the diversion that only culture of some sort can provide.[5]

This manufactured culture tries to capture the effects of genuine culture, but is watered down for easy consumption. It takes ideas, style, and manner from high culture and makes them palpable for the masses by mechanical means and formulaic solutions, relying always on the lowest common denominator. It is all artifice, "simulacra of genuine culture," as Greenberg calls it. It is easily understandable and has wide appeal, but is fake. As Greenberg puts it, "Kitsch is the epitome of all that is spurious in our time."

It was in reaction to this onslaught that the avant-garde was born in the first place, Greenberg claims. The avant-garde wanted to cut itself off from, as he calls it, "a culture in decline."

> Retiring from the public altogether, the avant-garde poet or artist sought to maintain the high level of his art by both narrowing it and raising it to the expression of an absolute in which all relativities and contradictions would be either resolved or beside the point.[6]

The only authentic absolute that the artist could find in this culture of imitation, according to Greenberg, was the very materiality of the paint and the actual flatness of the canvas.

Content, meanwhile, was progressively eliminated in avant-garde art as it sought its dissolution in form and in its materiality.

> Content is to be dissolved so completely into form that the work of art or literature cannot be reduced in whole or in part to anything not itself.[7]

Since it is forced by circumstance to be self-referential, art can remain most authentically honest for Greenberg only if it grapples with the actual physical properties of the medium and leaves aside other concerns—it is an art of means and process. Kitsch, in contradistinction, is characterized by imitating the effects of art rather than the processes of the medium. It has integrity neither to materials nor to the process of its creation.

What's more, there is the danger that genuine culture can become high class kitsch. This typically happens, Greenberg explains, when some degree of compromise is struck with the mainstream culture — usually regarding issues of accessibility to a broad audience. This is but a thinly veiled criticism of the entire enterprise of making art accessible to the people, an idea that, as has been shown, dominated American art of the 1930s. The only hope for the survival of the avant-garde — identified here as the only authentic culture—is to keep itself pure from contamination with kitsch.

Thus, paradoxically, the essay argues against easy accessibility of culture to a broad audience, and does so in Marxist terms. The whole project of contemporary art as a force for social change, a tool for breaking down barriers between art and life, and between artist and non-artist, is abandoned here as one abandons a sinking ship. If formalist Henry McBride could look hopefully for a marriage between art and life in 1931, by 1939 Greenberg, his ideological heir, was filing for divorce.

Greenberg is here positioning art within a rarefied realm—something apart from the banal everyday world—as his predecessors did; but it cannot be said that this was a result of snobbishness, an accusation often leveled at earlier formalists. The necessity for art's purity was here ascribed to socioeconomic circumstances and historical forces. Greenberg gave formalist exclusivity a proper Marxist analysis and therefore a respectable face (Marxism had not yet become unrespectable).

Greenberg goes on to assert that the official art of both the Fascists and the Soviet Union is kitsch, imitating as it does the effects of former high art (often Romanticism or Baroque religious art) toward new and sinister political ends. In these governments, he points out, it is significant that the avant-garde is banned. The reader can't help drawing comparisons between the use of kitsch by these governments and the kitsch nature of much of the most important work of the previous decade in the United States, much of it executed under government patronage.

It was in his next essay, "Towards a Newer Laocoon," of 1940, that Greenberg's theories crystallized.[8] In this article, Greenberg broadens

his thesis by positioning avant-garde art, which he had already placed within contemporary culture, within a broad scheme of art historical development.

Like both Sam Kootz and George L. K. Morris before him, Greenberg blames the lingering effects of Romanticism for much of the current crisis in American art.

Greenberg also adopted Morris's concept of a single art being the dominant art form at a given time. But whereas Morris saw cycles of movement from an early stage dominated by architecture to later stages dominated by literature, Greenberg viewed all such dominance of one art form over another as a "confusion of the arts" and a decline into kitsch.

From Morris he also borrowed the idea of literature as the dominating art form of the previous century and along with Morris he sees the effects of this dominance as pernicious. By the end of the nineteenth century, painting—under the influence of literature—had "degenerated" (Greenberg's word) from the "pictorial to the picturesque."[9] But Greenberg does not agree with Morris's cyclical view of art historical forces. He uses instead the much more common linear, progressive model, pioneered by Willard Huntington Wright, where art develops toward purity.[10]

The purity Greenberg was interested in was a material purity. The history of modern art has been the progressive reduction of painting and sculpture to their material essentials, according to Greenberg, and this tendency he traces back as far as Courbet.

> The arts have been hunted back to their mediums, and there they have been isolated, concentrated and defined.[11]

Because of its birth in opposition to a culture based on the artifice and imitation of kitsch, however, the avant-garde strives above all for authenticity. Given these threatening circumstances, art tends to develop towards its own actual materiality in its search for the authentic. All roads ultimately lead in this direction, Greenberg asserts.

He goes on to disclaim the dominance of music in our own century (often cited by earlier formalists as a model for abstraction in the visual arts) as a merely more contemporary confusion of the arts. Although music is the abstract art par excellence, it cannot form an authentic metaphor for painting, claims Greenberg. It is only when painting tries to emulate the methods of music, rather than its effects, that it can become abstract in a concrete and honest manner.

Like so many formalist critics before him, Greenberg asserts that the avant-garde aims to create art entirely on its own terms, that is, in terms of its intrinsic qualities. Greenberg takes it farther: it becomes not only a matter of reduction to form, but a progressive reduction to materiality itself.

This schematization is remarkably similar to that of Willard Huntington Wright. Like Wright's, it is a progressive, teleological model that aims at a purity. But whereas Wright had isolated color as the irreducible given in painting, Greenberg emphasized the materiality of the medium. A frank acknowledgement of the fact of the flatness of the canvas in Greenberg, contrasts with Wright's talk of receding and advancing colors, which move and position themselves in an imagined pictorial depth.

Wright's progressive purism ultimately sought the dissolution of the materiality of paint and canvas into pure colored light. Greenberg's more prosaic purism led back to the painted surface as painted surface.

Both of them used art history as a witness to the superiority of the art they were promoting and as an indicator of the future direction of art. Both tried to present their views as above mere issues of taste and, to do this, both utilized history as the basis of their theories and projections. With Greenberg, this is explicit:

> I find that I have offered no other justification for the present superiority of abstract art than its historical justification. So what I have written has turned out to be an historical apology for abstract art. To argue from any other basis would require more space than is at my disposal and would involve an entrance into the politics of taste. . . .[12]

By using an argument derived from history, Greenberg, like Wright, was able to give his theory a certain sense of objectivity and authority that seemed to be independent of mere taste and subjective preference.

Although it resembled earlier formalisms, Greenberg's theory was able to deal more convincingly with the avant-garde's place in society than any previous formalist description. The kind of sophisticated Marxist analysis of the social and class parameters of contemporary art Greenberg explored in these early essays appealed to intellectuals more than earlier formalisms based strictly on art history. By presenting formalism as the only authentic art within a hostile environment oriented towards kitsch, Greenberg reestablished the anti-establishment stance of abstract art, rescuing it from accusations of academicism and restoring it to full avant-garde status.

The formalism of Greenberg also extended the fissure between avant-garde and life backwards in time, interpreting the period of earlier modernism as a series of essentially formal innovations, and this was in line with the less purist, earlier interpretations of Alfred Barr and George L.K. Morris. In his radical segregation of art from life, his decontexualized interpretation of European art and his progressive, advancing model of artistic development toward purity, as well as his elitism, Greenberg clearly continued and refined the received formalist paradigm.

Greenberg would abandon the Marxist class analysis in his later writing. However, during these years around 1940, with the waning of the still powerful artistic left, aesthetic arguments presented in this social form must have been very appealing.

Despite its limitations, the model of a "reduced" Modernism helped Greenberg to cope with the changed artistic and political climate of a world poised on the brink of collapse into war. This basic strategy was retained and expanded in the period that followed the war, the period when Abstract Expressionism emerged. Greenberg's critical foundation for dealing with Abstract Expressionism was laid well before that art actually came into being.

In 1947, Greenberg published one of his first essays on the new art for the British magazine, *Horizon*.[13] Predictably, and in line with the historical model he developed in "Towards a Newer Laocoon," Greenberg places the new American art, Abstract Expressionism, firmly within a Modernist tradition, dependent on "what the School of Paris, Klee, Kandinsky and Mondrian had achieved before 1935."[14]

He relates much of what he considers bad in American art to art historical causes as well. He attributes many things he doesn't like in current American art to the pernicious, lingering influence of Romanticism, "the Gothic, transcendental," and "subjective."[15]

In Greenberg's scheme the artist, and people in general, suffer from their "inability to be detached about either life or art," and he laments the "struggle to be a genius" which plagued the downtown artists later known as Abstract Expressionists.[16]

The only isolation important for the artist, the critic suggests, is the isolation of formal values above all others and the protection of the privileged realm of avant-garde art. Although Greenberg acknowledges it, he finds nothing romantically endearing in the Abstract Expressionist artist's tragic isolation:

> Their isolation is inconceivable, crushing, unbroken, damning. That anyone can produce art on a respectable level in this situation is highly improbable.[17]

He ends the article on a rarefied, elitist note by lamenting the minority position of the avant-garde and their audience, "What can fifty do against a hundred and forty million?" showing Greenberg's continued allegiance to the theory he first charted in 1939, the theory of the struggle between the avant-garde few and the kitsch many.

It wasn't until the mid-1950s that Greenberg's theory was to come to complete maturity. By this time, the Abstract Expressionists were widely regarded as the most significant artists of their generation. In "'American-Type' Painting," published in 1955 in *Partisan Review*, Greenberg celebrates the triumph of, as he calls it, "advanced painting," an epithet suggesting Greenberg's underlying teleological model.[18] Here, Greenberg's historical construct is presented in classic formalist terms, not as an aesthetic theory but as irrefutable law:

> It seems to be a law of modernism—thus one that applies to almost all art that remains truly alive in our time—that the conventions not essential to the viability of a medium must be discarded as soon as they are recognized.[19]

The new art, for Greenberg, is linked to earlier tendencies by historical laws and grows out of them naturally. "Abstract Expressionism," Greenberg states, "makes no more of a break with the past than anything before it in modernism has."[20] This was particularly important to assert at that time, because Rosenberg and others maintained that the new art was fundamentally different from earlier modernism and represented a decisive break. This will be dealt with subsequently. Suffice it to say here that the notion, now taken for granted, that early and late modernism represent a continuous and unbroken chain, was not by any means universally held during the late 1940s and 1950s.

Greenberg goes on to describe Abstract Expressionism in terms of style, linking the work of DeKooning, Gorky and Motherwell to what he calls, "Late Cubism."[21] He finds it in a "new kind of flatness" brought about by reduction in tonal range, increase in scale, and all-over composition to result in visual "fields."[22] The viewer reacts to these fields as "an environment as much as to a picture hung on a wall," largely, he explains, as a result of the lack of awareness on the viewer's part of the boundaries of the picture due to its vast size.[23] Acknowledging the environmental aspects of the work is a nod to Rosenberg's concept of the arena, but Greenberg quickly distances himself by insisting, "in the end one does react to the picture as a picture," and not, as Rosenberg would undoubtedly prefer, as an event.[24]

By 1962, it was clear to everyone that Abstract Expressionism as an

avant-garde movement was over. Greenberg is triumphal in tone in "After Abstract Expressionism," published in *Art International* in October of that year.[25] In this article, Greenberg addresses Abstract Expressionism as a phenomenon of the past, and views it in light of current art.

Just as he had predicted, painting had moved toward the pure. A more geometric style, exemplified by Kenneth Noland's "target" paintings and Jasper Johns's "Flags," had come to supplant the more painterly style of the earlier generation in a recapitulation of the move from geometric to painterly which attended the beginnings of Baroque art. The art history principle, Greenberg admits, comes from Heinrich Wölfflin's categories of linear versus painterly from the turn of the century.[26]

He posits a similar recapitulation-in-reverse of Cubism as an historical principle:

> The whole evolution of Abstract Expressionism could, in fact, be described as a devolution from a Synthetic kind of abstract Cubism to an Analytical kind.[27]

The breakthrough into all-over field painting is analogous for Greenberg to the breakup and analysis of form in the earlier kind of Cubism. But the careful reader may question to what extent can one legitimately play with history as Greenberg does, reversing earlier trends as when "Late Cubistic" space becomes, through the breakup of form and reduction in value contrast in "field" painting, more to resemble the earlier, Analytic Cubism?

Inventing visual and historical "laws" based on visual resemblance and fancied stylistic reversals, as in this comparison, exposes the serious methodological errors underlying Greenberg's otherwise convincing arguments. Far from being historical processes based on some sort of eternal laws, Greenberg seems to discern historical trends and stylistic recapitulations almost arbitrarily, just where it is most convenient for him in his explication. His own highly selective "history" is made to support his own argument, which comes more and more to seem less than objective and leads the reader to suspect that, perhaps after all, Greenberg's "laws" are just a matter of taste—of weapons used to promote certain artistic tendencies, argued articulately and dispassionately, and proffered in a convincing writing style. Such has been the use of history by critics throughout the century. Greenberg just does it better than most.

Rosenberg, like Greenberg, started his career as a Marxist and wrote for *New Masses* during the mid-1930s following the paradigm as it appears in writings by Meyer Schapiro and other critics of the radical left. During these years Rosenberg was supportive of political artists such as William Gropper and Ben Shahn. Significantly, he did not write for this magazine after July 1937, when he broke with the editors over the Communist party's position on the Moscow trials.[28] This was Rosenberg's first move away from mainstream Marxism and also his first assertion of the autonomy of art and politics as separate arenas of activity. Like Greenberg's parallel distancing of himself from Marxism, it was among other things, a way of coping with the disillusionments of the period.

Rosenberg did not, however, implode his critical position into a formalist exclusivism, but rather transformed the experiential paradigm into an individual, existential realm where the environment was still of paramount importance, but was seen as part of an inclusive, but subjective, process of artistic creation which encompassed the artist, his materials, and the audience itself.

By 1940, Rosenberg had developed his characteristic ahistorical interpretation of modernism in "On the Fall of Paris," published in *Partisan Review*.[29] In this pivotal essay, he lays the groundwork for a new type of the paradigm.

Unlike many critics in the experiential camp both on the right and the left during the previous decade, Rosenberg asserts the validity of the international, Modernist enterprise that Paris was engaged in:

> What was done in Paris demonstrated clearly and for all time that such a thing as international culture could exist. Moreover, that this culture had a definite style: the *Modern*.[30]

Despite the talk about style, it was other than formal aspects of art that mainly interested him.

The Modern, to Rosenberg, is not just the most advanced, up-to-date art, utilizing the latest materials and techniques, but art which escapes from time and history in an almost messianic way—severing art's link to what went before and came after and placing art in a more rarefied realm of the moment:

> So the Modern became, not a progressive historical movement, striving to bury the dead deeper, but a new sentiment of eternity and eternal life. . . . Thus the Paris Modern, resting on the deeply felt assumption that history

could be entirely controlled by the mind, produced a No-Time, and the Paris "International" a No-Place. And this is as far as mankind has gone toward freeing itself from the past.[31]

Paris created a sort of cultural no man's land, a space transcending nationality and history, in which artists and intellectuals from across the globe could act out their freedom.

This space apart was a special environment where artists could divorce themselves from mainstream culture and, as such, it formed a cultural niche of the highest importance for artists. Far from the decadent Bohemia described earlier in the decade by Thomas Craven, the School of Paris was for Rosenberg a perfect environment for the development of a heroic Modernism as a symbol of human freedom.

Freedom was a key concept for Rosenberg and was unequivocal. It was not only political freedom, but freedom from nationality, from real time, and from historical time. Unlike so many other critical constructs explored in previous chapters, Rosenberg does not use history to justify his position. In fact, history is by nature suspect by association because freedom has no past for Rosenberg. Fascism, the antithesis of freedom, he depicts as a sinister, alternative "Modernism" rooted in nationalism and history.[32]

Of course, during these years with the spread of Nazism and the dawning realization of the truth about Stalinism and the U.S.S.R., freedom was understandably an important hope and aspiration. It would again become an important concept during the years of McCarthyism and the cold war.[33]

Still operating as he was within the Trotskyist universe of discourse in 1940, Rosenberg had not yet completely abandoned Marxist thinking, as this "class analysis" shows:

> The hospitality of this cultural Klondike [Paris] might be explained as the result of a tense balance of historical forces, preventing any one class from imposing upon the city its own restricted forms and aims.[34]

It is therefore also a space somehow beyond class, where class antagonisms are temporarily on hold. This is the sort of Marxist reasoning he virtually forsakes in the postwar period.

Rosenberg's idealized vision of Paris-of-the-Modern, the realm of freedom, suspended, as he says, like a "magic island," over France — represented for Rosenberg, during these difficult years, a way of coping with the end of the Capitol of Modern by drawing in parameters for

art, forming a rarefied sphere above history and nationality, in a realm beyond time and space.[35] And yet, it is a realm, a space, a world in which the artist acts. In this sense it is a continuation of the earlier environmental paradigm, the parameters of which are now much more modest. Rather than to try to influence the world, the artist's immediate environment became a world unto itself.

The basic tenets of Rosenberg's mature criticism on Abstract Expressionism, although not explicitly stated and not yet fully developed in "On the Fall of Paris," are already suggested and in place in 1940, well before Abstract Expressionism itself exists. Thus both Greenberg and Rosenberg developed their basic models before the appearance of the work which they later became famous for defending.

When the art which later would be called Abstract Expressionism first appeared in the years following World War II, Rosenberg and Greenberg each brought to their understanding of the new art the critical models they had first developed nearly a decade earlier in reference to different art. Both of their positions were now de-politicized and began, in their mature forms, to resemble and extend the earlier paradigms.

Rosenberg's relationship to earlier types of the experiential paradigm is perhaps less clear than is Greenberg's link to earlier formalism. Formalism, based on historical "laws," developing throughout the century reached its apex and crystallized in Greenberg's late modernist paradigm. Rosenberg brings the experiential paradigm to a parallel culmination, tying back to earlier critical thought. But like earlier manifestations of the paradigm, it is situational, changing, and reinventing itself as it goes along, adapting itself to suit the current scene.

In his short article, "Introduction to Six American Artists" in *Possibilities* 1, from 1947, a short-lived magazine he co-edited with artist Robert Motherwell, Rosenberg conjures up the same kind of insular environment for art in the critical explanation of Abstract Expressionism that he first postulated in "On the Fall of Paris." He writes of the internationalism of the group in similar terms to his earlier treatment of Paris Modern.[36] The artists, according to Rosenberg, "assimilating all national vestiges into a transcendental world-style," reminiscent of his earlier concept of a sort of "magic island" beyond national identity that presumably Rosenberg now thinks floats above New York City as it once did over Paris.

However, these artists unlike their Parisian predecessors, are detached from "community," "estranged" according to Rosenberg to "the level of pathos."[37] Devoid of the camaraderie of Paris, these recent New

York artists seemed to Rosenberg to draw in the parameters of art even more, an extension of his earlier theory. This detachment is, moreover, a key to their creative strategy for renewal:

> The very extremity of their isolation forces upon them a kind of optimism, an impulse to believe in their ability to dissociate some personal essence in their experience and rescue it as the beginning of a new world.[38]

A new beginning was necessary, he maintains, because of the artist's estrangement from the past. According to Rosenberg, "Not one of these painters shows the slightest sentiment about his own past. Nor, what is perhaps more unusual, for the past of the art of painting as a tradition."[39] Cut off from history as well as from community, the artist creates his own space in the present because he is "fatally aware that only what he constructs himself will ever be real to him."[40]

Rosenberg here puts forth the idea that the new art represents a radical break with the art of the earlier part of the century. This is in marked contrast to Greenberg, who attempts vigorously to link up the new art with the continuing tradition of modernism. In fact, Greenberg's linkages to earlier art were so convincing that it is now often forgotten how, to some observers at the time, it seemed that modernism was defunct.

Painters and sculptors who would later be identified with Abstract Expressionism were going through an acute artistic crisis in the years immediately following the war. Stephen Polcari describes the malaise well from a psychological perspective and quotes from Gottlieb and Newman about the artists' feelings of "absolute desperation" during the period. Polcari observes, "Seemingly he [the Abstract Expressionist painter] would start from scratch, to paint as if painting had never existed before, to paint a new world."[41] This new beginning was necessitated, according to Newman, because it was feared that, "painting was dead."[42]

One of the results of this artistic crisis was that artists weren't talking about their work.[43] This was described by Max Kozloff in an relatively early article on Rosenberg, Greenberg and the critical reception of Abstract Expressionism:

> Crucial to an understanding of the whole critical ambiance of Abstract Expressionism is the famous concept of crisis . . . A sense of heightened conflict or change has not been absent from occasional comment in the past—but it was hardly associated, as it is now, with the beginning and not the decline of a movement.[44]

In Kozloff's view this crisis became an acute problem for criticism because of the unprecedented nature of the art and the resulting lack of a language to talk about it. According to Kozloff, "*Ambiguity* of concept, execution, role and meaning" was the essence of the problems of criticizing Abstract Expressionism and placing it in meaningful relationship to what went before it.[45] This opened the possibility of "mutually antagonistic conclusions" with regard to interpreting the new art.[46] The opposing conclusions Kozloff was referring to were those of Greenberg and Rosenberg and their respective followers.

Stephen C. Foster, in a radically revisionist, as of yet unpublished essay, asserts that the crisis in criticism in the immediate postwar years was due to nothing less than the failure of the whole Modernist enterprise during these years.[47] Around 1947, Foster asserts, the Abstract Expressionists became disillusioned with the possibilities of continuing the Modernist project. Modernism's idealism, its vanguard approach to cultural transformation along progressive lines, and its means of transcending the twentieth-century dilemma were simply no longer sufficient or believable. It was not so much that the artists had failed at modernism, but that modernism "had failed them."[48] Foster regards the mature work of the Abstract Expressionists as somehow operating outside the field of modernism, and this idea recalls Rosenberg's ahistoricality.

His views also echo the post modern interpretation of Rosenberg by Jerome Klinkowitz in *Rosenberg/Barthes/Hassan: The Post Modern Habit of Thought*, and like Klinkowitz, Foster is unabashedly in favor of a rehabilitation of Rosenberg's point of view.[49] If these post modern interpretations are correct, they explain Kozloff's observation, cited above, that "A sense of heightened conflict . . . was hardly associated, as it is now, with the beginning and not the decline of a movement."[50] According to Foster and Klinkowitz, the modern movement was beyond decline and had exhausted itself. Abstract Expressionism is seen as an attempt to move beyond Modernism. The failure of Greenberg's criticism, according to these authors, was the inadequacy of his formal and historically determinist terms. Ironically, this critical failure is exactly its key to success as an "art world strategy," as Foster calls it. The fact that Greenberg's interpretation finally "won out" over Rosenberg's does not in any way nullify the legitimacy of the latter.

Rosenberg further develops his musings on space and time in an introduction to an exhibition catalogue from October, 1949.[51] In it, he elaborates the theme of the new beginning by asserting that the artist is inspired, not by what he has seen, but by what he hasn't seen yet. "In

short, he begins with nothingness. That is the only thing he copies. The rest he invents." Rosenberg defines the "nothing" the artist begins with as "Space":

> All this is space or nothingness, and that the modern painter begins by copying. Instead of mountains, corpses, nudes, etc., it is his space that speaks to him, quivers, turns green or yellow with bile, gives him a sense of sport, of sign language, of the absolute.[52]

The transcendental aspects of this "Space" are, whatever else they may be, a space apart.

This idea of "Space" gives way to the metaphor of the "arena" in the culmination of the concept in his famous article, "The American Action Painters" from 1952:

> At a certain moment the canvas began to appear to one American painter after another as an arena in which to act—rather than as a space in which to reproduce, redesign, analyze or "express" an object, actual or imagined. What was to go on the canvas was not a picture but an event.[53]

This implied the new painting differed from older art fundamentally. The very function of painting was different from earlier abstraction, as the author points out. The artist creates, Rosenberg says, an environment of functions, among these "functions" are the spectators themselves.[54]

The "act" of painting as understood by Rosenberg, is inextricably linked to the biography of the artist. This act breaks down all distinctions between his life and his art, at least at the moment it is being created.[55] The artist is free to use any means at his disposal in this act: psychology, philosophy, history, mythology, etc., anything, that is, *except* art criticism.[56] According to Rosenberg, "The artist gets away from art through his act of painting: the critic can't get away from it."[57] The ultimate value of the new painting must be sought, Rosenberg asserts, "apart from art."[58]

That the ultimate goal of the work was unengaged, private and introverted is suggested by Rosenberg's assertion that the "center of the movement" was conceived of as "away from, rather than toward."[59] This implosion is summarized in the phrase referred to earlier, "The lone artist did not want the world to be different, he wanted his canvas to be a world."[60]

Greenberg's formalistic concept of "purism" as a goal for avant-garde painting is flatly denied by Rosenberg:

The new American painting is not "pure" art. . . . The apples weren't brushed off the table to make room for perfect relations of space and color. They had to go so that nothing would get in the way of the act of painting.[61]

Greenberg's whole enterprise of linking Abstract Expressionist painting to the traditions of earlier modern art by limiting considerations to those of form is lampooned by Rosenberg:

Limited to the esthetic, the taste bureaucracies of Modern Art cannot grasp the human experience involved in the new action paintings. One work is equivalent to another on the basis of resemblances of surface, and the movement as a whole a modish addition to twentieth-century picture making.[62]

The new art, came into being, as Rosenberg says, "Fastened to Modern Art"—appended to, but apparently for Rosenberg, not of the same substance.[63] Rosenberg's artist, disengaged from both history and society, clears out a space to create a new, subjective world. The artist's effort is heroic, his isolation a romantic tragedy.

The development of Rosenberg's position has often been linked to the spread of European existentialist thought in the postwar years.[64] Greenberg asserts that the ideas came from a "half-drunken conversation" between Rosenberg and Jackson Pollock (somewhat implausible, given the probable level of Pollock's familiarity with existentialist philosophy), although lectures by emegré artist Hubert Kappel on Heidegger at the Club during the previous year may be a more believable source for some of the European ideas in Rosenberg's thought.[65]

Without denying the connection to existentialism, Rosenberg's developing conception during the immediate postwar years of the individual artist in intense interaction with his actual, immediate surroundings and materials during the creative act, links him to earlier experiential paradigms in American thought stretching all the way back to the beginning of the century. It is on these, not the European precedents, that I will concentrate in the following section. In addition, as will be shown, Rosenberg's criticism had strong ideological parallels with Dewey, as different as was the art being explained by Rosenberg and that being promoted by experiential critics of the 1920s and 1930s for whom Dewey's thought was so important.

The anti-formalist thought of Rosenberg has echoes as far back as William James. The Abstract Expressionist artist, or "action painter," as Rosenberg calls him, is involved in an act or series of acts taking place relentlessly in the present moment. Like James's concept of the

stream of consciousness, the creative activity of the artist for Rosenberg is fluid—no historical laws govern the present or determine the future. In addition, as will be remembered, freedom was as central a concept to James as to Rosenberg.

Rosenberg's concepts also correspond to earlier Dadaist notions of the importance of an active, engaged attitude toward life. Dadaism as an historical movement had been all but dismissed by "serious" critics and historians until it received a more respectable presentation in the Museum of Modern Art's blockbuster 1936 exhibition, "Dada, Surrealism and their Heritage." Even then, Dada was almost completely overshadowed by its progeny, Surrealism, to which it was seen as merely a precursor.

At the time that Rosenberg wrote his important article on the action painters, renewed interest was being paid to Dadaism as a movement in its own right. Stimulating this new interest was the publication the year before of *The Dada Painters and Poets*, an anthology of manifestoes and memoirs of the original documents of not only New York Dada but also of French, German and Swiss Dada for the first time in English translation, edited by Rosenberg's sometime collaborator, Robert Motherwell.[66]

This publication dispelled many of the earlier stereotypes about the movement's nihilism and anarchism, revealing Dada's diversity and theoretical richness and presenting it as a movement in its own right, not as just a prelude to Surrealism. Many of the ideas first explored by the Dadaists were taken up by Rosenberg, for example, in "En Avant Dada" by Richard Huelsenbeck, the author states:

> The Dadaist should be a man who has fully understood that one is entitled to have ideas only if one can transform them into life—the completely active type, who lives only through action because it alone holds the possibility of his achieving knowledge.[67]

Action then, for Huelsenbeck, is the only way of knowing the world—through participating in the process, not just by observing or imitating life, or by the creation of objects for aesthetic contemplation. This emphasis on action and the process of creation was taken up wholeheartedly by Rosenberg, who declined, however, to extend this activity into the political sphere as Huelsenbeck had advocated.[68]

But the disengagement from life and the circumscribing of a space apart for the work of art also had precedents in the Dadaist thought of Marcel Duchamp. This is particularly true of his "readymades," disen-

gaged from their utilitarian function and set apart, chosen with aesthetic indifference. Duchamp continued his allegiance to the idea of the creative process operating in a separate realm, as shown in an essay from 1957 entitled, "The Creative Act."

> To all appearances, the artist acts like a mediumistic being who, from the labyrinth beyond time and space seeks his way out to a clearing.[69]

This "clearing," set apart from the confusions of time and space for the creative act, resembles closely Rosenberg's "arena." Although this very late essay makes its appearance five years after Rosenberg's seminal publication (and may actually have been influenced by it), it builds on ideas developed from Duchamp's "readymades" of the Dadaist years. The continuing presence of Duchamp on the New York scene and the critical reevaluation his work began to receive during the 1950s testifies to his renewed influence in avant-garde circles.

Rosenberg's action painter, making his canvas into a world, operates somewhere in between Duchamp's "readymades,"—designated art and set apart from ordinary experience—and Coady's broad inclusiveness which expands the boundaries of art indeterminately. The work of art is not so much an object set apart for Rosenberg as it is an experience, an action, an event—but an event with definite parameters in both time and space.

The direct and engaged concept of experience pioneered by Coady was continued and expanded during the 1920s in the little magazines such as *Broom* and *Contact*, and like both Coady's earlier and Rosenberg's later schema, the experience considered relevant takes place in the present and has no particular ties to history, making no claims for the future.

All this changes when Craven adds history to the experiential paradigm. Here, experience is seen as background which determines to a large extent the success or failure of the art. The particular nature of the artist's experience now becomes all-important. Only specifically American experience is relevant to the development of a national art, and only subject matter that corresponds to the experiences of a broad audience is acceptable.

Some of these directions were taken further by the critics of the left during the 1930s, who wanted art not only to reflect experience, but to be itself a transformative experience—a catalyst for change. The experience of both the artist and the viewer was placed into a larger Marxist context of social change and situated in relationship to the culture at

large through an approach drawn from contemporaneous anthropology.

Rosenberg's criticism, having its genesis in this leftist version of the paradigm, drew in the parameters of relevant experience to the subjective, self-contained, and isolated realm of the studio. This implosion of the experiential paradigm to a smaller, more manageable sphere was an act of self-survival for art at a time when Marxist dialectics was being discredited. It reflected the disillusionment of artists with Marxism and addressed the sense of crisis felt by artists and critics during the era of the cold war.

In retrospect, as different in other aspects as they were, the critical positions of Greenberg and Rosenberg agreed on at least these two points: authentic art is an activity that should be set apart from the mainstream or populist concerns of American culture; and Abstract Expressionism (though each interpreted it differently) was the art that did this most effectively and genuinely.

Rosenberg's critical thought also has much in common with John Dewey's aesthetic theory, but it is different aspects from Dewey that Rosenberg draws on than those which inspired the experiential paradigm as it was manifested in the 1930s. Leaving aside Dewey's populism, Rosenberg latches onto and expands Dewey's concept of the creative process.

Even though Dewey's concepts had been influential on the experiential paradigm of the 1930s, which favored recognizable subject matter, Dewey himself was not opposed to abstract art.[70] In fact, *Art as Experience*, was dedicated to the art collector and champion of modernism, Albert Barnes, whose writings Dewey quotes from extensively and on whom he relies for his discussion of abstraction.

Dewey, like Rosenberg, sees art as a process rather than a product.[71] He describes this process as the organization of energies, and devotes an entire chapter to explaining the creative act in these terms.[72] The "energies" Dewey talks about are not limited to the psychological energies an artist brings to his work, but also (like Rosenberg's action painter) refers to the counter-forces exerted on the creative process by the physical nature and properties of the materials and the limits set by the environment. The spectators themselves also bring their own specific energies in Dewey's model and thereby significantly contribute to the overall experience of the work of art as well. This parallels Rosenberg's contention, referred to earlier, that what goes on the canvas is not a picture but an event.

When form itself is discussed by Dewey, it is in surprisingly un-for-

malist terms. In the chapter entitled, "The Natural History of Form," Dewey uses the word in an active, verb sense to refer to the process of forming and shaping the materials. The entire experience of the work of art—whether this is the experience of the artist, the "former," or the experience of the viewer, also in some senses a "former,"—is an act of perceptual and spatial organization of energy.

> Form may then be defined as the operation of forces that carry the experience of an event, object, scene, and situation to its own integral fulfillment.[73]

The definition of form as an active process rather than a static quality— although difficult to apply to the art favored by the experiential critics of the 1930s (rather from the right or the left)—seems entirely suited to the work of the action painters as described by Rosenberg in 1952, even though of course this work did not yet exist when Dewey wrote *Art as Experience*.

Dewey also writes about space in terms which recall Rosenberg's formulation from 1949 discussed earlier, a space which (it will be remembered), Rosenberg says "speaks to him, quivers, turns green or yellow with bile," etc. Dewey's description is more prosaic:

> Space thus becomes something more than a void . . . it becomes a comprehensive and enclosed scene within which are organized the multiplicity of doings and undergoings in which man engages.[74]

This "doing" and "undergoing" are reciprocal processes between the artist and his environment, or in Dewey's description, the creative act of the "environing" artist.

The artist's activity of "forming," to use Dewey's active description of the process, involves both the person and their environment in a unitary event, an environment-as-experienced by an individual.

> Interaction of environment with organism is the source, direct or indirect, of all experience and from the environment come those checks, resistances, furtherances, equilibria, which, when they meet with the energies of the organism in appropriate ways, constitute form.[75]

The concept is strikingly similar to Rosenberg's description of the arena in which the artist acts. The environing artist, engaged in the process of the organization of energies through the means of doing and undergoing, contributes (but only contributes) to the development of form in the work of art. As Dewey puts it, he is the "doer of the deed that

breeds."[76] The process is continued and completed (breeds), when the viewer experiences the form, organizing the energies in the work of art to a perceptual culmination referred to by Dewey as an experience or, in Rosenberg, as the "event" that went onto the canvas of the action painter.

Even the term "work of art" takes on the attributes of action in Dewey's parlance, the real "work" being the building up of the experience on the part of the artist or viewer "while moving with constant change in its development" toward culmination.[77]

Despite the similarity of their descriptions of the creative process, Rosenberg cannot accept Dewey's call for the integration of the artist and the society, because it no longer seemed possible. In the aftermath of the war, this lack of optimism is perhaps understandable.

Yet it was Dewey's call for the artist's entry into the life of the community that was heeded more directly during the time of the publication of *Art as Experience*. Writers and artists of the 1930s might not have been able to apply Dewey's fluid theory of the artistic process to their work, but they seemed to agree with his description of their responsibility to society.

> Works of art that are not remote from common life, that are widely enjoyed by a community, are signs of a unified collective life. But they are also marvelous aids in the creation of such a life. The remaking of material of experience in the act of expression is not an isolated event confined to the artist and to a person here and there who happens to enjoy the work.[78]

Were it not for his occasional digression from discussion of the artistic process into his theory of community, Dewey's *Art as Experience* could almost read as a textbook for Abstract Expressionism if that movement is understood in terms of Rosenberg's arena of action rather than Greenberg's flat, material/visual fields.

---

By the early 1960s, when Greenberg's formalism was triumphant, Rosenberg realized that his view of Abstract Expressionism had "lost" in the struggle for defining the movement. In "Action Painting: A Decade of Distortion," published in *Art News* just two months after Greenberg's self-congratulatory essay, "After Abstract Expressionism," appeared in *Art International*.[79] Unconvinced and unrepentant, Rosenberg reiterates his position that painting, for these artists, was a means

of "confronting in daily practice the problematic nature of modern individuality."[80]

This was accomplished by a "shift inward," a "disengagement," as he says from the "crumbling Liberal-Left" to Rosenberg's more rarefied arena of artistic activity where "a succession of champions performed feats of negation for the liberation of all."[81] Somewhat on the defensive at this point, Rosenberg asserts that this was not an opportunistic escapism from current problems, but a radical means of transcending these problems.[82]

He assails the art establishment for distorting the history of Abstract Expressionism through its adoption of the formalist interpretation of this work derived from Greenberg, which Rosenberg, like his predecessors in the experiential camp, refers to as a new form of academicism:

> The root theory of the distortion is the academic concept of art as art — whatever the situation or state of the artist, the only thing that "counts" is the painting and the painting itself counts only as line, color, form.[83]

This "arid professionalism" ignores the "crisis-dynamics" of the movement's genesis and so misses the point, according to Rosenberg.[84]

Grasping the situation of cultural crisis into which Abstract Expressionism was born, and to which it was a response, is essential to understanding it properly in Rosenberg's view. The art establishment suppresses this aspect of the work:

> To forget the crisis, individual, social, esthetic, that brought Action Painting into being, or to bury it out of sight (it cannot really be forgotten), is to distort fantastically the reality of postwar American art. This distortion is being practiced daily by all who have an interest in "normalizing" vanguard art, so that they may enjoy its fruits in comfort: these include dealers, collectors, educators, directors of government cultural programs, art historians, museum officials, critics, artists — in sum, the "art world."[85]

It is only by understanding Abstract Expressionism within its original context of crisis, Rosenberg maintains, that we arrive at a meaning for that art deeper than the merely formal.

---

The critical theory underlying the opposing positions of Greenberg and Rosenberg represent the culmination of the paradigms that have been traced in this book. Their interpretations gained such authority that, by 1975, Tom Wolfe asserted irreverently in his notorious article,

"The Painted Word," that future generations may well be more impressed with the critical commentary than the painting of the period itself, framing enlarged texts by these critics for future exhibitions and illustrating them with small reproductions of the work of Pollock, Rothko, and the others—so much have their interpretations overshadowed the art.[86]

Although Wolfe's comments take the issue to an absurd extreme, they do summarize the enormous importance criticism held during the postwar period—an importance criticism has not held before or since in the American (and for that matter, the international) art world.

But Greenberg and Rosenberg represent both the climax and the swan song of these strains of thought in American critical discourse. During the late 1950s and into the 1960s, the critical matrix began to shift, with artists themselves increasingly engaged in the critical and theoretical discourse. They came to assume a position of authority comparable to the position earlier assumed by critics and to take the modern formalist and experiential paradigms into new, heterogeneous, postmodern directions.

# Conclusion

Two opposing paradigms have dominated American critical thought since the beginning of the century. This debate has its genesis in American ideas from a number of fields during the preceding twenty years. Called formalism and anti-formalism, or modernism and anti-modernism, by later writers, these strains of thought were clearly active shapers of the critical discourse in the United States during the first decades of the century.

That field was drastically altered with the advent of modern art on the critical scene in the Armory Show of 1913. Realignments at that time pitted pre-modern critics of both types against the new enemy. For this reason they are often lumped together by contemporary scholars. But within a few years, the moderns themselves had split into formalist and anti-formalist interpretations of the new art along the old fault line: a disagreement over the parameters appropriate to art. The new art was to be thought of either in terms of formalist determinism or experiential organicism. It was in some senses a struggle for the soul of modernism.

This struggle is exemplified by the debate surrounding the Forum Exhibition of 1916. Willard Huntington Wright posited "laws" of art historical development that governed the direction of art. Chief among these was a tendency toward purity of form, a reduction (a "minimization," in Wright's parlance) to essence, and a maintenance of exclusivity. R. J. Coady, on the other hand, posited a more open-ended modernism based on art as experience. Rather than setting itself apart, Coady's approach broke down barriers between art and life and between artist and non-artist. It was self-consciously American in concept.

The formalist tendencies of Wright overtook the experiential approach of Coady during the 1920s, but the publication of Dewey's *Art and Nature* at mid-decade, with its dynamic theory of aesthetic experience and its commitment to localism and community, provided a basis for a nationalistic version of the experiential paradigm as exemplified by the writings of Thomas Craven. He and others championing the American Scene movement of the 1930s rose to a position of dominance

during the first half of the decade, while a more politically engaged form of the experiential paradigm developed and then fell apart in the years immediately before the war.

Meanwhile, the formalist paradigm was kept alive through teachers and influential exhibitions throughout these years and during the war, providing the basis for its continuation and eventual domination of the critical arena in the postwar period.

Clement Greenberg and Harold Rosenberg wrote about Abstract Expressionism and their interpretations came to dominate the critical arena in the years following the war. Greenberg's call for purity, his historical determinism, and his exclusivity clearly mark him as the heir to formalist thought stretching back to Willard Huntington Wright. His most original addition to the paradigm was his theory of the inauthenticity of mainstream culture in the United States and his call for an art based on truth to materials.

Harold Rosenberg drew in the parameters of relevant experience in his postwar version of the opposing paradigm. Returning to earlier, Dadaistic manifestations of the experiential paradigm, he called for a process-oriented interpretation of the new art in terms reminiscent of Dewey, but without Dewey's populism. Because his interpretation emphasized freedom, it was particularly popular during the early 1950s at the height of the cold war. Later, when the threat from the right had abated, Greenberg's formalism came to dominate late modern critical thought. Accompanying the ascendance of Greenberg's formalism was a disparagement, not only of Rosenberg's experience-based interpretation of late modernism, but a wholesale critical dismissal of the art of the 1930s championed by the experiential critics from that period.

Perhaps now at the beginning of a new century, having realized the limitations of the formalist interpretation that had dominated late modernist criticism until recently, twentieth-century art in the United States can be reevaluated in terms of the struggle of rival critical thought in its reception.

# Notes

## Introduction

1. Frances Stoner Saunders, *Who Paid the Piper: The Cultural Cold War and the World of Arts and Letters*, (New York: W.W. Norton and Company, 1999).

2. There have been several studies of this sort stretching back nearly three decades, including Max Kozloff, "American Painting During the Cold War," *Artforum* 12 (May 1973): 43–54; Eva Cockcroft, "Abstract Expressionism, Weapon of the Cold War," *Artforum* 12 (June 1974): 39–41; and Serge Guilbaut, *How New York Stole the Idea of Modern Art*, (Chicago: University of Chicago Press, 1983).

3. Stephen Polcari, *Abstract Expressionism and the Modern Experience* (New York: Cambridge University Press, 1991). See especially the chapter entitled "The Psychology of Crisis: The Historical Roots," pp. 3–30.

4. A parallel, but very different kind of, battle is posited by Rosalind Krauss in *The Optical Unconscious* (Cambridge: MIT Press, 1993). According to Krauss, mainstream, classic Modernism of the twentieth century is organized around the principle of the grid, ultimately derived from Cubism (but already implicit in Renaissance perspective). The grid, according to Krauss, masks a deeper structure: that of dislocation or "slippage" into an unconscious realm of forbidden desire (Modernism's dark "Other").

Equating the figure ground relationship in Gestalt perceptual psychology with the functions of the conscious and unconscious mind in Freudian psychoanalysis, Krauss sees a repeated sabotaging of the Modernist principle of the grid in certain key works from the past century, especially by Duchamp, Ernst, Giocometti, Pollock, and Hesse. This important dialectic in Modernism was "lost," according to the author, because it was repressed.

When this lost "Other" appears, Krauss suggests, it is most often as a rupture in the fabric of rational Modernism, having the uncanny, numinous quality of a partially recovered memory (and so, to me, what she describes is a sort of postmodern sublime, already evident in Dada).

While these kinds of studies are fascinating (although highly speculative), what I am attempting in this book is much more modest: to trace an entirely conscious strategy for dominance of the critical discourse as it shows up in writings from the period.

This is not to say that oedipal urges were not at work in the critical debate I will describe (or, for that matter, in the case of the writing of Krauss, Greenberg's former protégé).

5. John Dewey, *Experience and Nature* (Chicago: Open Court Publishing Co., 1925); *Art as Experience* (New York: Minton, Balch Co., 1934).

6. Morton White, *Social Thought in America: The Revolt Against Formalism* (New York: Viking Press, 1949).

7. Willard Huntington Wright, *Modern Painting: Its Tendency and Meaning* (New York: Dodd, Mead Co., 1915).

8. A number of his essays and books explicate this position. See especially Richard Rorty, *Contingency, Irony, and Solidarity* (New York: Cambridge University Press, 1989).

9. Cornel West, "The New Cultural Politics of Difference," *The Cornel West Reader*, (New York: Basic Civitas Books, 1999), 119. Originally published in *Out There* (New York: New Museum of Contemporary Art, 1991), an exhibition catalogue.

10. Conrad Aikin, "The Function of Criticism?" *Broom* 1 (November 1921): 33 (emphasis in original).

## CHAPTER 1. FORMALISM AND ANTI-FORMALISM IN . . . THOUGHT

1. The quest for these all-encompassing laws was given an impetus and a rational form by Hegel at the beginning of the nineteenth century. He postulated a dialectical process of "advance" in history through the resolution of antagonistic social and historical forces. This linear directionality replaced earlier models of history which tended to be cyclical. It also implied a telos or end state of equilibrium. In terms of its linear directionality and its anticipation of the future, it was progressive.

2. I.e., David W. Marcell, *Progress and Pragmatism: James, Dewey, Beard and the American Idea of Progress* (Westport, Conn.: Greenwood Press, 1974).

3. Ibid., 11–58.

4. For an excellent treatment of the era the reader should consult T. J. Jackson Lears, *No Place of Grace: Antimodernism and the Transformation of American Culture 1880–1920* (New York: Pantheon Books, 1981), to which this chapter is indebted.

5. Herbert Spencer, *Social Statics: The Conditions Essential to Human Happiness Specified, and the First of Them Developed,* (New York: D. Appleton Co., 1888).

6. Quoted in Marcell, 99.

7. The most prominent American spokesman for Spencer was John Fiske. Fiske was an historian, essayist, and popular speaker. A part-time lecturer and librarian at Harvard and a nonresident professor at Washington University in St. Louis, Fiske wrote regularly for popular journals and newspapers. He lectured widely and became well known for his popular, interpretive books on American history. See George Winston, *John Fiske* (New York: Twayne Publishers, 1972).

8. See Henry Adams, "The Tendency of History" (1894) and "The Rule of Phase Applied to History" (1909) in *The Degradation of the Democratic Dogma* (New York: Macmillan Co., 1919).

9. Ibid., 308.

10. See George Miller Beard, *American Nervousness: Its Causes and Consequences* (New York: Putnam, 1881). Interestingly, the disease seemed most likely to afflict the upper classes—see Lears, 50–51.

11. Lears, 48.

12. Ibid., 124.

13. Henry James, ed., *The Letters of William James* (Boston: The Atlantic Monthly Press, 1920), 147. Quoted in Henry James's (W. James's son) section introduction as a notebook entry by his father dated April 30, 1870.

14. See William James, *The Will to Believe and Other Essays in Popular Philosophy* (New York: Longmans, Green Co., 1897).

15. William James, "Great Men, Great Thoughts, and the Environment," *The Atlantic Monthly* 46 (October 1880): 454.

16. Ibid., 455.

17. Marcell, 38.

18. White, 12.

19. Ibid., 13.

20. Ibid., 27.

21. James Harvey Robinson, *The New History: Essays Illustrating the Modern Historical Outlook* (New York: Macmillan, 1912): 44, 54.

22. Ibid., 69.

23. Charles A. Beard, *Contemporary American History 1877–1913* (New York: Macmillan, 1914).

24. Ibid., v.

25. Ibid., vi.

26. Van Wycks Brooks, "On Creating a Usable Past," *Dial* 64 (April 1918): 337–41.

## CHAPTER 2. FORMALISM AND ANTI-FORMALISM IN . . . SHOW

1. Virginia Mecklenburg, "Aesthetic Theory in America, 1910–1920" (PhD diss., University of Maryland, 1983), 23.

2. Kenyon Cox, *The Classic Point of View* (New York: C. Scribners and Sons, 1911), 4–5.

3. Ibid., 7.

4. Ibid., 10.

5. Ibid., 26.

6. Kenyon Cox, *What is Painting: "Winslow Homer" and Other Essays* (1914; reprint, New York, London: Norton, 1988), xxiii. Gene Thorton's new introduction to this republication of Cox's essays provides a concise overview of Cox and his career.

7. Ibid., 20.

8. Cox, *The Classic Point of View*, 20.

9. Ibid., 22.

10. Ibid., 3.

11. Ushers were placed in the exhibit to lead the crowd through the show in this chronological order.

12. *Arts and Decoration* 3 (March 1913): 150.

13. Walter Pach, "Hindsight and Foresight," in *For and Against* (New York: Association of American Painters and Sculptors, 1913), 27.

14. Ibid., 29.

15. Walter Pach, "The Cubist Room," in *For and Against*, 52.

16. Martin Burgess Green, *New York 1913: The Armory Show and the Patterson Strike Pageant* (New York: Scribner, 1988), 18.

17. Pach, "The Cubist Room," 63.

## CHAPTER 3. A SPLIT AMONG THE MODERNS

1. "Current News of Art and the Exhibitions," *New York Sun*, March 12, 1916.

2. Ibid.

3. Ibid.

4. "Current News of Art and the Exhibitions," *New York Sun*, March 19, 1916.

5. W. D. MacColl, "The International Exhibition of Modern Art: An Impression," *The Forum* 50 (July 1913): 24–36.

6. Frederick James Gregg, "Bread and Butter and Art," *The Forum* 52 (September 1914): 443–50.

7. Ibid., 449.

8. Willard Huntington Wright, "The Aesthetic Struggle in America," *The Forum* 55 (February 1916): 201–20.

9. Willard Huntington Wright, "Art, Promise and Failure," *The Forum* 55 (January 1916): 34.

10. Ibid.

11. Willard Huntington Wright, *Modern Painting* (New York: Dodd, Mead, 1915). In order to reach a broader readership, Wright reworked chapters from the book into articles for *Forum* magazine. It was republished in later editions under the pseudonym S. S. Van Dine.

12. The Forum Exhibition Committee, Press Release, no date (circa February/March 1916), from scrapbook in the *S.S. Van Dine Papers* 38, Rare books and Manuscripts, Firestone Library, Princeton University.

13. William Innes Homer, "The Armory Show and Its Aftermath," in *Avant-Garde Painting and Sculpture in America 1910–1925* (Wilmington: Delaware Art Museum, 1975), 18.

14. See Clive Bell, *Art* (London: Chato and Windus, 1913). The book was simultaneously published by Stokes and Co. in New York and was undoubtedly familiar to Wright. Roger Fry had published articles in *The Burlington Magazine*, a British art journal, since 1908. He was also the main organizer of the important Grafton Gallery exhibition of Post Impressionism, held in London in 1912. For a general account of his thought see *Vision and Design* (London: Chatto and Windus, 1920).

15. Willard H. Wright, "The Truth About Painting," *The Forum* 54 (October 1915): 443–54.

16. Ibid., 444.

17. Ibid., 447.

18. Ibid., 450.

19. Ibid., 452.

20. Willard H. Wright, "Impressionism to Synchromism," *The Forum* 50 (December 1913): 757–70.

21. Ibid., 762.

22. Willard H. Wright, "Notes on Art," *The Forum* 55 (June 1916): 691.

23. Although Wright often compares music to abstract art (i.e., *Modern Painting*, 10).

24. See William C. Agee, "Willard Huntington Wright and the Synchromists," *Archives of American Art Journal* 24 (March 1984): 10–15. Agee compares original artist's statement by Morgan Russell sent from Paris to heavily edited version which actually appeared in the Forum exhibition catalogue. He also notes a letter sent from Thomas Hart Benton to art historian Matthew Baigell. According to Benton, Wright forced him to add a paragraph to be "in harmony" with the other artists and with the aims of the exhibit (p. 12). If one compares all the artist's statements in the catalogue, the final paragraph in most cases tends to reflect Wright's teleological model. Significantly, each of Stieglitz's artists seem to be free of this.

25. "Current News," *New York Sun*, 19 March, 1916.

26. Ibid.

27. Charles Chaplin, "Making Fun," *The Soil: A Magazine of Art* 1 (December 1916): 5–8.

28. F. M., "Dressmaking," *The Soil*: 26–30.

29. J. B., "Bert Williams—An Interview," *The Soil*: 19–23.

30. R. J. Coady, "The Stampede," *The Soil*: 24.

31. Ibid., 25.

32. R. J. Coady, "American Art," *The Soil*: 3–4.

33. *Blind Man* 1 (May 1917): 5. This was one of the extremely short-lived Dadaist magazines which proliferated at the time. It lasted only two issues.

34. Duchamp is quoted as having said this in *The Blind Man*, cited above.

35. Arthur Craven, "Arthur Craven vs. Jack Johnson," *The Soil: A Magazine of Art*, 1 (June 1917): 162.

36. Judith K. Zilczer, "Robert J. Coady, Forgotten Spokesman for Avant-Garde Culture in America," *American Art Review* 2 (1975): 82.

37. R. J. Coady, quoted in Zilczer, 84.

38. "Old John Smith," *The Soil* 1 (January 1917): 57.

39. Van Wyck Brooks, "Highbrow and Lowbrow," *The Forum* 53 (April 1915): 481–92.

## Chapter 4. The Paradigms Take Shape

1. For a concise overview, see Susan Noyes Platt, "Formalism and American Art Criticism in the 1920's," *Art Criticism* 2 (1986): 69–83. However, please note that there are many puzzling typographical errors in her footnotes.

2. *The Arts* 1 (April 1921): 1.

3. Forbes Watson, "The Latest Thing," *The Arts* 16 (May 1928): 595.

4. Ralph Block, "The Failure of Modern Criticism," *The Freeman* 2 (June 1921): 300–301.

5. Platt, 76.

6. Henry McBride, "Modern Art," *The Dial* 74 (February 1923): 218.

7. Henry McBride, "Modern Art," *The Dial* 73 (November 1922): 586–87.

8. Willard Huntington Wright, *The Future of Painting* (New York: W. Huebsch, 1923).

9. He later published detective novels under the pseudonym S. S. Van Dine.

10. Thomas Craven, "An Aesthetic Prophesy," *The Dial* 75 (July 1923): 88.

11. Ibid.

12. Thomas Craven, "The Progress of Painting: The Modern Background," *The Dial* 74 (April 1923): 358.

13. Ibid.

14. Ibid.

15. Ibid., 587.

16. Ibid., 588.

17. Ibid., 593.

18. Walter Pach, "The Contemporary Classics," *The Freeman* 3 (July 13, 1921): 423.

19. Walter Pach, "Art in America," *The Freeman* 2 (November 17, 1920): 232.

20. Ibid., 233.

21. Ibid.

22. Walter Pach, *The Masters of Modern Art* (New York: B. W. Huebsch, 1924): 1.

23. Ibid., 102.

24. Ibid.

25. Guy Eglington, "Art and Other Things" *International Studio* 80 (January 1925): 341.

26. Ibid.

27. Guy Eglington, "The American Painter," *The American Mercury* 1 (February 1924): 219.

28. Ibid.

29. Ibid., 220.

30. Guy Eglington, "The Complete Dictionary of Modern Art Terms for the Use of Aspiring Amateurs," published as a series in *International Studio* 31: (March 1925): 68–70; (April 1925): 141–51; (June 1925): 224–31; (July 1925): 307–9; (August 1925): 375–77.

31. Ibid. (March, 1925): 495.

32. Frank Jewett Mather, et al., "Pure Art or 'Pure Nonsense?'" *The Forum* 74 (July 1925): 146.

33. Ibid.

34. Henry Billings, "Artifice and Metaphor," *The Arts* 13 (February 1928): 290. See also the series by Thomas Hart Benton published in 1927 in the same journal, entitled collectively, "The Mechanics of Form Organization," *The Arts* 10 (November 1926): 285–90; 11 (January 1927): 43–45; (February 1927): 95–97; (March 1927): 145–47. It is surprising to what degree Benton was a formalist at the time.

35. Irving Babbitt, "Genius and Taste," *The Nation* (February 7, 1918), reprinted in *Criticism in America: Its Function and Status* (New York: Harcourt, Brace, 1924): 163.

36. Ibid., 169.

37. Ibid., 170.

38. [No author listed], "The Critic and the Artist," *The Freeman* 2 (November 1920): 222.

39. [No author listed], "The Illusion of the Critics," *The Freeman* 4 (November 1921): 175.

40. W. G. Blaikie-Murdoch, "For Freedom in Criticism." *The Freeman* 4 (February 1922): 544.

41. Ibid.

42. Ibid.

43. Conrad Aikin, "The Function of Criticism?" *Broom* 1 (November 1921): 33, 36.

44. Ibid., 34.

45. Ibid., 36.

46. Ibid., 37.

47. Ibid.

48. Robert A. Sanborn, "A Champion in the Wilderness," *Broom* 3 (October 1922): 179.

49. Frederick Hoffman et al., *The Little Magazine: A History and a Bibliography*, (Princeton: Princeton University Press, 1946): 85.

50. Ibid.

51. *Broom*, 1 (November 1921): 95.

52. H. A. Leob, "The Mysticism of Money," *Broom* 3 (September 1922): 115.

53. Ibid.

54. Ibid.

55. Ibid. 128.

56. Ibid.

57. Ibid.

58. Ibid., 129.

59. Matthew Josephson, "The Great American Billposter," *Broom* 3 (November 1922): 305.

60. Ibid.

61. Ibid., 304.

62. William Carlos Williams, *Contact* 1 (December 1920): 1.

63. William Carlos Williams, "Comment," *Contact* 1 (n.d.): 18.

64. John Gould Fletcher, "Art and Life," *The Freeman* 3 (1921): 247.

65. Laurence Buermeyer, "Some Popular Fallacies in Aesthetics," *The Dial* 76 (February 1924): 115.

66. John Dewey, *Experience and Nature* (Chicago: Open Court Publishing Co., 1925): 356.

67. Thomas M. Alexander, *John Dewey's Theory of Art, Experience and Nature: The Horizons of Feeling* (Albany: State University of New York Press, 1987), 187.

68. Dewey, 1934: 358.

69. Ibid., 359.

70. Ibid., 364.

71. Matthew Baigell, "American Art and National Identity," *Arts* 61 (February 1987): 49.

72. John Dewey, "Americanism and Localism," *The Dial* 68 (June 1920): 684.

73. Ibid., 185.

74. Ibid.

75. Ibid., 687.

76. Wayne L. Roosa, "American Art Theory and Criticism During the 1930s: Thomas Craven, George L. K. Morris, Stuart Davis," PhD diss., Rutgers University, 1983.

77. Thomas Craven, "Daumier and the New Spirit," *The Dial* 78 (March 1925): 241.

78. Ibid.

79. Thomas Craven, "Photography and Painting," *The Dial* 79 (September 1925): 196.

80. Ibid., 202.

81. Thomas Craven, "Men of Art," *American Mercury* 6 (December 1925): 426.

82. Ibid, 427.

83. Ibid., 426.

84. Ibid., 432.

85. Thomas Craven, "Have Painters Minds?" *American Mercury* 10 (March 1927): 257.

86. Ibid., 258.

87. Ibid., 262.

88. Thomas Craven, "The Curse of French Culture," *The Forum* 82 (July 1929): 62.

## CHAPTER 5. THE PARADIGM COMES OF AGE I

1. Matthew Baigell, *The American Scene: American Painting of the 1930's* (New York: Praeger, 1974): 21.

2. John Dewey, "Individualism, Old and New I: The United States, Incorporated," *The New Republic* 61 (January 22, 1930): 241.

3. John Dewey, "Individualism Old and New II: The Lost Individual," Capitalism or Public Socialism?'" *The New Republic* 61 (February 5 1930): 296.

4. John Dewey, "Individualism Old and New IV: Capitalism or Public Socialism?" *The New Republic* 61 (March 5, 1930): 64–66.

5. John Dewey, "Individualism Old and New III: Toward a New Individualism," *New Republic* 62 (February 19, 1930): 14.

6. John Dewey, "Individualism Old and New V: The Crisis in Culture," *The New Republic* 62 (March 19, 1930): 123.

7. Ibid.

8. Ibid., 126.

9. "On 8th Street," *Time* 18 (November 23, 1931): 23.

10. Henry McBride, "The Palette Knife," *Creative Arts* 9 (November 1931): 355.

11. Ibid., 358.

12. This essay will be dealt with in a subsequent chapter.

13. "Decorous Jubilee," *Time* 19 (April 25, 1932): 26.

14. Baigell, *The American Scene*, 18.

15. Holger Cahill, "American Art Today," *America as Americans See It* (New York: The Literary Guild, 1931): 243–66. Cahill was later to become the national director of the WAP (see chapter 6).

16. Ibid., 244.

17. Ibid.

18. Ibid.

19. Robert L. Duffus, *The American Renaissance* (New York: A. A. Knopf, 1928): 317.

20. McBride, 358.

21. Ibid., 356.

22. Thomas Craven, *Men of Art* (New York: Simon and Schuster, 1931): xix.

23. Ibid., xxi

24. Ibid.

25. Ibid., xxii.

26. Ibid., 24.

27. Ibid., 9–10.

28. I will continue to use masculine pronouns when summarizing Craven's thought because it gives the reader a better sense of the tone of the writing, which was both sexist and homophobic.

29. Ibid., 29–31.

30. Ibid., 30.

31. Ibid., 52.

32. See Franz Boas, *Anthropology and Modern Life* (New York: Norton, 1928), for a nearly contemporaneous view.

33. Craven, *Men of Art*, 491.

34. Ibid., 506.

35. Ibid.

36. Ibid., 513.

37. "Recent Books on Art: 'Men of Art,'" *Art News* 29 (April 11, 1931): 14.

38. Ibid.

39. "New Books," *Parnassus*, (October 1931): 40.

40. Ibid., 41

41. Thomas Craven, "Renaissance Near?" *Art Digest* 5 (September 1931): 5.

42. Thomas Craven, "The Snob Spirit," *Scribners Magazine* 91 (February, 1932): 81–86.

43. Ibid., 81.

44. Ibid., 83.

45. Ibid., 83.

46. Ibid., 86.

47. Ibid., 84.

48. "Craven's Crusade," *Art Digest* 1 (May 1932): 26.

49. Thomas Craven, *Modern Art: The Men, the Movements, the Meaning* (New York: Simon and Schuster, 1934). This book will henceforth be referred to as *Modern Art*.

50. Ibid., xx.

51. The first chapter is entitled "Bohemia." Ibid., 1–60.

52. Ibid., 30.

53. Ibid., 218.

54. Ibid.

55. Ibid., 165.

56. Ibid., 174.

57. Ibid., 210.

58. Ibid., 324.

59. These ideas come from Dewey's concepts of "doing" and "undergoing," discussed later.

60. Ibid., 312.

61. Ibid.

62. Ibid., 335

63. "An Epochal Book," *Art Digest* 32 (June 1934): 29.

64. "Recent Art Books: Modern Art," *Art News* 32 (May 1934): 16.

65. "Modern Art," *American Magazine of Art* 27 (August 1934): 449.

66. Ibid.

67. I.e., "How to Interest Children in Art," *Good Housekeeping* 112 (January 1941): 25, 63; *Pocket Book of Greek Art* (New York: Pocket Books, 1940); *The Rainbow Book of Art* (Cleveland: World Publishing Co., 1956).

68. Thomas Craven, Introduction to *Benvenuto Cellini*, trans. John Symonds, (Verona, NJ: Heritage Press, 1937).

69. Experience is a concept flexible enough in Dewey to accommodate not only the American Scene painting and Social Realist art of his own present, but would also be able to encompass later developments.

70. John Dewey, *Art as Experience* (New York: Minton, Balch, and Co., 1934).

71. Ibid., 54. Emphasis his.

72. Ibid., 55.

73. Ibid., 331.

74. Ibid., 6.

75. Ibid.

76. Ibid., 295.

77. Ibid., 299.

78. Ibid., 589.

79. Ibid.

80. Ibid.

## CHAPTER 6. THE PARADIGM COMES OF AGE II

1. Edwin Alden Jewell, *Americans* (New York: Knopf, 1930): 28.

2. Ibid., 20.

3. Ibid., 34, 35.

4. Ibid., and throughout chapter 3.

5. Ibid., 33–38.

6. This view was given really widespread influence in 1934 through the publication of Ruth Benedict's, *Patterns of Culture* (Boston: Houghton Mifflin and Co., 1934), perhaps the most widely sold anthropology book of all time. In it, Benedict argues convincingly against the racial theories of the old anthropology.

7. Edwin Alden Jewell, "Toga Virilis: The Coming of Age of American Art," *Parnassus* 4 (April 1932): 1.

8. Edwin Alden Jewell, *Have We an American Art?* (New York: Longmans, Green and Co., 1939): 206.

9. Ibid.

10. As they continually boast in their advertisements.

11. Peyton Boswell Jr., *Modern American Painting* (New York: Dodd, Mead, 1940): 11, 69.

12. Ibid., 45.

13. Ibid., 60.

14. Ibid., 79.

15. David Shapiro, *Social Realism: Art as a Weapon*, (New York: Ungar, 1973).

16. Matthew Baigell, and Julia Williams, eds., *Artists Against War and Fascism: Papers of the First American Artists' Congress* (New Brunswick: Rutgers University Press, 1986). By the time of their first annual exhibition in 1932, they had established no less than thirteen clubs nationwide and were involved in a number of activities. By 1934, their number had increased to around thirty.

17. See "Draft Manifesto of the John Reed Clubs," *New Masses* (June 1932): 14. Reprinted in Shapiro, *Social Realism*.

18. Anita Brenner, "Revolution in Art," *The Nation* (March 8, 1933): 267–69. Reprinted in Shapiro, 74–78.

19. Brenner in Shapiro, *Social Realism*, 75.

20. Ibid., 77.

21. Francis V. O'Connor, ed., *Art For the Millions: Essays from the 1930s by Artists and Administrators of the WPA Federal Art Project* (Greenwich: New York Graphic Society, 1979). See O'Connor's introduction for a detailed overview.

22. Museum of Modern Art, *New Horizons in American Art* (New York, 1936): 20.

23. See Gerald M. Monroe, "Artists as Militant Trade Union Workers During the Great Depression," *Archives of American Art Journal* 14 (Spring 1974): 7–10.

24. O'Connor, *Art for the Millions*, 23.

25. Ibid., 34.

26. Communist Party influence was apparent from the start. Alexander Trachtenberg, who represented the central committee of the CPUSA, had called for both a Writers' and an Artists' Congress in the second national conference of the John Reed Clubs during the summer of 1934. In early May, having seen the realization of the Writers' Congress the previous month, Trachtenberg attended a meeting of the John Reed Club, urging them to form a Congress to attract a broad spectrum of artists the John Reed

Clubs could not recruit. The first organizational meeting of the Congress later that month was also attended by Trachtenberg, as was the second meeting in June. It was later that same summer, it will be remembered, that the Communist International established the Popular Front policy described earlier. It is possible that Trachtenberg, as an insider to communist party policy, may have foreseen the shift in strategy and began to push for an organization which would represent the aspirations of the Popular Front, perhaps knowing that the John Reed Clubs were to be phased out. See Baigell and Williams, *Artists Against War*, 8.

27. Ibid., 10.

28. Ibid.

29. Meyer Schapiro, "The Social Bases of Art," in *Proceedings of the First American Artists' Congress* (New York, 1936): 31–37. Reprinted in Baigell and Williams, *Artists Against War*, 103–13.

30. Baigell and Williams, *Artists Against War*, 103.

31. Ibid., 110.

32. Ibid.

33. Ibid., 108.

34. Ibid.

35. Ibid., 105.

36. Ibid., 106.

37. Ibid., 108.

38. Meyer Schapiro, "Race, Nationality and Art," *Art Front* 2 (March 1936): 10–12.

39. Ibid., 10.

40. Ibid., 12.

41. Ibid.

42. Ibid.

43. Meyer Schapiro, "Nature of Abstract Art," *Marxist Quarterly* 1 (January-March 1937): 77–98.

44. *Arts and Decoration*, 3 (March 1913): 150.

45. Schapiro, "Nature of Abstract Art," 82.

46. Ibid., 81.

47. Ibid., 82.

48. Ibid., 92.

49. Ibid., 77, 78.

50. Ibid., 78, 90.

51. Ibid., 85.

52. Ibid., 86.

53. Annette Cox, *Art as Politics: The Abstract Expressionist Avant-Garde and Society* (Ann Arbor: UMI Research Press, 1982): 26.

54. "17 Members Bolt Artists' Congress," *New York Times* (April 17, 1940): 25.

55. Another group—decidedly less liberal—was formed in reaction to the breakup of the congress by disillusioned former members. The Federation of Modern Painters and Sculptors formed in June of 1940, decided to pursue the exposure of Party influence within artist's organizations, such as Artists for Victory and Artists Equity. It became an active agent for anti-communism in the art world and can now be seen as a prelude to the red-baiting of the McCarthy years. See Cox, 28–29.

56. And, incidentally, a student of Meyer Schapiro.

57. Milton Brown, "After Three Years," *Magazine of Art* 34 (April 1946): 138.

## CHAPTER 7. FORMALISM AS A MINORITY POSITION

1. Sam Kootz, *Modern American Painters*, (New York: Brewer and Warren, 1930): 1.

2. Ibid., 2.

3. I.e., Willard Huntington Wright, Walter Pach, Thomas Craven, Meyer Schapiro.

4. Ibid., 4.

5. Ibid., 5.

6. Ibid., 5, 9.

7. Ibid., 11. Kootz later became an important dealer of Abstract Expressionism, a style that would seem to fit into his earlier prescriptive for a new but unliterary sublime.

8. Ibid., 19.

9. See Kootz, "American Uber Alles: Critic Rises to Admonish Our 'Renaissance'—Urges 'Let's Forget Premature Circus,'" *New York Times*, (Sunday, December 20, 1921): 6,7.

10. Kootz's *New Frontiers of American Painting*, (New York: Hastings House, 1943) reiterates his position so strongly that the rhetoric becomes bombastic.

11. Marcia Epstein Allentuck, *John Graham's System and Dialectics of Art*, (Baltimore: Johns Hopkins University Press 1971): 22.

12. See the foreword to Allentuck's book, a reminiscence by sculptor Dorothy Dehner. Peter Agostini, an artist I have worked with in connection with another project, also spoke very insistently to me of Graham's importance at the time.

13. Allentuck, 102.

14. Ibid., 26–27. Graham's *Systems and Dialectics of Art* was published in 1937. These aphorisms, however, developed out of earlier conversations and may easily be points he had been making for a number of years. Greenberg first states his position on this matter in "Towards a Newer Laocoon" in *Partisan Review* in March 1940. Graham's description of a "unified surface" also anticipates Greenberg's "unified field" a concept which is not articulated by Greenberg until 1955 in "American Type Painting," *Partisan Review* 22 (Spring 1955): 179–96.

15. Cynthia Goodman, *Hans Hofmann*, (New York: Abbeyville Press, 1986): 28.

16. His ideas were gathered together in Sara T. Weeks, ed., *"Search for The Real" and Other Essays* (Cambridge: M.I.T. Press, 1967).

17. A. E. Gallatin, "The Plan of the Gallery of Living Art," (New York: 1933):no page numbers.

18. See also "The Evolution of Abstract Art as Shown in the Gallery of Living Art," Ibid.

19. A. E. Gallatin, "The Plan of the Gallery,"

20. Alfred H. Barr, ed. and principal author, *Cubism and Abstract Art*, (New York: Museum of Modern Art, 1936): 13.

21. Ibid., 9.

22. Nothing is done of course, to dispel the image of collectors as wealthy.

23. The chart is reproduced as a frontispiece in the reissued version of the catalogue.

24. Barr, *Cubism*, 18.

25. Ibid., 200.

26. Edwin Alden Jewell, *New York Times*, April 11, 1937.

27. Robert M. Coates, "Abstractionists and What About Them?" *New Yorker* (March 18, 1939): 57.

28. *The Art Critics—How Do They Serve the Public? What Do They Say? How Much Do They Know? Lets Look at the Record!* (New York: 1940): 3.

29. Ibid., 9.

30. Ibid., 12.

31. The Artists' Congress and the artists' union were primarily organized for political action.

32. See Melinda Lorenz, *George L.K. Morris: Artist and Critic*, (Ann Arbor: UMI Research Press, 1982). For lengthy discussions of Morris's criticism see Peninah Petruck, *American Art Criticism, 1910–1939.* (New York: Garland Publishers, 1981), and Wayne L. Roosa, *American Art Theory and Criticism During the 1930s: Thomas Craven, George L.K. Morris, Stuart Davis.* (Unpublished Dissertation, Rutgers University, 1989).

33. George L. K. Morris, "On America and a Living Art," catalog of the *Museum of Living Art: A.E. Gallatin Collection* (1936 edition).

34. George L. K. Morris, "On the Mechanics of Abstract Painting," *Partisan Review* 8 (September 1941): 412.

35. Ibid., 415.

36. See George L. K. Morris, "On Fernand Leger and Others," *The Miscellany* 1 (March 1931): 1–17. These ideas are refined in the "On America and a Living Art," cited above, and "On the Abstract Tradition," *Plastique* 1 (1937): 13–15.

37. "On Abstract Tradition," 13.

38. "On America and a Living," 12.

39. "On Abstract Tradition," 13.

40. Ibid. See also "A Note on the London Exhibition of Italian Art," *The Miscellany* 1 (May 1930): 22.

41. "On Abstract Tradition," 13.

42. George L. K. Morris, "Art Chronicle: Some Personal Letters to American Artists recently Exhibiting in New York," *Partisan Review* 4 (March 1938): 36–37.

43. Ibid. 37.

44. "On Fernand Leger": 4–5.

45. George L. K. Morris, "Art Chronicle: The Museum of Modern Art (as Surveyed from the Avant-Garde)," *Partisan Review* 7 (May–June 1940): 53.

46. Ibid.

47. "On the Mechanics of Abstract": 409.

48. "On America and a Living": 6.

## CHAPTER 8. THE CULMINATION OF THE PARADIGMS

1. This change in critical paradigms occurs around the same time that most art historians place the transition from Late Modern to Post modern in American Art.

2. A number of studies have been done around the issues of the cold war and the ascendance of Abstract Expressionism in America during this period; see especially, Max Kozloff, "American Painting During the Cold War," *Artforum* 12 (May 1973): 43–54; Eva Cockcroft, "Abstract Expressionism, Weapon of the Cold War," *Artforum* 12 (June 1974): 39–41.

3. Andreas Huyssen, *After the Great Divide: Modernism, Mass Culture and Post Modernism* (Bloomington: Indiana University Press, 1986).

4. Clement Greenberg, "Avant-garde and Kitsch," *Partisan Review* 6 (Fall 1939): 34–

49. Reprinted in *Clement Greenberg: The Collected Essays and Criticism* (Chicago: University of Chicago Press, 1986), also in *Art and Culture* (Boston: Beacon Press, 1961): 3–21.

5. Greenberg, *Art and Culture*, 4.

6. Ibid., 8.

7. Ibid., 6.

8. Clement Greenberg, "Towards a Newer Laocoon," *Partisan Review* 7 (Fall 1940): 296–310; reprinted in *Clement Greenberg: The Collected Essays* (Chicago: University of Chicago Press, 1986), 22–37.

9. Greenberg, *Collected Essays*, 28.

10. Morris responded to Greenberg's thesis by publishing "Relations of Painting and Sculpture," *Partisan Review* 9 (March/April 1942): 125–27. In this essay, Morris states that cross-fertilization between media is good and enriching.

11. Greenberg, "Newer Laocoon," 42.

12. Ibid., 45.

13. Clement Greenberg, "The Present Prospects of American Painting and Sculpture," *Horizon* 93 (October 1947): 20–30.

14. Ibid., 20.

15. Ibid., 24. It is exactly on these transcendental and subjective qualities that Rosenberg's theory depends for its interpretation of the same tendencies in painting.

16. Ibid., 30.

17. Ibid.

18. Clement Greenberg, " 'American Type' Painting," *Partisan Review* 22 (Spring 1955): 179–96. Reprinted in *Art and Culture* (Boston 1961): 208–29.

19. Greenberg, *Art and Culture*, 208.

20. Ibid., 210.

21. Ibid., 214.

22. Ibid., 227.

23. Ibid., 226.

24. Ibid.

25. Clement Greenberg, "After Abstract Expressionism," *Art International* 6 (October 1962): 24–32.

26. Ibid., 24.

27. Ibid., 27.

28. Fred Orton, "Action, Revolution and Painting," *Oxford Art Journal* 14 (1991): 3–17.

29. Harold Rosenberg, "The Fall of Paris," *Partisan Review* 7 (Fall 1940): 44–54. Reprinted in *The Tradition of the New* (New York: Horizon Press, 1959): 209–20.

30. Ibid., 210. Emphasis in original.

31. Ibid., 213–14.

32. Ibid., 219.

33. See Alfred Barr, "Is Modern Art Communistic?" *New York Times Magazine*, 6 (December 14, 1951): 22–25, 28. Barr utilized Rosenberg's ideas in this article defending Modern art against the charges of it being "communistic." He calls principally on Rosenberg's concept of the new painting as an act of freedom, which he politicizes by contrasting this quintessentially "American" virtue against the enforced artistic code in Communist countries. Later in the decade, when the threat from the right had abated, the Museum of Modern Art tended to prefer Greenberg's more art historical interpretation.

34. Harold Rosenberg, "On the Fall of Paris," *Partisan Review* 7 (Fall 1940): 44.

35. Ibid.

36. Harold Rosenberg, "Introduction to Six American Painters," *Possibilities* 1 (Winter 1947/48): 75.

37. Ibid.

38. Ibid.

39. Ibid.

40. Ibid.

41. Stephen Polcari, *Abstract Expressionism and the Modern Experience* (Cambridge, 1991): 28.

42. Ibid.

43. See Ann Gibson, Abstract Expressionism's Evasion of Language," *Art Journal* 47 (Fall 1988): 208–14.

44. Max Kozloff, "The Critical Reception of Abstract Expressionism," *Arts* 40 (December 1965): 28.

45. Ibid.

46. Ibid. Emphasis in original. This of course, is exacerbated by the artists' reluctance to talk about their work.

47. Stephen C. Foster, "Abstract Expressionism and the Crisis of Criticism." (Unpublished essay, 1994.)

48. Ibid., 5.

49. Jerome Klinkowitz, *Rosenberg/Bathes/Hassan: The Postmodern Habit of Thought* (Athens: University of Georgia Press, 1988).

50. Kozloff, "Critical Reception," 48.

51. Harold Rosenberg, "On Space," exhibition pamphlet, Kootz Gallery, (October 1949).

52. Ibid.

53. Harold Rosenberg, "The American Action Painters," *Art News* 51 (December 1951): 24–28. Reprinted in *Tradition of the New* (New York: Horizon Press, 1959): 23–39.

54. Ibid., 38.

55. Ibid., 27.

56. Ibid., 28.

57. Ibid. This ban against artists entering the critical discourse was to be overruled in the following decade by the artists themselves.

58. Ibid., 29.

59. Ibid., 30.

60. Ibid.

61. Ibid., 26.

62. Ibid., 38.

63. Ibid. 35.

64. See Greenberg's pointed attack of Rosenberg and his followers in "How Art Writing Earns its Bad Name." *Encounter* 19 (December 1962): 67–71.

65. See Irving Sandler, "The Club," *Artforum* 70 (September 1965), reprinted in *Abstract Expressionism: A Critical Record* (New York: Cambridge University Press, 1990): 53. Kappel studied with Heidegger in prewar Germany.

66. Robert Motherwell, ed., *The Dada Painters and Poets* (New York: Wittenborn, Schulz, 1951).

67. Richard Huelsenbeck, "En Avant Dada," originally published 1920. Translated

and published in *The Dada Painters and Poets*, (New York: Wittenborn, Sculth, 1951), 28.

68. Stephen Foster, cited above, believes Dada operated outside the parameters of modernism and so provided a model for art after the failure of the modern. Dadaism was also important to Allan Kaprow, Pop Art, and the Fluxus movement of the 1960s.

69. Marcel Duchamp, "The Creative Act," presented to the American Federation of Arts (Houston: 1957); reprinted in *The New Art: A Critical Anthology* ed. Gregory Battcock (New York: Dutton, 1966): 23.

70. John Dewey, *Art as Experience* (New York: Minton, Balch and Co., 1934): 92–95.

71. Ibid., 47.

72. Ibid. 184. See chapter 8, "The Organization of Energies," 162–86.

73. Ibid., 137.

74. Ibid., 23.

75. Ibid., 147.

76. Ibid., 67.

77. Ibid., 51.

78. Ibid., 81.

79. Clement Greenberg, "After Abstract Expressionism," *Art International* 6 (October 1962): 24–32; Harold Rosenberg, "Action Painting: A Decade of Distortion," *Art News* 61 (December 1962): 42–45, 62–63.

80. Ibid., 43.

81. Ibid.

82. Ibid.

83. Ibid., 44.

84. Ibid.

85. Ibid.

86. Tom Wolfe, "The Painted Word," *Harpers Magazine*, 250 (April 1975): 57–103.

# Bibliography

## Unpublished Sources

Foster, Stephen. "Abstract Expressionism and the Crisis of Criticism" (unpublished essay, 1994).

Mecklenburg, Virginia. "Aesthetic Theory in America, 1910–1920" (Ph.D. diss., University of Maryland, 1983).

Roosa, Wayne. *American Art Theory and Criticism During the 1930s: Thomas Craven, George L.K. Morris, Stuart Davis.* PhD diss., Rutgers University, 1983.

*S.S. Van Dine Papers.* Rare Books and Manuscripts, Firestone Library, Princeton University.

## Primary Sources

Adams, Henry. *The Degradation of the Democratic Dogma.* New York: The Macmillan Company, 1919.

Aikin, Conrad. "The Function of Criticism?" *Broom* 1 (November 1921): 33–38.

American Abstract Artists (AAA). *The Art Critics—How Do They Serve the Public? What Do They Say? How Much Do They Know? Lets Look at the Record!* New York: (publisher?) 1940.

Babbitt, Irving. "Genius and Taste." *The Nation* (February 7, 1918): 139–41.

Barr, Alfred, ed. and principal author. *Cubism and Abstract Art.* New York: The Museum of Modern Art, 1936.

———. "Is Modern Art Communistic?" *New York Times Magazine*, December 14, 1951.

Beard, Charles A. *Contemporary American History 1877–1913.* New York: Macmillan, 1914.

Beard, George Miller. *American Nervousness: Its Causes and Consequences.* New York: Putnam, 1881.

Bell, Clive. *Art.* London: Chatto and Windus, 1913.

———. *Vision and Design.* London: Chatto and Windus, 1920.

Benton, Thomas Hart. "The Mechanics of Form Organization." *The Arts* 10 (November 1926): 285–290; 11 (January 1927):43–45; (February 1927): 95–97; (March 1927): 145–47.

Billings, Henry. "Artifice and Metaphor." *The Arts* 13 (February 1928): 89–91.

Blaikie-Murdoch, W. G. "For Freedom in Criticism." *The Freeman* 4 (February 1922): 544–45.

161

*Blind Man*. May 1917.

Block, Ralph. "The Failure of Modern Criticism." *The Freeman* 2 (June 1921): 300–301.

Boas, Franz. *Anthropology and Modern Life*. New York: W.W. Norton and Co., 1928.

Boswell, Peyton Jr. *Modern American Painting*. New York: Dodd, Mead, 1940.

Brenner, Anita. "Revolution in Art." *The Nation* (March 8, 1933): 267–69.

Brooks, Van Wycks. "Highbrow and Lowbrow." *The Forum* 53 (April 1915): 481–92.

———. "On Creating a Usable Past." *Dial* 64 (April 1918): 337–41.

Brown, Milton. "After Three Years." *Magazine of Art* 34 (April 1946): 138, 166.

Buermeyer, Laurence. "Some Popular Fallacies in Aesthetics." *The Dial* 76 (February 1924): 107–21.

Cahill, Holger. "American Art Today." *America as Americans See It*. New York: The Literary Guild, 1931: 243–66.

Chaplin, Charles. "Making Fun." *The Soil: A Magazine of Art* 1 (December 1916): 5–8.

Coady, Robert J. "American Art." *The Soil: A Magazine of Art* 1 (December 1916): 3–4.

———. "Old John Smith." *The Soil* 1 (January 1917): 57.

———. "The Stampede." *The Soil: A Magazine of Art* 1 (December 1916): 24–26.

Coates, Robert M. "Abstractionists, and What About Them?" *New Yorker* (March 18, 1939): 57–59.

Cortissoz, Royal. *Art and Common Sense*. New York: (publisher?) 1913.

Cox, Kenyon. *The Classic Point of View*. New York: C. Scribners and Sons, 1911.

Craven, Arthur. "Arthur Craven vs. Jack Johnson." *The Soil: A Magazine of Art*, 1 (June 1917): 162.

Craven, Thomas. "The Curse of French Culture." *The Forum* 82 (July 1929): 57–63.

———. "Daumier and the New Spirit." *The Dial* 78 (March 1925): 240–45.

———. "Have Painters Minds?" *American Mercury* 10 (March 1927): 257–62.

———. "How to Interest Children in Art." *Good Housekeeping* 112 (January 1941): 25, 63.

———. "Men of Art." *American Mercury* 6 (December 1925): 425–32.

———. *Men of Art*. New York: Simon and Schuster, 1931.

———. *Modern Art: The Men, the Movements, the Meaning*. New York: Simon and Schuster, 1934.

———. "Photography and Painting." *The Dial* 79 (September 1925): 25–32.

———. *The Pocket Book of Greek Art*. New York: Pocket Books, 1940.

———. "The Progress of Painting: The Modern Background." *The Dial* 74 (April 1923): 355–59.

———. *Rainbow Book of Art* Cleveland: World Publishing Co., 1956.

———. "Renaissance Near?" *Art Digest* 5 (September 1931): 5.

———. "The Snob Spirit." *Scribners Magazine* 91 (February 1932): 81–86.

Dewey, John. "Americanism and Localism." *The Dial* 68 (June 1920): 684–88.

———. *Art as Experience*. New York: Minton, Balch & Co., 1934.

———. *Experience and Nature*. Chicago: Open Court Publishing Co., 1925.

————. "Individualism, Old and New I: The United States, Incorporated." *The New Republic* 61 (January 22, 1930): 239–41.

————. "Individualism Old and New II: The Lost Individual," Capitalism or Public Socialism?" *The New Republic* 61 (February 5 1930): 294–96.

————. "Individualism Old and New III: Toward a New Individualism." *New Republic* 62 (February 19, 1930): 13–21.

————. "Individualism Old and New IV: Capitalism or Public Socialism?" *The New Republic* 61 (March 5, 1930): 64–67.

————. "Individualism Old and New V: The Crisis in Culture." *The New Republic* 62 (March 19, 1930): 123–26.

Duffus, Robert L. *The American Renaissance.* New York: A. A. Knopf, 1928.

Eglington, Guy. "The American Painter." *The American Mercury* 1 (February 1924): 128–220.

————."Art and Other Things." *International Studio* 80 (January 1925): 338–41.

————. "The Complete Dictionary of Modern Art Terms for the Use of Aspiring Amateurs," published as a series in *International Studio* 31 (March 1925): 68–70; (April 1925): 141–51; (June 1925): 224–31; (July 1925): 307–9; (August 1925): 375–77.

Fletcher, John Gould. "Art and Life." *The Freeman* 3 (1921): 247.

Greenberg, Clement. "After Abstract Expressionism, *Art International* 6 (October 1962): 24–32.

————. "'American Type' Painting," *Partisan Review* 22 (Spring, 1955): 179–96.

————. *Art and Culture: Critical Essays.* Boston: Beacon Press, 1961.

————. "Avant-garde and Kitsch." Partisan Review 6 (Fall 1939): 34–49.

————. "How Art Writing Earns its Bad Name." *Encounter* 19 (December 1962): 67–71.

————. "The Present Prospects of American Painting and Sculpture." *Horizon* 93 (October 1947): 20–30.

————. "Towards a Newer Laocoon." *Partisan Review* 7 (Fall 1940): 296–310.

Gregg, Frederick James. "Bread and Butter and Art." *The Forum* 52 (September 1914): 443–50.

Hoffman, Frederick. *The Little Magazine: A History and a Bibliography.* Princeton: Princeton University Press, 1946.

James, Henry, ed., *The Letters of William James.* Boston: The Atlantic Monthly Press, 1920.

James, William. "Great Men, Great Thoughts, and the Environment." *The Atlantic Monthly* 46 (October 1880): 441–59.

————.*The Will to Believe and Other Essays in Popular Philosophy.* New York: Longmans, Green and Company, 1897.

Jewell, Edwin Alden. *Americans.* New York: Knopf, 1930.

————. *Have We an American Art?* New York: Longmans, Green and Co., 1939.

————. "Toga Virilis: The Coming of Age of American Art." *Parnassus* 4 (April 1932): 1–3.

Josephson, Matthew. "The Great American Billposter," *Broom* 3 (November 1922): 304–12.

Kootz, Sam. "American Uber Alles: Critic Rises to Admonish Our 'Renaissance'— Urges 'Let's Forget Premature Circus,'" *New York Times*, December 20, 1921.

———. *Modern American Painters*. New York: Brewer and Warren, 1930.

———. *New Frontiers of American Painting*. New York: Hastings House, 1943.

Leob, H. A. "The Mysticism of Money." *Broom* 3 (September 1922): 115–30.

MacColl, W. D. "The International Exhibition of Modern Art: An Impression." *The Forum* 50 (July 1913): 24–36.

McBride, Henry. "Modern Art." *The Dial* 73 (November 1922): 586–87.

———. "Modern Art." *The Dial* 74 (February 1923): 218.

———. "The Palette Knife." *Creative Arts* 9 (November 1931): 355.

Mather, Frank Jewett et al., "Pure Art or 'Pure Nonsense?'" *The Forum* 74 (July 1925): 146–50.

Morris, George L. K. "Art Chronicle: The Museum of Modern Art (as Surveyed from the Avant-Garde)." *Partisan Review* 7 (May-June 1940): 53.

———."Art Chronicle: Some Personal Letters to American Artists Recently Exhibiting in New York." *Partisan Review* 4 (March 1938): 36–37.

———. "On America and a Living Art," *Museum of Living Art: A.E. Gallatin Collection* (1936 edition).

———. "On Fernand Leger and Others," *The Miscellany* 1 (March 1931): 1–17.

———. "On the Abstract Tradition," *Plastique* 1 (New York, 1937): 13–15.

Pach, Walter. "Art in America." *The Freeman* 2 (November 17, 1920): 232–33.

———. "The Contemporary Classics." *The Freeman* 3 (July 13, 1921): 423.

———. "Hindsight and Foresight." In *For and Against*. New York: Association of American Painters and Sculptors, 1913.

———. *The Masters of Modern Art*. New York: B. W. Huebsch, 1924.

———. "Paris in New York." *The Freeman* 2 (February 2, 1921): 492–94.

———. "The Truth About Painting." *The Forum* 54 (October 1915): 443–54.

Robinson, James Harvey. *The New History: Essays Illustrating the Modern Historical Outlook*. New York: Macmillan, 1912.

Rosenberg, Harold. "Action Painting: A Decade of Distortion," *Art News* 61 (December 1962): 42–45, 62–63.

———. "The American Action Painters." *Art News* 51 (December 1951): 24–28.

———. "Introduction to Six American Artists." *Possibilities* 1 (Winter 1947/48): 75.

———. "On the Fall of Paris." *Partisan Review* 7 (Fall 1940): 44–54.

———. "On Space." Exhibition pamphlet, Kootz Gallery, October 1949.

———. *The Tradition of the New*. New York: Horizon Press, 1959.

Sanborn, Robert A. "A Champion in the Wilderness." *Broom* 3 (October 1922): 174–79.

Schapiro, Meyer. "Nature of Abstract Art," *Marxist Quarterly* 1 (January-March 1937): 77–98.

———. "Race, Nationality and Art." *Art Front* 2 (March 1936): 10–12.

———. "The Social Bases of Art," *American Artists' Congress*. New York 1936: 31–37.

Spencer, Herbert. *Social Statics: The Conditions Essential to Human Happiness Specified, and the First of Them Developed*. New York: D. Appleton and Company, 1888.

Watson, Forbes. "The Latest Thing." *The Arts* 16 (May 1928): 595.

Williams, William Carlos. "Comment," *Contact* 1 (December 1920): 18.

Wright, Willard Huntington. "The Aesthetic Struggle in America." *The Forum* 55 (February 1916): 201–20.

———. "Art, Promise and Failure." *The Forum* 55 (January 1916): 29–42.

———. *The Future of Painting.* New York: W. Huebsch, 1923.

———. *Modern Painting: Its Tendency and Meaning.* New York: Dodd, Mead, 1915.

———. "Notes on Art." *The Forum* 55 (June 1916): 691.

———. "The Truth About Painting." *The Forum* 54 (October 1915): 443–54.

## SECONDARY SOURCES

Agee, William C. "Willard Huntington Wright and the Synchromists." *Archives of American Art Journal* 24 (March 1984): 10–15.

Alexander, Thomas M. *John Dewey's Theory of Art, Experience and Nature: The Horizons of Feeling.* Albany: State University of New York Press, 1987.

Allentuck, Marcia Epstein. *John Graham's System and Dialectics of Art.* Baltimore: Johns Hopkins University Press, 1971.

Baigell, Matthew. "American Art and National Identity." *Arts* 61 (February 1987): 48–55.

———. *The American Scene: American Painting of the 1930s.* New York: Praeger 1974.

Baigell, Mathew, and Julia Williams, eds. *Artists Against War and Fascism: Papers of the First American Artists' Congress.* New Brunswick: Rutgers University Press, 1986.

Battcock, Gregory. *The New Art: A Critical Anthology.* New York: Dutton, 1966.

Benedict, Ruth. *Patterns of Culture.* Boston: Houghton, Mifflin and Co., 1934.

Cockcroft, Eva. "Abstract Expressionism, Weapon of the Cold War." *Artforum* 12 (June 1974): 39–41.

Cox, Annette. *Art as Politics: The Abstract Expressionist Avant-Garde and Society.* Ann Arbor: UMI Research Press, 1982.

Foster, Stephen C. *The Critics of Abstract Expressionism.* Ann Arbor: UMI Press, 1980.

Gibson, Ann. "Abstract Expressionism's Evasion of Language." *Art Journal* 47 (Fall 1988): 208–214.

Goodman, Cynthia. *Hans Hofmann.* New York: Abbeyville Press, 1986.

Green, Martin Burgess. *New York 1913: The Armory Show and the Patterson Strike Pageant.* New York: Scribner, 1988.

Greenberg, Clement. *Clement Greenberg: The Collected Essays and Criticism.* Chicago: University of Chicago Press, 1986.

Guilbaut, Serge. *How New York Stole the Idea of Modern Art.* Chicago, University of Chicago Press, 1983.

Hoffman, Frederick et. al. *The Little Magazine: A History and a Bibliography.* Princeton: Princeton University Press, 1946.

Homer, William Innes. "The Armory Show and Its Aftermath." In *Avant-Garde Painting and Sculpture in America 1910–1925.* Wilmington: Delaware Art Museum, 1975.

Huyssen, Andreas. *After the Great Divide: Modernism, Mass Culture and Post Modernism* Bloomington: University of Indiana Press, 1986.

Klinkowitz, Jerome. *Rosenberg/Bathes/Hassan: The Postmodern Habit of Thought.* Athens: University of Georgia Press, 1988.

Kozloff, Max. "American Painting During the Cold War." *Artforum* 12 (May 1973): 43–54.

———. "The Critical Reception of Abstract Expressionism." *Arts* 40 (December 1965): 28.

Krauss, Rosalind. *The Optical Unconscious.* Cambridge: MIT Press, 1993.

Lears, T. J. Jackson. *No Place of Grace: Antimodernism and the Transformation of American Culture 1880–1920.* New York: Pantheon Books, 1981.

Lorenz, Melinda. *George L.K. Morris: Artist and Critic.* Ann Arbor: UMI Press, 1982.

Marcell, David W. *Progress and Pragmatism: James, Dewey, Beard and the American Idea of Progress.* Westport, Conn.: Greenwood Press, 1974.

Monroe, Gerald M. "Artists as Militant Trade Union Workers During the Great Depression." *Archives of American Art Journal* 14 (Spring 1974): 7–10.

Motherwell, Robert, ed. *The Dada Painters and Poets.* New York: Wittenborn, Schultz, 1951.

O'Connor, Francis V., ed. *Art for the Millions: Essays from the 1930s by Artists and Administrators of the WPA Federal Art Project.* Greenwich: New York Graphic Society, 1979.

Orton, Fred. "Action, Revolution and Painting." *Oxford Art Journal* 14 (1991): 3–17.

Platt, Susan Noyes. "Formalism and American Art Criticism in the 1920's." *Art Criticism* 2 (1986): 69–83.

Petruck, Peninah. *American Art Criticism, 1910–1939.* New York: Garland Publishers, 1982.

Polcari, Stephen. *Abstract Expressionism and the Modern Experience.* New York: Cambridge University Press, 1991.

Rorty, Richard. *Contingency, Irony, and Solidarity.* New York: Cambridge University Press, 1989.

Sandler, Irving. "The Club." *Artforum* 70 (September 1965).

———. *The Triumph of American Painting: a History of Abstract Expressionism.* New York: Praeger, 1970.

Saunders, Frances Stoner. *Who Paid the Piper: The Cultural Cold War and the World of Arts and Letters.* New York: W.W. Norton and Co., 1999.

Shapiro, David. *Social Realism: Art as a Weapon.* New York: Ungar, 1973.

Shapiro, David, and Cecile. *Abstract Expressionism: A Critical Record.* New York: Cambridge University Press, 1990.

Weeks, Sara. *"Search for the Real," and Other Essays.* New York: Abbeyville Press, 1986.

White, Morton. *Social Thought in America: The Revolt Against Formalism.* New York: Viking Press, 1949.

Winston, George. *John Fiske.* New York: Twayne Publishers, 1972.

Wolfe, Tom. "The Painted Word," *Harpers Magazine*, 250 (April 1975): 57–103.

Zilczer, Judith K. "Robert J. Coady, Forgotten Spokesman for Avant-Garde Culture in America." *American Art Review* 2 (1975): 80–84.

# Index